Beauty, Horror and Immensity

Beauty, Horror and Immensity

Picturesque Landscape in Britain, 1750–1850

Exhibition selected and catalogued
by Peter Bicknell
Fitzwilliam Museum, Cambridge,
7 July–31 August 1981

Cambridge University Press

Cambridge
London New York New Rochelle
Melbourne Sydney

Fitzwilliam Museum
Cambridge

Published by the Press Syndicate of the University of Cambridge
The Pitt Building, Trumpington Street, Cambridge CB2 1RP
32 East 57th Street, New York, NY 10022, USA
296 Beaconsfield Parade, Middle Park, Melbourne 3206, Australia

First published 1981

Printed in Great Britain by Balding + Mansell, London and Wisbech

British Library cataloguing in publication data

Fitzwilliam Museum
Beauty, horror and immensity.
1. Fitzwilliam Museum – Catalogs
2. Landscape in art – Catalogs
3. Art, Modern – 17th–18th centuries – Catalogs
4. Art, Modern – 19th century – Catalogs
I. Bicknell, Peter
760'.04436'09033 N1217 80-42388

ISBN 0 521 23880 3 hard covers
ISBN 0 521 28278 0 paperback

Contents

Foreword by Michael Jaffé *page* vii

Introduction *page* ix

Acknowledgements *page* xvii

References and bibliography *page* xviii

Abbreviations *page* xx

Note *page* xx

The catalogue *page* 1

 Antecedents *page* 3

 Followers of Claude *page* 12

 Followers of the Dutch and other painters *page* 16

 The *Liber Veritatis* *page* 26

 The Reverend William Gilpin *page* 35

 Picturesque theory *page* 41

 Doctor Syntax *page* 44

 Picturesque travel *page* 47

 Picturesque topography *page* 56

 The Sublime *page* 68

 Picturesque illustration *page* 74

 Drawing books *page* 88

Index of artists, engravers and authors *page* 101

Plates *following page* 104

Colour plate section *between plates* 53 *and* 54

Foreword

The picturesque approach to the scenery of lakes and mountains, the eighteenth-century prelude to the romantic, while Italianate in its inspiration, was essentially British in its pursuit. It may seem surprising that there has been no considerable attempt to display publicly the range of picturesque production, graphic in every sense, in which so much passion and curiosity were involved. It may seem still more surprising that the first such exhibition should be in Cambridge, where the flatness of the surrounding countryside so conspicuously lacks picturesque appeal; but no other city has ready and willing such a true Laker as Peter Bicknell. It was a happy day when he accepted our invitation to select and catalogue material a substantial part of which he himself collected.

The scope is the historically extensive reaction to the wildness and beauty of mountainous scenery to be explored in the British Isles. Of that, Mr Bicknell has been making a personal exploration since Christmas 1914: then it was that as a schoolboy he first stayed, with his parents, at a house at the head of Buttermere called Lower Gatesgarth, a house which had been designed for Professor A. C. Pigou of King's by a young Kingsman, Arthur Moberley. Thirty years later Mr Bicknell, then known as a mountaineer as well as an architect and teacher of architecture in Cambridge, contributed *British hills and mountains* to Collins's Britain in Pictures series; and in that short book he included 'The discovery of the hills', a section examining the early travellers, their books and their pictures. He helped to choose the illustrations from a rich field of topographical drawings and prints. He soon found that he was buying the books and the prints for his own delectation. The encouragement and the pleasures which he received from Dr A. N. L. Munby in the book collecting and the series of enchanted holidays at Lower Gatesgarth have led him to transfer a substantial part of the collection to the library at King's, in grateful memory of these two friends, what had become one of the finest private libraries of picturesque travel.

This remarkable gift to King's, considered with the holdings of the University Library and of Emmanuel, meant that we did not need to look outside Cambridge for loans of publications. The British Museum and the Victoria and Albert Museum have lent from their Departments of Prints and Drawings with characteristic generosity. We are pleased to have been able to borrow from Temple Newsam and from the Laing Art Gallery as well as from private collectors some of whom wish to remain anonymous; and from the City Art Galleries of Manchester and Birmingham we have borrowed paintings by great masters of the highest importance to this exhibition. We thank them all for their noble support of this pioneering endeavour.

Michael Jaffé

vii

Introduction

When John Varley told his pupils that nature wants cooking, he was putting his finger on one of the essential elements of the Picturesque. Whether in painting, prose, poetry or garden, the Picturesque is the art of cooking nature – cooking her according to certain principles originally deriving from the seventeenth-century landscape painters – to produce what in William Gilpin's terms 'would look well in a picture'.

In Christopher Hussey's *The Picturesque*, first published in 1927, and generally accepted as the standard work on the subject, he borrowed freely from Elizabeth Wheeler Manwaring's *Italian landscape in eighteenth century England: a study chiefly of the influence of Claude Lorrain and Salvator Rosa on English taste, 1700–1800*. The main theme of this exhibition is very much that of Professor Manwaring's book, though the period is extended well into the nineteenth century. The exhibition illustrates particularly the influence of the landscape painters working in Italy in the seventeenth century on the appreciation of the natural scene in the British Isles, and is concerned with wild and mountainous rather than pastoral scenery. In doing so it presents the Picturesque as a transition from the classically arranged world of Claude and the Augustan poets to the romantic vision of Constable and Wordsworth. It covers neither the Picturesque in architecture nor in garden design. As far as books are concerned, it deals with illustration and not the theory of the Picturesque.

Captain Birt, a surveyor officer in General Wade's army of occupation in the Highlands of Scotland in the 1720s, would have seen eye to eye with Samuel Johnson, who found the mountains 'matter incapable of form or usefulness; dismissed by nature from her care and left in its original elemental state'. Birt, writing to his friend in London, described them as 'monstrous excrescences . . . rude and offensive to the sight . . . their huge naked rocks producing the disagreeable appearance of a scabbed head . . . of a dismal gloomy brown drawing upon a dirty purple and most of all disagreeable when the heath is in bloom'. However, he also describes another kind of hill: 'Now what do you think of a poetical Mountain, smooth and easy of Ascent, cloath'd with a verdant flowery turf, where shepherds tend their Flocks; sitting under the Shade of tall Poplars, &c. In short, what do you think of *Richmond* Hill, where we have pass'd so many hours together, delighted with the beautiful Prospect.' Birt was clearly seeing the Prospect as a picture by Claude Lorrain; and in doing so his description is highly picturesque. He was typical of a generation of English gentlemen who, by making the Grand Tour, were both seeing the paintings of the 'Italian' landscape artists and becoming familiar with the scenes that inspired their pictures: the Virgilian tranquillity of the Campagna evoked by Claude and the horror of Alp and Apennine evoked by Salvator. They bought the pictures of Claude, Salvator and Poussin,[1] or made do with those of their followers, copiers and imitators in Italy, France, Holland and England. These they displayed in their Palladian houses;

1 In eighteenth-century England 'Poussin' normally referred to Gaspar Dughet and not Nicolas Poussin.

they read the poetry of Thomson and Dyer which described nature in terms of landscape painting; and they transformed the surroundings of their houses into dream Arcadian scenes.

Towards the middle of the century they began to visit the wilder parts of their own island, where they viewed the prospect of lake and mountain, rock and torrent as a series of pictures. One of the earliest of the picturesque travellers was Dr John Brown of St John's College, Cambridge, who, writing to Lord Lyttelton, probably in 1753, explained that 'the full perfection of *KESWICK* consists of three circumstances, *Beauty, Horror* and *Immensity* united . . . But to give you a complete idea of these three perfections, as they are joined in *KESWICK*, would require the united powers of *Claude, Salvator,* and *Poussin*. The first should throw his delicate sunshine over the cultivated vales, the scattered cots, the groves, the lake, and wooded islands. The second should dash out the horror of the rugged cliffs, the steeps, the hanging woods, and foaming waterfalls; while the grand pencil of *Poussin* should crown the whole with the majesty of the impending mountains.'

Of the three it was Claude who appealed most to English taste; indeed the English love of Claude was almost an obsession. By 1728 the *Liber Veritatis* was in the possession of the Duke of Devonshire; and in 1777 Earlom gave it wide circulation by the publication of his mezzotint prints of the complete series. At the end of the century Richard Payne Knight, prophet of the Picturesque, acquired the splendid collection of Claude drawings which are now in the British Museum. Claude was better represented in England than in any other country. By the middle of the nineteenth century nearly two-thirds of the pictures recorded in the *Liber Veritatis* were in English collections.

English artists like John Wootton and George Lambert painted ideal landscapes in the manner of Claude. Others such as the brothers George and John Smith of Chichester presented the English scene in a manner little less Claudian than the imaginary worlds of Wootton and Lambert. Engravings of their pictures, both ideal and supposedly topographical, as well as of those of Claude himself did much to popularise the formula. George Smith was known as the 'English Claude'. So too, with more justification, was Richard Wilson, who worked in Italy from about 1749 to 1755, painting the scenes that had inspired Claude. When he returned to England he painted historical, ideal and topographical landscape in his own personal version of the master's idiom. His view of Snowdon from Llyn Nantlle presents the mountains of his native Wales with a fair degree of topographical accuracy (described by Pennant as 'magnificent as it is faithful'), but the landscape is arranged to make a correct picturesque composition – the three parallel planes, the framing trees, the rocks taking the place of ruins in the middle distance and the suitably grouped figures in the foreground. But in his view of Cader Idris, Llyn-y-Cau, he left the Claudian Picturesque far behind. Only a tranquil, golden glow, rare in the mountains of Wales, reminds us of Arcadia. In interpreting his own emotional reactions to the mountain scene Wilson foreshadows Wordsworth and the romantics. It was of pictures such as this that Ruskin was thinking when he said, 'With the name of Richard Wilson the history of sincere landscape art, founded on the meditative love of nature, begins in England.'

The artist who did most to relate Claude to the Romantic Movement was Turner. The *Liber Studiorum*, although different in intention from the *Liber*

Veritatis, clearly derived from it, and many of the engravings are highly picturesque in the Claudian manner. Turner's desire to outpaint Claude in pictures like *Dido building Carthage* is well known. In his picture *Thomson's Aeolian harp* he epitomises beautifully the English cult of Claude and its relation to the Picturesque. The painting pays homage both to Claude and to the poet Thomson's *An ode to Aeolus's harp*, and by a happy chance the prospect from Richmond Hill is the one so picturesquely described by Captain Birt.

Almost without exception landscape artists in eighteenth-century England were infected by the Picturesque. Gainsborough was no exception, but what he selected to look well in a picture was very different from the vocabulary of the followers of Claude. He was generally much more influenced by Wynants, Ruisdael and the Dutch painters. His picturesqueness was not that of a golden age, but one of roughness, muddy lanes and thatched cottages. His compositions were as contrived as those of the 'English Claudes', but they were built on spirals and not on parallel planes. His figures were rustic and not classical. If there is anything Italianate in his scenes it is of Salvator rather than Claude. It was a genre that was adopted less satisfactorily by painters such as Morland and Wheatley, later to be vulgarised by the Victorians. Gainsborough visited the Lake District in 1783, and from then on he introduced Salvatorian mountains into many of his imaginary landscapes. It is significant that four of the eight transparencies for his Peep Show, now in the Victoria and Albert Museum, are of such scenes. There was a strong element of serendipity in his compositions, for he would seek inspiration by making arrangements in trays. 'He would place cork or coal for his foregrounds, make middle grounds of sand or clay, bushes of mosses and lichens and set up distant woods of broccoli' – a method of inspiration which is comparable with Alexander Cozens' blot drawing, by which he evolved landscape compositions from casual ink blots.

The cult of the Picturesque developed the habit of picturesque travel. The picturesque traveller is one who has formed an image of an ideal form of nature from landscape painting and travels in pursuit of this ideal. His 'first source of amusement', says William Gilpin, himself perhaps the most notable of them all, 'is the pursuit of his object and searching after effects'.

Two of the earliest such travellers, Thomas Gray and Horace Walpole, both in their early twenties, included in their continental tour of 1739 the Grande Chartreuse, where they both responded to the Picturesque, Gray romantically: 'I do not remember to have gone ten paces without an exclamation which there was no restraining: not a precipice, not a torrent, not a cliff, but is pregnant with religion and poetry.' Walpole more prosaically and more conventionally saw the scene as a picture: 'Precipices, mountains, torrents, wolves, rumblings, Salvator Rosa . . .' In 1765 Gray visited Scotland and found the highlands 'ecstatic'. Four years later he was in the Lakes, and at Keswick he 'passed six days lap'd in Elysium'. The mountains which Birt had so heartily disliked had, like the grounds of Stowe and Stourhead, become Elysian.

The Lake District became established as one of the principal quarries for those in pursuit of the Picturesque, and their reaction to the district is a gauge of the picturesque taste of the time. As we have seen, John Brown was at Keswick, probably in 1753, but in 1755 (before Brown's letter was published in 1766) a poem by John Dalton, describing the Vale of Keswick in the picturesque couplets of the landscape poets, appeared. Young in 1768, Gray in 1769, Gilpin and

Hutchinson both in 1773 began the avalanche of dons, divines and dilettanti that descended on the Lakes and recorded their impressions in picturesque terms. They were no doubt familiar with the prints of William Bellers' views of the Lakes, the first of which was issued in 1752. These were the earliest of the thousands of prints of the Lakes which were to pour from the presses for the next hundred years; and in them Bellers presented the prospect with some degree of topographical accuracy, as a Claudian scene with elegantly disposed figures grouped in classical attitudes in the foreground. In 1788 *A guide to the Lakes, dedicated to lovers of landscape scenery* appeared, by a Jesuit priest, Thomas West, in which he directed the tourist to 'stations' from which, weather permitting, a correct picturesque prospect could be guaranteed. West's 'stations' were marked on the maps surveyed, drawn and published by Peter Crosthwaite, self-styled 'Admiral of the Keswick Regatta, who keeps the Museum at Keswick, & is Guide, Pilot, Geographer & Hydrographer to the Nobility and Gentry who make the Tour of the Lakes'. West's *Guide* enjoyed considerable popularity and was into a seventh edition by 1799. The second and later editions included copious addenda which formed a handy anthology of extracts from picturesque works about the Lakes by writers such as Dalton, Brown, Gray, Cumberland and Mrs Radcliffe. By the end of the century the tour to the Lakes had become the height of fashion, to be satirised in Joseph Plumptre's comic opera *The Lakers*, 1789. When it was suggested that Elizabeth Bennet should visit the Lakes, Jane Austen, a keen observer of fashion, made her exclaim, 'What are men to rocks and mountains?'

If the picturesque traveller could not himself sketch he took with him, if possible, a draughtsman. Pennant employed Moses Griffith on his journeys; Greville was accompanied by both 'Warwick' Smith and Julius Caesar Ibbetson. Gray more modestly had to make do with a Claude Lorrain Glass. This was a neat little convex mirror in which the traveller, placing his back to the view, could see a small framed, tinted picture of the prospect. Claude Glasses could be obtained in various tints so that, whatever the natural state of the light, a suitably mellow glow could be imparted to the picture.

Not only were the more affluent travellers accompanied by artists, but others were very ready to buy drawings and prints of the places they had visited. To meet this need the portrayal of wild and mountainous scenery became a thriving industry. Early in the century topographical draughtsmen had been busy recording country seats and antiquities. If like the Buck brothers in pursuit of castles in North Wales, they found themselves deep in the mountains, they delineated the landscape with neither interest nor accuracy. But from the time Bellers visited the Lakes, landscape was one of the principal interests of the topographers, who became deeply involved in the mountain scene. It was in the years from 1750 to 1800 that British artists, working as a rule in delicate line and transparent wash, transformed picturesque topography into the romantic art of Cotman, Girtin and Turner.

The work of the topographers was almost universally picturesque, in the sense that in recording nature they converted it into compositions of ideal landscape; in fact they 'cooked' nature in the manner of Claude, Salvator and Poussin, with occasionally a leaven of Zuccarelli or Vernet. One of the most prolific and accomplished of these artists was Paul Sandby. In his work the influence of Claude is perhaps more evident than in that of any of his contemporaries. His *Views in South Wales*, 1775, the first English book of aquatints, was published two years

earlier than Earlom's *Liber Veritatis*, to which it is closely related. The presentation of the plates in warm brown monochrome is similar and many of the views are highly Claudian in composition. Sandby's reliance on Claude is beautifully illustrated by a little watercolour of Snowdon where he has taken the Tiber, the Ponte Molle and the Italian vernacular round-towered farmhouse, all familiar from the *Liber Veritatis*, and planted them in the middle distance in front of Snowdon. At Drakelow Hall Sandby painted a room (now in the Victoria and Albert Museum) as an illusionistic landscape setting, where views of mountain scenery, such as the prospect of Dolbadern Castle and Snowdon, were seen through openings framed with real trellis which could be entered through real little wicket gates left half open – described by Hussey as 'the high water mark of the cult of the picturesque'.

The most dedicated traveller in search of the Picturesque was the Reverend William Gilpin. Between 1769 and 1774 he made a series of tours which he recorded in observations illustrated by his own sketches. These were circulated in manuscript among his friends, who constantly encouraged him to publish. This he eventually did in 1782, when he started with the *River Wye*, which was an immediate success. For the next seventeen years the others followed, eight tours in all as well as *An essay on prints, Five essays on picturesque subjects* and *Poem on landscape painting*. He invented the term 'picturesque beauty', which, as we have seen, he defined as 'that which would look well in a picture'. The title of each of the eight tours begins with *Observations . . . relative to picturesque beauty*. They were illustrated with monochrome aquatints of his drawings, usually oval. He explained that they were not meant to be topographical portraits but were simple arrangements of natural elements organised according to the correct principles of picturesque beauty. Although he worshipped nature, he constantly had to reprove her for her inadequacy in composition. His illustrations put things right for her.

It was the kindly, comical figure of the late Doctor Gilpin that Rowlandson and Combe were satirising in *The tour of Doctor Syntax in search of the Picturesque* which came out month by month in Ackermann's *Poetical Magazine*, 1809–11. The alternative title was *Doctor Syntax's tour to the Lakes*, and the climax of the tour is illustrated by a plate of Doctor Syntax sketching Derwentwater.

Although the idea of the Picturesque had been much in evidence for most of the eighteenth century, Gilpin was the first author to make any attempt to analyse or define it. Imprecise and amateurish as his contribution to aesthetics is, it was the bridgehead from which the battle of words which raged at the turn of the century was launched. The principal protagonists were Richard Payne Knight with his *Landscape: a didactic poem*, 1794, and *An analytical enquiry into the principles of taste*, 1805; Uvedale Price with his *Essay on the Picturesque*, 1794; and Humphry Repton with his *Sketches and hints on landscape gardening*, 1795. These books make difficult and contradictory reading. Payne Knight is the most intellectual and his *Analytical enquiry* covers a considerable philosophical field; but the clearest statement comes from Price, who tries to establish the Picturesque as an aesthetic category to supplement the Sublime and the Beautiful, defined by Edmund Burke thirty-eight years earlier.

In *A philosophical inquiry into the origin of our ideas of the Sublime and the Beautiful*, 1756, Burke had made no reference to the Picturesque. During the years that passed between Burke and Price the Sublime had in fact been an

important constituent of the Picturesque. Indeed, by the time Captain Birt's letters had been published in 1754 his reactions to mountain scenery were hopelessly out of date. Gentlemen on the Grand Tour had begun to peep under the blinds of their carriages to enjoy the visual horrors of the Alps. Walpole and Gray had already been thrilled by the horrid surroundings of the Grande Chartreuse. Through Burke the picturesque travellers rapidly became familiar with the concept of the Sublime, at a time when the concept of the Picturesque was still to be defined. Burke's Sublime covered those elements that created feelings of fear and wonder and aroused the instinct of self-preservation – elements which could only be enjoyed as travel became less hazardous. As Macaulay explained, 'A traveller must be freed from all apprehension of being murdered or starved before he can be charmed by the bold outlines and rich tints of the hills. He is not likely to be thrown into ecstasies by the abruptness of a precipice from which he is in imminent danger of falling two thousand feet perpendicular; by the boiling waves of a torrent which suddenly whirls away his baggage and forces him to run for his life; by the gloomy grandeur of a pass where he finds a corpse which marauders have just stripped and mangled; or by the screams of those eagles whose next meal may probably be his own eyes.'

In the countless pictures which were being poured out by the topographical draughtsmen there was often a strong element of the Sublime. Claude could be equated with the Beautiful, Salvator with the Sublime. P. J. de Loutherbourg, who leant more heavily on Salvator than on Claude, was involved in theatrical design and invented the Eidophusikon, a small stage where scenes such as 'the region of the fallen angels with Satan arranging his troops on the banks of the Fiery Lake' were enacted. His view of Snowdon from Llyn Nantlle (the same view that was painted by Wilson) is animated by a strong gust of the Sublime, which has blown away any trace of Claudian tranquillity; and in his lurid views of Coalbrookdale he introduces the Sublime of the dark satanic mills. When Greville was touring Wales accompanied by 'Warwick' Smith and Ibbetson they were caught in the Pass of Aberglaslyn by a sudden violent thunderstorm. Both artists subsequently recorded in similar pictures the dramatic moment when the group of travellers were illuminated by a flash of lightning. Ibbetson recorded on the back of his drawing 'An actual scene. The Honble Robert Greville(s) Phäeton between Pont Aberglaslyn and Tan y Bwlch, crossing the Mountain [Range] in a Thunder Storm. Painted by Julius Ibbetson who was passer [i.e. passenger].'

The apotheosis of the topographical sublime is achieved by James Ward in his enormous *Gordale Scar* which dwarfs its neighbours in the Tate Gallery. Gordale Scar, the fantastic limestone cleft near Malham in the Pennines, was a Mecca for picturesque travellers journeying to and from the Lakes. Gray described it in Salvatorian terms, and the landscape artist Edward Dayes ends his description by saying, 'Good heavens, what a scene. how awful! . . . The lover of drawing will be much delighted with this place: immensity and horror are its inseparable companions . . . The very soul of Salvator Rosa would hover over these regions of confusion.' In the foreground of Ward's picture stands a splendid white bull, the sublimest of the domestic animals. Sheep are beautiful, goats are picturesque, but bulls are sublime.

In his picture of the Welsh bard John Martin presents the apotheosis of the historical sublime. It is inspired by Gray's *Ode* to the Welsh bard, 'founded on a tradition current in Wales, that Edward the First when he completed the

conquest of that country, ordered all the Bards, that fell into his hands, to be put to death'. Deep in the heart of Erye, the domain of the eagle, the bard stands on a pinnacle of rock, playing his last dirge upon his Welsh harp, while eagles, the symbols of freedom, circle about his head, before he casts himself headlong into the cataract beneath to escape from the invading hosts advancing in endless procession from the castle stronghold of the tyrant king.

The Picturesque has been engulfed in the Romantic.

Prints and drawing books

The work of the topographical artists fed a flourishing trade in print-selling. Often, as in the case of Sandby's views of Wales, the artist himself was the publisher; but publishing houses like Boydell's and Ackermann's, by issuing large numbers of prints, often of a high technical and artistic standard, did much to further the improvement of engraving techniques. Until the publication of Sandby's views, topographical prints were in general copperplate engravings. But once aquatint had been introduced it rapidly became one of the favourite media for landscape illustration. The process of etched line, aquatinted tones and coloured or monochrome washes reproduced with considerable fidelity the drawings of artists like Paul Sandby, working in line, monochrome wash and watercolour.

During the first twenty years of the nineteenth century a series of colour-plate books illustrated with aquatints of great beauty emanated from the presses. Outstanding are William Daniell's 308 plates for *The voyage round Britain* and William Westall's for such books as *Views of the lake and vale of Keswick* and Ackermann's histories of the universities of Oxford and Cambridge; but there are a great many others of equal quality.

A by-product of the vogue for sketching and the demand for drawing masters was the output of drawing books illustrated in aquatint, often arranged in series of progressive stages, showing line by line, wash by wash and colour by colour how a landscape watercolour drawing should be built up. In Laporte's *The progress of a water-coloured drawing, wherein is represented to the learner various gradations through which a drawing passes from the outline to its finished state, consisting of fourteen tinted lessons,* the plates were coloured by hand. The first etched plate represented the line drawing, and the subsequent plates were coloured progressively, involving ninety-one hand-colouring operations for each copy of the book. The hacks who coloured these and other aquatints in large numbers became highly accomplished in the art of laying transparent washes, contributing an important skill to the art of watercolour. The artists responsible for the drawing books were the landscape watercolourists who were also active as drawing masters, such as John Varley, John Laporte and notably David Cox. Cox's *A treatise on landscape painting and effect in water colours: from the first rudiments, to the finished picture. With examples in outline, effect, and colouring,* issued in twelve parts, is a splendid folio volume in which some of the fully coloured plates are hardly distinguishable from his watercolour drawings. John

Heaviside Clark reused the very picturesque plates from *Gilpin's day*, colouring them in a vividly un-Gilpin-like way to convert them into illustrations for a drawing book. The drawing books were intended for amateurs and not for the instruction of professionals. Industrious young ladies must have spent countless hours following the instructions stage by stage, sometimes even laboriously copying every line of the text.

The artists who produced the drawing books also produced various picturesque pastimes and games, such as John Clark's Myriorama, which consisted of twenty-four cards of Italian scenery which, however fitted together, will form a continuous picture. 'The changes or variations which may be produced, amount to the astounding and almost incredible number of 620,448,401,733,339,360,000.' A 'pastime', indeed, for an age more leisurely than the twentieth century.

Acknowledgements

I am deeply indebted to the Director of the Fitzwilliam Museum for his imaginative proposal for an exhibition on the Picturesque. In helping to arrange it, I have had his constant and sympathetic help.

Professor Luke Hermann and Dr Charles Warren showed enthusiastic interest in initial discussions.

I have received much courteous help from the private collectors who have generously lent their treasures. I should also like to express my gratitude to the directors and members of the staffs of the following institutions: City of Birmingham Museums and Art Gallery; the British Museum; Leeds Art Galleries, Temple Newsam House; City of Manchester Art Galleries; Laing Art Gallery, Tyne and Wear County Council Museums; the Science Museum; the Victoria and Albert Museum; the Cambridge University Library; the Library of Emmanuel College, Cambridge; the Library of King's College, Cambridge. All of these have made easier the task of borrowing and collecting information about the works of art and books within their care. I am especially grateful to Miss Lindsay Stainton of the British Museum and the staff of the Print Room in the Victoria and Albert Museum for taking endless trouble in locating and supplying information about drawings and prints.

Within the Fitzwilliam Museum I have had wise, cheerful and generous help from everyone. Eric Chamberlain, Paul Woodhuysen and Julia E. Poole of the Keeper staff, Doreen Lewisohn, Andrew Morris and Sarah Lorimer have each made special contributions. Vivian Tubbs was constantly kind and helpful. But above all I would like to thank David Scrase, with whom I have shared the selection of the exhibits and compilation of the catalogue. Thanks to his cooperation, what might have been an arduous task has been throughout an enjoyable and stimulating experience.

Peter Bicknell

References and bibliography

Books

Books which are being exhibited are not included. Unless otherwise stated, the place of publication is London.

Balston: Thomas Balston. *The Life of John Martin*. 1947.

Barbier: Carl Paul Barbier. *William Gilpin: his drawing, teaching and theory of the picturesque*. Oxford, 1963.

Binyon, *Water-colours*: Laurence Binyon. *English water-colours*. 2nd edn. 1944.

Boase: T. S. R. Boase. *English art, 1800–1870*. Oxford, 1959.

Burke, Edmund. *A philosophical inquiry into the origin of our ideas of the sublime and the beautiful: with an introductory discourse concerning taste*. 1756.

Burke: Joseph Burke. *English art, 1740–1800*. Oxford, 1976.

Butlin: Martin Butlin. *The paintings of J. M. W. Turner*. 1977.

Constable: W. G. Constable. *Richard Wilson*. 1953.

Feaver, William. *The art of John Martin*. 1975.

Gage, John. 'Turner and the picturesque', *Burlington Mag.*, 107, no. 742 (January 1965), pp. 16–29; no. 743 (February 1965), pp. 75–81.

Grant, M. H. *A chronological history of the old English landscape painters*. 3 vols. n.d.

Hardie: Martin Hardie. *English coloured books*. 1906.

Hardie, *Water-colour*: Martin Hardie. *Water-colour painting in Britain*. Vol. I, *The eighteenth century*. Vol. II, *The Romantic period*. Vol. III, *The Victorian period*. 1966–8.

Hayes: John Hayes. *The drawings of Thomas Gainsborough*. 1970.

Hipple: Walter John Hipple, jun. *The beautiful, the sublime, and the picturesque in eighteenth-century British aesthetic theory*. Carbondale, Ill., 1957.

Hussey: Christopher Hussey. *The picturesque: studies in a point of view*. London and New York, 1927.

Kitson, *L.V.*: Michael Kitson. *Claude Lorrain: Liber Veritatis*. 1978.

Knight, Richard Payne. *An analytical inquiry into the principles of taste*. 1805.

Leslie, C. R. *Memoirs of the life of John Constable, R.A.* (1845). Ed. and enlarged by the Hon. Andrew Shirley. 1937.

Manwaring: Elizabeth Wheeler Manwaring. *Italian landscape in eighteenth century England: a study chiefly of the influence of Claude Lorrain and Salvator Rosa on English taste, 1700–1800*. New York, 1925.

Moir: Esther Moir. *The discovery of Britain: the English tourists, 1540–1840*. 1964.

Nicholson, Marjorie Hope. *Mountain gloom and mountain glory*. Ithaca, N.Y., 1959.

Nicholson: Norman Nicholson. *The Lakers: the adventures of the first tourists*. 1955.

Oppé: A. P. Oppé. *Alexander and John Robert Cozens*. 1952.

Pevsner, Nikolaus. *Studies in art, architecture and design*. Vol. I, *From mannerism to romanticism*. 1968.

Price, Uvedale. *Essays on the picturesque, as compared with the sublime and the beautiful; and on the use of studying pictures, for the purpose of improving real landscape.* 3 vols. 1810.

Prideaux: S. T. Prideaux. *Aquatint engraving: a chapter in the history of book illustration.* 1909.

Röthlisberger, *Drawings*: Marcel Röthlisberger. *Claude Lorrain: the drawings.* 2 vols. (text, vol. i; repr., vol. ii). 1968.

Röthlisberger, *Paintings*: Marcel Röthlisberger. *Claude Lorrain: the paintings.* 2 vols. (text, vol. i; repr., vol. ii). 1961.

Templeman: William D. Templeman. *The life and work of William Gilpin.* Champaign-Urbana, 1937.

Tooley: R. V. Tooley. *English books with coloured plates, 1790–1860.* Rev. edn. 1943.

Williams: Iolo A. Williams. *Early English watercolours: and some cognate drawings by artists born not later than 1785.* 1952.

Catalogues

Abbey: *Scenery of Great Britain and Ireland in aquatint and lithography, 1770–1860, from the library of J. R. Abbey: a bibliographical catalogue.* 1952.

Abbey, *Life: Life in England in aquatint and lithography, 1770–1860: architecture, drawing books, art collections, magazines, navy and army, panoramas, etc. from the library of J. R. Abbey: a bibliographical catalogue.* 1953.

Binyon: Laurence Binyon. *Catalogue of drawings by British artists . . . in the British Museum,* vol. iv. 1907.

Constable, *Marlay*: W. G. Constable. *Catalogue of pictures in the Marlay bequest.* Fitzwilliam Museum, Cambridge, 1927.

Earp: F. R. Earp. *A descriptive catalogue of the pictures in the Fitzwilliam Museum.* Cambridge, 1902.

Gerson and Goodison: Fitzwilliam Museum, Cambridge. *Catalogue of paintings.* Vol. i, *Dutch and Flemish*, by H. Gerson and J. W. Goodison. Cambridge, 1960.

Goodison: Fitzwilliam Museum, Cambridge. *Catalogue of paintings.* Vol. iii, *British School*, by J. W. Goodison. Cambridge, 1977.

Hazlitt: *Landscapes from the Fitzwilliam.* Loan exhibition, Hazlitt, Gooden and Fox, London, 1974.

Joppien: Rüdiger Joppien. *Philippe Jacques de Loutherbourg 1740–1812.* Exhibition catalogue. Kenwood, 1973.

Kitson, *C.L.*: Michael Kitson. *The art of Claude Lorrain.* Exhibition catalogue. Hayward Gallery, London, 1969.

Lugt: Frits Lugt, *Les marques de collections de dessins et d'estampes.* Amsterdam, 1921. Supplement, The Hague, 1956.

Smith: John Smith. *A catalogue raisonné of the works of the most eminent Dutch, Flemish and French painters of the seventeenth century.* 8 parts. 1829–37.

Upcott: William Upcott. *A bibliographical account of the principal works relating to English topography.* 1818.

Since this catalogue was compiled, there have appeared the following exhibition catalogues relating to the subject:

Wilton, Andrew. *The art of Alexander and John Robert Cozens*. Yale Center for British Art, New Haven, Conn., 1980.

Wilton, Andrew. *Turner and the sublime*. British Museum Publications for the Yale Center for British Art and the Trustees of the British Museum, Toronto, New Haven and London, 1980.

French, Anne. *Gaspard Dughet called Gaspar Poussin 1615–75: a French landscape painter in seventeenth century Rome and his influence on British art*. Kenwood, 1980.

Hayes, John. *Thomas Gainsborough*. Tate Gallery, London, 1980.

Abbreviations

B.F.A.C. Burlington Fine Arts Club, London
C.U.L. Cambridge University Library
N.A.-C.F. National Art-Collections Fund
R.A. Royal Academy, London
V. & A. Victoria and Albert Museum, London

Note

Catalogue items illustrated in the plates section are indicated by the marginal symbol □ followed by the plate number; and roman numerals refer to the colour plates following Plate 53.

Whate'er *Lorrain* light touched with softening Hue,
Or savage *Rosa* dash'd or learned *Poussin* drew.

(James Thomson)

John Brown 1715–1766

1 *A description of the lake at Keswick, (and the adjacent country), in Cumberland. Communicated in a letter to a friend, by a late popular writer*

Kendal: printed by W. Pennington, 1771. Pamphlet

LITERATURE: Donald D. Eddy, *A bibliography of John Brown*, New York, 1971; *idem*, 'The Columbus of Keswick', *Journal of Modern Philology*, 73, no. 4 (May 1976); Manwaring, pp. 116, 168, 175; Hussey, pp. 97–100; Templeman, p. 128; Barbier, pp. 39–40; Nicholson, pp. 27–9.

Dr John Brown of St John's College, Cambridge, was a close friend of the Gilpin family, and was one of the Lyttelton–Gray–Walpole group. He made 'an annual voyage to Keswick, not only as an innocent amusement, but a religious act'. After a visit, probably in 1753, he wrote a letter (now lost) to George Lyttelton, part of which was first published anonymously in the *London Chronicle*, April 24–6, 1766, p. 393, and first published separately in Newcastle, 1767. It was reproduced as an appendix to the second edition of West's *Guide to the Lakes*, 1780 (see cat. no. 87) and in many other eighteenth-century books. There is a comprehensive list of reprintings and references in Eddy's *Bibliography*, and in 'The Columbus of Keswick' he has reconstructed the whole of the original letter, including Brown's poetical rhapsody 'Now sunk the sun . . .' which was first published in Cumberland's *Odes*, 1776.

Brown's letter is probably the earliest prose description of wild and mountainous scenery in Britain in picturesque terms. In particular in his reference to Claude, Salvator and Poussin he epitomises the relation between the Picturesque in England and the landscape artists working in Italy in the seventeenth century.

Comparing Keswick with Dovedale, he writes:

'Were I to analyse the two places into their constituent principles, I should tell you that the full perfection of *KESWICK* consists of three circumstances, *Beauty*, *Horror*, and *Immensity* united; the second of which is alone found in *Dovedale*. Of beauty it hath little: Nature having left it almost a desart: Neither its small extent, nor the diminutive and lifeless form of the hills admit magnificence. – But to give you a complete idea of these three perfections, as they are joined in *KESWICK*, would require the united powers of *Claude, Salvator,* and *Poussin*. The first should throw his delicate sunshine over the cultivated vales, the scattered cots, the groves, the lake, and wooded islands. The second should dash out the horror of the rugged cliffs, the steeps, the hanging woods, and

1

foaming waterfalls; while the grand pencil of *Poussin* should crown the whole with the majesty of the impending mountains.'

Brown was no doubt familiar with James Thomson's couplet quoted at the head of page 1 from *The castle of indolence*, 1748.

Lent by King's College, Cambridge (Bicknell Collection)

Antecedents

Claude Gellée, called le Lorrain 1606–1682

2 Pastoral landscape with the Ponte Molle

☐2 Oil on canvas. 74.5 × 98.0 cm
Signed and dated 'Claude Roma 1645'
Recorded *Liber Veritatis*, no. 90

COLLECTIONS: painted for a Parisian collector (M. du Tranblay); possibly
Bragge, sale, London, 1743, 3rd day, no. 30, as *View of the Ponte Mola*, bought
by Mr Furness; Robert Dingley; Richard Houlditch, sale, Langford, London, 5
March 1760, bought by the 2nd Earl Ashburnham; thence by descent in the
Ashburnham Collection; sales, Christie's, 20 July 1850, no. 78, bought in, and
Sotheby's, 24 June 1953, no. 62, bought by E. E. Cook, by whom bequeathed to
the N.A.-C.F. and given to City of Birmingham Art Gallery, 1955

EXHIBITED: R.A., 1949–50, no. 23; Agnew, London, *Old Masters*, March 1957,
no. 34; R.A., 1962, no. 94; Walker Art Gallery, Liverpool, *Gifts to galleries made
by the National Art-Collections Fund*, 1968, no. 15; Northern Arts Association,
Laing Art Gallery, Newcastle upon Tyne and Hayward Gallery, London, *The
art of Claude Lorrain*, 1969, no. 19

ENGRAVED: Th. Major, 1753; Earlom, 1777, no. 90; Caracciolo, 1815, no. 90

LITERATURE: Kitson, *C.L.*, pp. 21–2, pl. 20 (includes full bibliography)

'The round tower and farm buildings on the left of the picture appear often in
Claude's work. The Ponte Molle in the right background was also one of his
favourite motifs. This bridge over the Tiber north of Rome, the ancient *pons
Milvius*, was restored and given a fortified gatehouse in the fifteenth century. The
present gatehouse was built in the nineteenth century, but the four central arches
are still the originals, dating from the second century B.C. Claude represents the
bridge exactly as it was in his time, and the sunlight falling on it and on the water
constitutes one of the most exquisite passages in his paintings of the forties. A
slight shadow lying across the middle ground on the left enhances the effect. The
warm colours and placid composition institute a new phase of serenity in Claude's
work' (Kitson, *C.L.*, p. 21).

As the painting almost certainly has been in England since 1743, it was well
known in this country before it was brought to a wide public by the publication of
Earlom's *Liber Veritatis* in 1777 (cat. no. 45).

Lent by City of Birmingham Museums and Art Gallery (P.111/55)

3 Pastoral landscape with Lake Albano and Castel Gandolfo

☐1 Oil on copper. 30.5 × 37.5 cm (octagonal)
Inscribed, *verso*, 'Camera dell'ancona No. 3' with seals of the Barberini family
Recorded *Liber Veritatis* (with alterations), no. 35

3

COLLECTIONS: Pope Urban VIII (d. 1644), for whom it was painted; remained in the possession of the family in the Barberini Palace, Rome, until after the dissolution of the Fidecommissio Barberini in April 1934. Bought by Colnaghi from Princess Barberini, late 1962. Bought by the Fitzwilliam Museum from funds bequeathed by Miss E. M. E. Hitchcock and L. D. Cunliffe with grants from the N.A.-C.F. and the V. & A., 1963

EXHIBITED: Petit Palais, Paris, *Le paysage français de Poussin à Corot*, 1925, no. 117; Colnaghi, *Old Masters*, 1963, no. 4; Northern Arts Association, Laing Art Gallery, Newcastle upon Tyne and Hayward Gallery, London, *The art of Claude Lorrain*, 1969, no. 14; Hazlitt, Gooden and Fox, London, *Landscapes from the Fitzwilliam*, 1974, no. 8, repr.

ENGRAVED: Earlom, 1777, no. 35; Caracciolo, 1815, no. 36; Pasboni, early nineteenth century; (all completed as rectangle)

LITERATURE: Burckhardt, *Cicerone*, IV, 414; Röthlisberger, *Paintings*, pp. 164f, no. 35, fig. 90; A. J. Finberg, *Inventory of drawings in the Turner Bequest*, I (1909), pp. 575–6; Colnaghi catalogue *Paintings by Old Masters*, 1963, pl. 4; *Burlington Mag.*, (1963), p. 224, repr.; Fitzwilliam Museum, *Annual report 1963*, p. 3, pl. 9; J. Goodison in *Apollo*, 78 (1963), p. 97, repr.; J. Ziff in *Gazette des Beaux-Arts*, 65, (1965), p. 62; Röthlisberger, *Drawings*, p. 160

'This is a jewel of a painting, a small masterpiece designed for intimate contemplation yet one which suggests a country-wide view' (Kitson, *C.L.* p. 19).

It is the third of Claude's four paintings for Urban VIII. It has an octagonal pair, *Landscape with the port of Santa Marinelta*, now in the Dutuit Collection, Petit Palais, Paris. Röthlisberger (*Paintings*, p. 164) suggests 1639 as the date. The painting represents a view of the pope's summer residence, recently built for him by Maderna, seen across Lake Albano. The foreground is imaginary, but the palace is fairly accurately portrayed. The castle-like building bathed in sunlight is a forerunner of the highlighted castles in the middle ground so beloved of Gilpin (see cat. nos. 62, 63, 66, 67, 71).

Turner made pencil sketches of this painting and its pendant with colour notes, in one of his sketchbooks, on his 1819 Italian tour.

Fitzwilliam Museum, P.D.950–1963

4 Jacob wrestling with the angel

□6 Pen and brown ink, brush, blue and grey wash heightened with white on blue paper. 243 × 352 mm

Signed and dated, lower centre, 'Claudio in F. Roma 1671'; inscribed in ink, *verso*, in an old hand, 'Claudio Gilé en efe 1663'; inscribed on old mount, in Esdaile's hand, 'W. Esdaile 1827 WE Ld Hampden's colln P. 42 N 34 XX Claude Lorraine'; inscribed on old mount, in Poynter's hand, 'E.J.P. 1881'

COLLECTIONS: 1st Viscount Hampden (1705/6–83); W. Esdaile (Lugt, no. 2617); G. S. Bale; Sir E. J. Poynter (Lugt, no. 874); sold Sotheby's, 25 April 1918 (lot 208), bought Agnew for Charles B. O. Clarke; Louis C. G. Clarke, by whom bequeathed 1960

EXHIBITED: R.A., 1902, no. 256; Petit Palais, Paris, *Le paysage français de Poussin à Corot*, 1925, no. 497; Paris, Lille, Strasbourg, *Cent dessins français du*

Fitzwilliam Museum, Cambridge, 1976, no. 37, repr.; U.S.A., Cambridge, *European drawings from the Fitzwilliam Museum*, 1976–7, no. 107, p. 67

LITERATURE: Mme Pattison, *Claude Lorrain: sa vie et ses oeuvres*, Paris, 1884, p. 290, no. 2; Röthlisberger, *Paintings*, p. 428; *idem, Drawings*, pp. 387–9, no. 1050, repr.

The account of Jacob wrestling with the angel is in Gen. xxxii, 24–30.

The drawing is one of at least seven known studies connected with the painting done for Henri van Halmale (1624–76), Bishop of Ypres, and now in the Hermitage, Leningrad (no. 1237).

Fitzwilliam Museum, P.D.69–1961

Salvator Rosa 1615–1673

5 Landscape

□5 Oil on canvas. 47.2×65.4 cm

COLLECTION: by family descent from at least the end of the eighteenth century to Mrs J. Boulthurst, Skipton

EXHIBITED: Hayward Gallery, London, *Salvator Rosa*, 1973, no. 41

Throughout the 1660s Rosa continued to paint small landscapes to satisfy the demands of his patrons, despite his own preference for large-scale history painting. This picture, which is characteristically bold and dashing, probably dates from this late period. An early copy is in the Spada Gallery, Rome, no. 212 (see F. Zeri, *La Galleria Spada in Rome*, 1954, p. 119, pl. 158, entitled *Paesaggio*).

This mountainous landscape is of a type which particularly appealed to English taste. It could be a 'Salvatorian' version of a scene in the Lake District or North Wales. The name Salvator became almost universally associated with the Sublime. Not only were artists widely influenced by his work, and by that of followers like Vernet, but the writers of the picturesque literature of the period 1750–1850 made constant reference to him.

Lent from a private collection

6 Landscape with Christ and St John the Baptist

Pen and brown ink with grey wash. 130×187 mm

COLLECTIONS: J. Richardson, sen. (Lugt, no. 2184); John Barnard (Lugt, no. 1419); Benjamin West (Lugt, no. 419), his sale, Christie's, 10 June 1820 (lot 60); G. T. Clough, by whom given, 1913

EXHIBITED: Fitzwilliam Museum, Cambridge, *Seventeenth Century Italian Drawings*, 1959, no. 64; U.S.A., Cambridge, *European drawings from the Fitzwilliam*, 1976–7, no. 36

LITERATURE: G. Buchanan, 'Salvator Rosa at Glasgow', *Scottish Art Reviews*, 11 (1967), pp. 7ff, pl. 8; M. Mahoney, *The drawings of Salvator Rosa*, 1972, I, p. 503, no. 55.1

This is a study for *The baptism in the wilderness* in the Glasgow Art Gallery (no. 2969). In the finished painting, the composition is reversed and details of the landscape and figures adjusted. Mahoney assigns the drawing to the late 1650s, a date consistent with that of the painting.

The vigorous free strokes of the pen give the drawing the splendid feeling of movement and drama so characteristic of Salvator Rosa.

Fitzwilliam Museum, no. 3124

Gaspard Dughet called Poussin 1615–1675

When the British in the eighteenth century referred to 'Poussin', it was normally to Gaspard Dughet and not his now better known brother-in-law Nicolas Poussin. So it is Dughet who makes up the third of the trio Claude, Salvator and Poussin so often referred to in picturesque writing.

7 Landscape near Rome

□4 Oil on canvas. 73.5 × 110.5 cm
COLLECTIONS: bequeathed by Charles Brinley Marlay, 1912
LITERATURE: Constable, *Marlay*; Gerson and Goodison, p. 190, pl. 99

A splendid example of Dughet's classical landscape compositions of the type which were so popular in England.

Dughet started his career in his brother-in-law's studio but later came under the influence of Claude, as can be seen in his later pictures.

Fitzwilliam Museum, M.73

8 Landscape

□7 Pen and ink with brown wash on grey-brown paper, laid down. 245 × 365 mm
Inscribed on mount, l.r., 'G. Poussin'
COLLECTION: G. J. F. Knowles, by whom given, 1958

Previously thought to be the work of an imitator. Professor Anthony Blunt identified it as a 'certain Poussin'.

Fitzwilliam Museum, PD.23–1958

Sebastien Bourdon 1616–1671

9 A classical landscape

□9 Oil on copper. 20.3 × 31.8 cm

COLLECTIONS: bought from the Gow fund, with contributions from the V. & A., Grant-in-Aid and Mr Clyde Newhouse, 1979

Bourdon, who worked in Rome, resettled in Paris in 1654 after a period in Sweden. After this he was inspired to some of his finest work by the most classical productions of Nicolas Poussin. Here he is clearly influenced by Poussin's *Phocion* landscapes of 1648. On the scale of a cabinet picture it captures the order and idyllic serenity of these great examples, with a delicacy of touch and illumination which is highly characteristic of Bourdon. It is a type of ideal landscape which was much less influential in England than those of Claude, Salvator and Dughet.

Fitzwilliam Museum, PD.15–1979

Jan Wynants *c.* 1620–1684

10 Landscape with a woman and a dog

□13 Oil on canvas. 22.2 × 27.9 cm
Signed, l.r., 'J.W.'
COLLECTIONS: given by A. A. VanSittart, 1876
EXHIBITED: British Institution, London, *Works of ancient Masters*, 1860, no. 9; Hazlitt, Gooden and Fox, London, *Landscapes from the Fitzwilliam*, 1974, no. 66
LITERATURE: Earp, pp. 222–3; C. Hofstede de Groot, *A catalogue raisonné of 17th century Dutch painters*, VIII (1927), p. 560, no. 585; Hazlitt, p. 54, pl. 6, no. 66; Gerson and Goodison, p. 146, pl. 76

The figures have been ascribed by Earp to J. Lingelbach, but Gerson and Goodison have no doubt that they are by Wynants himself.
The spiral muddy lane and the rustic figure were features to be adopted by Gainsborough, who was much influenced by Wynants.

Fitzwilliam Museum, no. 38

Jacob Ruisdael 1628–1682

11 Landscape with a blasted tree near a house

□14 Oil on wood. 52.7 × 67.6 cm
Indistinctly signed 'v Ruisdael/16 . .', the 'v' and 'R' forming a monogram. 1648 appears to be the most likely date
COLLECTIONS: Edward King, bequeathed to his widow Susanna King, 1807; bequeathed by her to his niece Anne Windsor, later Countess of Plymouth, 1820; bequeathed to her great-nephew A. A. VanSittart, 1850, by whom given, 1864

EXHIBITED: Hazlitt, Gooden and Fox, London, *Landscapes from the Fitzwilliam*, 1974, no. 47

LITERATURE: Earp, p. 176; J. Rosenberg, *Jacob van Ruisdael*, 1928, pp. 36, 106, no. 541, pl. 13; Smith, VI, p. 85, no. 267; C. Hofstede de Groot, *A catalogue raisonné of the most eminent Dutch painters of the 17th century*, 1907–28, IV (1912), p. 271, no. 880; K. E. Simon, *Jacob van Ruisdael*, 1930, pp. 21, 79; W. B. P[ike] in *Cambridge University Gazette*, 1869, p. 159; Hazlitt, no. 47, pl. 7; Gerson and Goodison, p. 112, pl. 158

Typical of the kind of Dutch painting which had a considerable influence on English landscape artists. It demonstrates the elements of roughness of texture, irregularity of outline, and contrasting lights and shades which Gilpin found essential to the Picturesque (see cat. nos. 75, 76). Gainsborough, but perhaps to a greater degree Morland, adopted this shaggy rusticity.

Fitzwilliam Museum, no. 84

Marco Ricci 1679–1729

12 Classical landscape with a traveller and two figures kneeling before a cross

□10 Bodycolour, a line of black wash bordering it on all sides. 315 × 465 mm

COLLECTIONS: Major Henry Broughton, 2nd Lord Fairhaven, from whose executors it was purchased from the Biffen fund, 1976

This shares many topographical details with a drawing in the Royal Collection, *Herds terrified by a storm* (no. 156), catalogued by Blunt and Croft-Murray as almost certainly late. Unlike *Rocky landscape with penitents* (cat. no. 13), this is far more in the manner of Claude and Poussin (Dughet) than in that of Salvator, although there are shades of Salvator in the blasted tree and the rustic wayside cross.

Fitzwilliam Museum, PD.10–1976

13 Rocky landscape with penitents

□67 Bodycolour, a line of black wash bordering it on all sides, laid down on a washed mount. 303 × 419 mm

COLLECTIONS: Walker; Major Henry Broughton, 2nd Lord Fairhaven, from whose executors it was purchased from the Biffen fund, 1975

EXHIBITED: U.S.A., Cambridge, *European drawings from the Fitzwilliam*, 1976–7, no. 34

In contrast with many of the serene classical landscapes depicted in tempera by Marco Ricci this drawing has a dramatic quality reminiscent of his oil painting, executed before he went to England in 1708. Works like his *Monks tempted by demons* in the museum at Epinal show the influence which Magnasco exerted

c. 1706–7 on both Marco and his uncle Sebastiano Ricci. This drawing is evidence of the continuation of that influence on his work, as it is of his debt to the landscapes of Salvator Rosa. It is very much in the Salvatorian manner so popular in English 'sublime' Picturesque.

Fitzwilliam Museum, PD.6–1975

Francesco Zuccarelli 1702–1788

14 Stag hunt

□15 Oil on canvas. 71.7 × 105.4 cm
COLLECTIONS: Founder's bequest, 1816

'Francesco Zuccarelli was, with Canaletto and Marco Ricci in their different styles, one of the contemporary Italian artists who most influenced the development of landscape painting in eighteenth-century England. All three visited this country. Zuccarelli spent five years in London (apparently in the forties of the century) being largely employed as a scene painter. A second visit lasted from 1752–1773, in the course of which he became a foundation member of the Royal Academy . . . His drawings are picturesquely romantic scenes, with peasants, perhaps accompanied by goats and cattle, among rocks and trees, or beside humble cottages, all done with a considerable decorative flourish' (Williams, p. 67).

Fitzwilliam Museum, no, 200

15 *Landscape*

Line engraving with etching by William Austin. Plate size 356 × 569 mm
Published by the engraver, 1756
COLLECTIONS: Given by A. A. VanSittart
LITERATURE: Julius Meyer, *Allgemeines Kunstler-Lexikon*, 3 vols., Leipzig, 1872–85, II, no. 36, p. 448

Fitzwilliam Museum, V.111.18

George Lambert 1700 ?–1765 and Francesco Zuccarelli

16 La Rocca di Castiglione

□11 Pen, grey and brown ink, grey and brown wash over traces of black chalk.
288 × 465 mm

Inscribed, on old mount, 'The outline of Lambert and washed by Zuccarelli for Mr Kent.–La Rocca di Castiglione'
COLLECTIONS: (?) William Kent; Christopher Harris; Leonard G. Duke; with the Manning Galleries, from whom purchased from the Fairhaven fund, 1972
EXHIBITED: Manning Galleries, London, *20th anniversary exhibition*, 1972, no. 6
LITERATURE: Williams, p. 23

Lambert was employed as a scene-painter at Covent Garden where he probably worked with Zuccarelli. Presumably Lambert, who drew the outline of this drawing, was responsible for the composition. It is, however, in the manner of Zuccarelli and typical of the 'Italian' landscapes that were being produced in England at that time.

Fitzwilliam Museum, PD.14–1972

Claude-Joseph Vernet 1714–1789

17 View on the Arno

□12 Oil on canvas. 30.8 × 48.9 cm
Signed and dated, l.r., 'Joseph Vernet f Romae 1747'
COLLECTIONS: bequeathed by Daniel Mesman, 1834

It has not been possible to identify this painting with any of those listed by Vernet in his *Livre de raison* for 1747.
 Vernet was a master of 'agitated nature'. More than any other European artist he promoted the picturesque cult of storms, shipwrecks, volcanic eruptions, avalanches, thunderstorms, precipices and cataracts. Vernet's dramatic scenes, familiar in the form of prints (see cat. nos. 18, 19), probably inspired the Sublime of the later eighteenth century to an even greater extent than those of Salvator himself. He had a powerful influence on Wilson's early work and especially on de Loutherbourg. However, he had absorbed the vocabulary of Claude as well as of Salvator, and this particular example shows him working in a Claudian manner, using many of the features which Gilpin was to adopt in simplified form.

Fitzwilliam Museum, no. 336

18 *La pêche à la ligne*

Line engraving with etching by Pierre Paul Benazech, 1771. 511 × 608 mm (impression trimmed within plate-mark)
Published by Lacombe, Paris
COLLECTIONS: Founder's collection
LITERATURE: Pierre Arlaud, *Catalogue raisonné des estampes gravées d'après Joseph Vernet*, Avignon, 1976, no. 58
Fitzwilliam Museum, 33.A.6.70

19 *Les voyageurs effrayés par le coup de tonerre*

Line engraving with etching by Jean-Jacques Avril, père. 420×532 mm
 (impression trimmed within plate-mark)
Published by Basan and Poignairt, Paris
COLLECTIONS: Founder's collection
LITERATURE: Arlaud, *op. cit.*, no. 29.II
Fitzwilliam Museum, 33.A.6.11

The theatrical effect of scenes momentarily and dramatically revealed by a sudden flash of lightning was one of the favourite devices of artists cultivating the picturesque Sublime. These two prints are in Vernet's 'agitated nature' manner which is much more characteristic than the gentler mood of nature in *View on the Arno* (see cat. nos. 129, 134, 141, 160, 175).

Followers of Claude

John Wootton 1683–1765

20 Classical landscape

□18 Oil on canvas. 81.3 × 107.9 cm
COLLECTIONS: given by A. A. VanSittart, 1876
LITERATURE: Grant, 1957–61 edn, II, pl. 72; Goodison, p. 292, pl. 5

A characteristic example of the ideal landscape which Wootton began producing after his visit to Rome in the 1720s in addition to the sporting pictures which distinguished his whole career. It is a very early example of an English artist emulating the works of Claude and Dughet in a way which was soon to become so general.

Fitzwilliam Museum, no. 5

Richard Wilson 1713–1782

21 Apollo and the seasons

□17 Oil on canvas. 100.0 × 125.7 cm
COLLECTIONS: sold Sotheby's, property of a lady (? Miss Turner), 6 March 1940, no. 25, bought Norris; Christopher Norris sale, Christie's, 4 July 1952, no. 20, bought Benson (for Tooth's); bought from the Fairhaven fund, 1952
EXHIBITED: probably R.A., 1779, no. 352; Goldsmith's Hall, London, *Treasures of Cambridge*, 1959, no. 325; Hazlitt, Gooden and Fox, London, *Landscapes from the Fitzwilliam*, 1974, no. 64
LITERATURE: Constable, pp. 93–4, 96, 167, pl. 26b; Arthur Tooth, London, catalogue *Recent acquisitions 7*, 1952, no. 3; Fitzwilliam Museum, *Annual report 1952*, pl. 2; John Hayes, *Richard Wilson*, The Masters, no. 57, 1966, pl. 13; Hazlitt, no. 64, pl. 12

Wilson's personal version of Claude. Compare the four seasons with those in Turner's *Thomson's Aeolian harp* (cat. no. 59).

Fitzwilliam Museum, P D.27–1952

22 *Snowden Hill, and the adjacent country in North Wales*

□74 Line engraving with etching, by William Woolett, 1775. Plate size 360 × 545 mm
Published by John Boydell, London
COLLECTIONS: Founder's collection

LITERATURE: Louis Fagan, *A catalogue raisonné of the engraved works of William Woolett*, 1885, no. 91.III; Constable, p. 186, pl. 55

There are versions of the original painting, now known as *Snowdon from Llyn Nantlle*, in the Walker Art Gallery, Liverpool and the Nottingham City Art Gallery. Thomas Pennant (*A tour in Wales*, 1783, II, p. 188) declares that 'Mr. Wilson has favoured us with a view as magnificent as it is faithful.' Nevertheless, the view has been rearranged and a foreground invented to conform with the ideals of Claudian composition.

Fitzwilliam Museum, 33.A.6.149

23 *The summit of Cader Idris mountain* [Llyn y Cau]

Line engraving and etching by E. and M. Rooker. Plate size 375 × 490 mm
No date or publisher on engraving
LITERATURE: Constable, p. 171, pl. 31a

The best-known version of the original painting, formerly known as *The summit of Cader Idris* (the true summit is over a mile away and five hundred feet higher than the lake), was given to the National Gallery by Sir Edward Marsh, as a thank-offering for victory, in 1945. Pennant (*op. cit.*, II, p. 98) in describing the view says that it is 'so excellently expressed by the admirable pencil of my Kinsman, Mr. Wilson, that I shall not attempt the description'. Although Wilson has abandoned accepted Claudian composition, in the words of Martin Davies 'the topography is summary and the foreground invented' (National Gallery catalogue *British School*, 1946).

Lent by the Trustees of the British Museum

George Smith of Chichester 1714–1776

24 The first-premium landscape

☐20 Line engraving with etching by William Woolett, 1762. Plate size 483 × 602 mm
Published by J. Boydell, London
In lower margin, below artist's and publisher's names, 'The original Picture, from which this Print was taken, in the year 1760, obtained the First Premium granted by the Society for the Encouragement of Arts, Manufactures, and Commerce, in London.'
LITERATURE: Louis Fagan, *A catalogue raisonné of the engraved works of William Woolett*, 1885, no. 45.VII

George Smith was one of several artists known as 'the English Claude'. The picture which won the first premium is an essay in the manner of the master.

Fitzwilliam Museum, 40.II.44

25 The second-premium landscape

Line engraving and etching by William Woolett, 1763. Plate size 483 × 602 mm
Published by J. Boydell, London
Inscription below imprint identical with that on cat. no. 24 except that 'Second'
 replaces 'First'
LITERATURE: Louis Fagan, *Catalogue raisonné of the engraved works of William Woolett*, 1885, no. 46.IV; repr. Manwaring, facing p. 73

This picture by John Smith is as Claudian as that of his brother George. He introduces the round tower and bridge similar to those in the Ponte Molle (cat. no. 2), which became so popular in English 'Italian' landscapes that for many artists producing picturesque landscape they became 'stock in hand'.

Fitzwilliam Museum, 40.11.43

William Marlow 1740–1813

26 View near Naples

□19 Oil on canvas. 73.0 × 98.4 cm
COLLECTIONS: Sir George A. H. Beaumont, Bart, Coleorton Hall, Leicestershire; sold by the Trustees, Sotheby's, 30 June 1948, no. 48, bought by Agnew; bought from Agnew from the Fairhaven fund, 1952
EXHIBITED: Agnew, London, summer exhibition, 1948, no. 48
LITERATURE: Goodison, pp. 161–2, repr. pl. 24

When sold at Sotheby's in 1948, this was catalogued generally as 'Wilson', but it was bought in 1952 as by Marlow. Marlow exhibited Italian views at the Society of Artists of Great Britain between 1767 and 1783, and at the R.A. between 1788 and 1795, the great majority of them painted after his return to England from France and Italy in 1768.

This picture, which probably belonged to Sir George Beaumont (1753–1827), is typical of the 'Italian' landscapes that were being painted in the manner of Claude by English artists in the second half of the eighteenth century.

Fitzwilliam Museum, PD.1–1952

Sir George Beaumont 1753–1825

27 Landscape

□8 Oil on canvas. 45.1 × 37.5 cm (lined, dimensions of painted surface)

COLLECTIONS: with Colnaghi, London, from whom bought from the Fairhaven fund

Sir George Beaumont, as connoisseur, collector, patron and landscape painter, was a focal figure in the English art world in the early nineteenth century. He befriended and encouraged many painters, notably Constable and Ibbetson. Before artists could see the works of Old Masters in the National Gallery, they could study them in Beaumont's collection. Indeed he played a significant part in the foundation of the National Gallery, and his three Claudes and Rubens' *Château de Steen*, which were among the paintings which he gave to it, particularly influenced the English School.

As an amateur painter he was conservative, adoring Claude and yet believing in sombre colours. The occasion when he asked Constable, 'Do you not find it very difficult to place your *brown tree* ?' and recommended 'the colour of an old Cremona fiddle for the prevailing tone of a picture' is recorded by Leslie (p. 155). The picture exhibited shows a nice balance between beauty, horror and immensity which epitomises the established Picturesque of the time.

Fitzwilliam Museum, P.D.23–1952

Alexander Cozens *c.* 1717–1786

28 A river between hills

Grey, black and brown washes with pencil outline on toned paper, laid down. 231 × 313 mm

Signed on mount, l.l., 'Alex.' Cozens'; numbered in pencil, u.r., '37' and on *verso* of mount, '87'

COLLECTIONS: sold Sotheby's, 29 July 1891 (lot 26), bought by William Ward of Richmond; Herbert Horne; Sir Edward Marsh, by whom bequeathed through the N.A.-C.F., 1953

EXHIBITED: B.F.A.C., 1916, no. 34; Sheffield and Tate Gallery, London, *Drawings and paintings by Alexander Cozens*, 1946, no. 40

LITERATURE: A. P. Oppé, 'Fresh light on Alexander Cozens', Print Collector's Quarterly, 8 (1921), pp. 61–80; *idem*, Sheffield and Tate Gallery catalogue *Drawings and paintings of Alexander Cozens*, 1946, introduction; *idem*, *Alexander and John Robert Cozens*, 1952; Williams, pp. 35–9; Hardie, *Watercolour*, I, pp. 78–86

It has been suggested that this drawing is a development of blot no. 10 in the *New method* (cat. no. 29). Although it has the character of a blot drawing, it is clearly not a development of pl. 10 nor of pl. 37 of the *New method*, despite the pencilled '37' on the drawing. This drawing is characteristic of the idealistic nature of Cozens' work. He worked, as Iolo Williams put it, 'in an artistic world almost entirely of the imagination though constructed out of types of landscape feature existing in reality, a world seen almost without exception in monochrome' (Williams, p. 35). His work is only rarely topographical or directly inspired by Claude and the other seventeenth-century 'Italian' landscape painters, though some of his earlier works, such as an etching of the Campagna in the V. & A., signed and dated 'A Cozens 1752' (E 4279–1920), with framing trees, three planes and farm buildings with the familiar round tower, do relate closely to Claude.

Cozens' intention was to create landscapes derived neither from the Old Masters nor from Nature herself; thus he pursued 'some spontaneous method of bringing the conception of an ideal subject fully to view'. But his fondness for the world of the imagination was combined with a love of systems. When he was staying at Fonthill his host, the arch-romantic William Beckford, with whom he was in close sympathy, wrote to Mrs Harcourt, 15 August 1781, 'Cozens is here, very happy, very solitary and so full of systems as the universe.' Of his many systems the one which has created the greatest interest is his method of blot drawing (see next item).

Fitzwilliam Museum, P.D.12–1953

16

29 *A new method of assisting the invention in drawing original compositions of landscape*

London: printed for the author by J. Duxwell, 1784 or 1785

Text published as small quarto vol. of 33 pages, 230×185 mm

PLATES: 43: 18 aquatints, 5 mezzotints, 20 engravings (4 to a page). Mezzotints engraved by W. Pether

Made-up copy

LITERATURE: as cat. no. 28. Oppé in *Alexander and John Robert Cozens* reproduces the text and 12 aquatints of blots. Michael Marqusee, *A new method of landscape*, Paddington Masterpieces of the Illustrated Book, 1977, is a facsimile of the whole book with an introduction

Cozens starts his introduction with a statement of his creed: 'Composing landscape by invention, is not the act of imitating individual nature; it is more; it is forming artificial representations of landscape on general principles of nature, founded in unity of character, which is true simplicity; concentring in each individual composition the beauties, which judicious imitation would select from those which are dispersed by nature.' He then develops the method of evolving landscapes by making blots with brush and ink, which are later worked up with monochrome washes. It is essential that the original blot should not be fortuitous, but should be controlled by the artist to interpret his 'general idea' of subject and composition.

The method is illustrated with eighteen aquatint blots, one of which (pl. 37) is developed in two mezzotint plates, representing 'a sketch made out with a brush from the preceding blot' and 'the same sketch, made into a finished drawing'; and another (pl. 40) is developed in three different ways (pls. 41, 42, 43). The remaining twenty engraved plates illustrate different types of sky, four to each page. They have nothing to do with the blot method.

Lent by the Trustees of the British Museum (Case 167 no. C.50)

29a *A blot*
Aquatint. 252×325 mm
Pl. 10 from the *New method*
Lent by the Victoria and Albert Museum, London (E.232–1925)

29b *A blot*
Aquatint. 252×325 mm
Pl. 16 from the *New method*
Lent by the Victoria and Albert Museum, London (E.238–1925)

29c *A blot*
Photograph
Pl. 40 from the *New method*

The eighteen prints of blots have usually been described as aquatints. They are printed in a rich black ink and no aquatint ground is discernible; black dots (particularly evident on pl. 16) occur in the areas of white paper. It is not clear how these prints, which were probably not engraved by Cozens himself, were

17

produced. Apparently the method was not any of the normal aquatint processes in use at the time.

29d Pl. 41 from the *New method: A print, representing a drawing done with a brush, from the preceding blot*
Mezzotint engraved by William Pether
DISPLAYED AS CAT. NO. 29

29e Pl. 42 from the *New method: A second drawing done from the same blot*
Mezzotint engraved by William Pether
Not exhibited, but see cat. no. 30

29f Pl. 43 from the *New method: A third drawing done from the same blot*
Mezzotint engraved by William Pether
See also cat. no. 31

30 Landscape with a wooded crag and lake

□22 Grey and black washes on tinted paper, laid down. 219 × 302 mm
Signed, l.l., on mount, in ink, 'Alex? Cozens'; numbered, u.r., in pencil, '59' (over 30?) and, *verso*, '74'
COLLECTIONS: Sold Sotheby's, 29 July 1891 (lot 26), bought William Ward of Richmond; Herbert Home; Sir Edward Marsh, by whom bequeathed through the N.A.-C.F., 1953
EXHIBITED: Grafton Gallery, London, 1911; B.F.A.C., 1916, no. 33; Tate Gallery, London, 1927; Bucharest, *Exhibition of British drawings*, 1935–6; Sheffield and Tate Gallery, *Drawings and paintings by Alexander Cozens*, 1946, no. 30, p. 45, pl. 6; Paris, *English landscape painting*, 1953, no. 34
LITERATURE: as cat. no. 28

This is a drawing of pl. 42 of the *New method* in reverse. It may be Cozens' model for the engraver William Pether.

Fitzwilliam Museum, PD.8–1953

31 Landscape with wooded crag, lake and deer

Grey and black washes on tinted paper, laid down. 216 × 301 mm
Signed, l.l., on mount, in ink, 'Alex? Cozens'; numbered, u.r., in pencil, '69'
COLLECTIONS: as cat. no. 30
EXHIBITED: Grafton Gallery, London, 1911, no. 169; B.C.A.F., 1916, no. 22; Sheffield and Tate Gallery, London, *Drawings and paintings by Alexander Cozens*, 1946, no. 31, p. 45
LITERATURE: as cat. no. 28

This is a drawing of pl. 43 of the *New method* in reverse. Like cat. no. 30, it may be the model for the engraver.

Fitzwilliam Museum, PD.9–1953

32 A blot drawing in progress

Indian ink. 242 × 328 mm

Consisting of a blot (not reproduced in the *New method*) on crumpled paper with a sheet of varnished paper attached, which has been squared and on which the essential lines of the composition suggested by the blot have been traced in pencil

Inscribed, *verso*, in ink, 'The passage of Hannibal over the Alps'

That the pencil drawing may be by John Robert Cozens is suggested by a MS. note in the catalogue in the Print Room of the V. & A. signed 'M.H.' (Martin Hardie): 'It is possible that this may have some connection with a painting bearing the title "The passage of Hannibal over the Alps" exhibited by J. R. Cozens at the RA in 1776 [but now lost]. The group of trees in pencil is not unlike the work of J.R.C.'

Lent by the Victoria and Albert Museum, London (E.243–1925)

33 Landscape with a dark hill

□21 A drawing done on pl. 16 of the *New method*

Brown wash and some pencil, laid down. 222 × 295 mm

Signed, l.l., on mount, 'Alex.ʳ Cozens'; engraved, u.r., '16'

COLLECTIONS: as cat. no. 30

EXHIBITED: B.F.A.C., *The Herbert Home collection of drawings*, 1916, no. 25; Wiener Secession, Vienna, *Meisterwerke Engelsche Malerie*, 1927, no. 226; R.A., *British art*, 1934, no. 1192, Souvenir, no. 573, pl. 147; Stedelijk Museum, Amsterdam, *Twee Eeuwen Englische Kunst*, 1936, no. 206; Louvre, Paris, *Peinture anglaise*, 1938, no. 190; Sheffield and Tate Gallery, *Drawings and paintings by Alexander Cozens*, 1946, p. 12 and no. 29; Paris, *English landscape painting*, 1953, no. 35; Arts Council, London, *The romantic movement*, 1959, no. 398; and *Sixty years of patronage*, 1965, no. 30, pl. 4a; British Council Tour, Tokyo and Kyoto, *English landscape painting of the 18th and 19th centuries*, 1970–1, no. 69; Petit Palais, Paris, *La peinture romantique anglaise et les préraphaélites*, 1972, no. 80; Hazlitt, Gooden and Fox, London, *Landscapes from the Fitzwilliam*, 1974, no. 15, pl. 53

LITERATURE: as cat. no. 28; Binyon, *Water-colours*, pl. 6; N.A.-C.F., *Annual report, 1953*, no. 1715; Fitzwilliam Museum, *Annual report 1953*, p. 2, pl. 2; C. Winter, *The Fitzwilliam Museum: an illustrated survey*, 1958, pp. 368–9, pl. 53

This well-known drawing has previously been exhibited both as a worked-up aquatint and as an original drawing based on pl. 16 of the *New method*. As the dark tones, the spots in the light areas and the engraved '16' correspond exactly with the plate, it seems clear that the drawing is worked on an impression of the plate. The underlying printer's ink imparts a deep, rich texture to the washes. The nature of the ground remains a mystery and suggests that Cozens or his engraver may have been experimenting with a novel technique. In whatever way it has been achieved, the drawing is brilliantly successful.

Fitzwilliam Museum, PD.7–1953

34 A woodland stream

Black and white chalk on blue-grey paper. 251 × 322 mm

COLLECTIONS: Dr Dibdin; Sir John Neeld, Grittlotson House; L. W. Neeld sale, Christie's, 13 July 1945 (lot 107, with another); bought by Agnew; Howard Bliss; with Leicester Galleries who sold it to Spink, from whom purchased by Mrs E. M. Young; with Agnew, from whom purchased from the Fairhaven fund, 1953

EXHIBITED: Aldeburgh, *Drawings by Thomas Gainsborough*, Festival exhibition, 1949; Leicester Galleries, London, *Gainsborough to Hitchens*, January 1950, no. 1

LITERATURE: Fitzwilliam Museum, *Annual report 1953*, p. 4, repr. pl. IIa; Hayes, I, p. 249, no. 607

A late landscape drawing, dated by Hayes in the mid 1780s, who compares it to a very similar composition at Holker Hall (*Wooded landscape with sheep and stream*), his no. 606 and pl. 192. It is ideal landscape, very un-Claudian in composition. There is no arranged foreground; trees occupy the whole of the middle of the drawing; a distant mountain only just appears in the background. The animated drawing of the trees and the spiral stream give the scene a great feeling of movement.

Fitzwilliam Museum, P.D.28–1953

35 Wooded landscape

Black and white chalk, grey wash and oil on brown prepared paper, varnished. 219 × 216 mm

Stamped, l.l., 'TG' in monogram

COLLECTIONS: collection, North of England; with Colnaghi, from whom bought from the Fairhaven fund, 1961

LITERATURE: Fitzwilliam Museum, *Annual report 1961*, p. 8; M. Woodall (ed.), *Letters of Gainsborough*, 1963, no. 103, p. 177; Hayes, p. 187, no. 340

As John Hayes points out, the brown preparation of the paper has now absorbed the upper layers of wash, so that the tonality has become brown throughout, thus distorting the original values. Dated by Hayes to the early 1770s.

Fitzwilliam Museum, P.D.17–1961

36 Wooded mountainous landscape with sheep

□26 Black chalk and stump. 281 × 403 mm

COLLECTIONS: the Hon. Mrs Fitzroy Newdegate; Newdegate sale, Christie's, 14 March 1952 (lot 224), bought by Colnaghi, from whom it was purchased by Sir Bruce Ingram

EXHIBITED: Arts Council, *Drawings from the Bruce Ingram collection*, 1946–7, no. 40, repr. pl. IV; Colnaghi, London, *English drawings and watercolours in memory of the late D. C. T. Baskett*, July–August 1963, no. 28

LITERATURE: Luke Hermann and Michael Robinson, 'Sir Bruce Ingram as a collector of drawings', *Burlington Mag.*, May 1963, repr. fig. 16; Hayes, p. 256, no. 639

Dated by Hayes mid to late 1780s.

Lent from a private collection in England

37 Study of Langdale Pikes

□25 Pencil and grey wash. 264 × 413 mm

COLLECTIONS: anon. sale, Sotheby's, 3 May 1918 (lot 24), bought by A. P. Oppé; sold to Agnew, 1939; Christopher Norris; with Spiro Gallery; William Lambshead; anon. sale, Sotheby's, 20 April 1955, lot 47, bought by Spink from whom bought by the present owner

EXHIBITED: Agnew, London, *67th annual exhibition of water-colour and pencil drawings*, February–March 1940, no. 125; Arts Council, 1960–1, no. 45 and p. 6; Tate Gallery, London, *Thomas Gainsborough*, 1980–1, no. 33

LITERATURE: Mary Woodall, *Gainsborough's landscape drawings*, 1939, no. 246; John Hayes, 'British patrons and landscape painting 3: the response to nature in the eighteenth century', *Apollo*, June 1966, fig. 5; *idem*, 'Gainsborough and the Gaspardesque', *Burlington Mag.*, May 1970, p. 308; Hayes, I, p. 242, no. 577, II, pl. 179

Hayes dates this with confidence to the visit made by Gainsborough to the Lakes in the late summer of 1783. He comments that 'although the silhouette of the peaks has been softened the view is otherwise an accurate representation of Langdale Pikes as seen from Elterwater'.

Charles Warren, who knows the district well, has suggested that the view may be from Blea Tarn. However, the silhouette of the two peaks is more like that seen from Elterwater. Pavy Ark, which lies to the right of the Langdale Pikes and is a prominent feature of both views, has disappeared in the drawing, and the middle ground bears little resemblance to either view. This is nonetheless a rare example of a topographical drawing by Gainsborough, studied from nature. After Gainsborough's visit to the Lakes his landscapes became noticeably more rugged and mountains frequently appeared in them, a change which may have been partly due to the influence of de Loutherbourg, whom he could have met in the Lake District.

Lent from a private collection in England

Robert Adam 1728–1792

38 Castle in a landscape, with waterfall

□27 Pen and brown ink, grey monochrome wash over traces of black chalk laid down on a washed mount. 245 × 301 mm

COLLECTIONS: W. Barclay Squire, M.A., given in accordance with his wishes by his sister and executrix, Mrs Fuller Maitland, 1927
EXHIBITED: Scottish Arts Council, Edinburgh, *Robert Adam and Scotland: the picturesque drawings*, 12 August–10 September 1972, no. 41
LITERATURE: A. P. Oppé, 'Robert Adam's picturesque compositions', *Burlington Mag.*, 1942, pp. 56–8; A. Bolton in *Architectural Review*, 57, nos. 338–42 (January–May 1925); Williams, pp. 72–3; A. A. Tait, 'The picturesque drawings of Robert Adam', *Master Drawings*, 9, no. 2 (1971), pp. 161–71
Fitzwilliam Museum, Cambridge, no. 1196[1]

39 Castle in a landscape above a river

Pen and brown ink and watercolour, laid down on a washed mount. 246 × 264 mm
Inscribed on mount, l.l., in brown ink, 'Robt Adam Archt Invt delint 1782'
COLLECTIONS: W. Barclay Squire, M.A., given in accordance with his wishes by his sister and executrix, Mrs Fuller Maitland, 1927
LITERATURE: as cat. no. 38
Fitzwilliam Museum, no. 1196[2]

Between 1777 and 1787 Robert Adam appears to have produced a series of picturesque watercolours in which landscape and architecture are combined in often fantastic compositions. They presumably appeared in the Adams' sales of 1818 and 1821 where several lots of 'picturesque scenery' and 'romantic landscapes' and 'coloured drawings' were mentioned.

Oppé wrote about the drawings: 'In manner they vary from pen outline and monochrome to full colour wash which would be quite bright were it not for the heavy underpainting and a very free use of black to strengthen the foreground and the trees. The favourite subject in these drawings is a castle, perched on a high rock, approached by a winding road over a bridge and encircled by a river.'

In his buildings Robert Adam occasionally achieved the romantic effects of his fantastic landscape drawings, notably at Culzean Castle, perched on a rocky headland on the coast of Ayrshire (see cat. no. 144a). He related the quality of movement in architecture to landscape and to the Picturesque. 'Movement is meant to express the rise and fall, the advance and recess with other diversity of form, in the different parts of a building, so as to add greatly to the picturesque of the composition. For the rising and falling, advancing and receding, with the convexity and concavity, and other forms of the great parts, have the same effects in architecture that hill and dale, foreground and distance, swelling and sinking have in landscape. That is, they serve to produce an agreeable and diversified contour, that groups and contrasts like a picture, and creates a variety of light and shade, which gives great spirit, beauty and effect to the composition' (Robert and James Adam, *The works in architecture of Robert and James Adam Esquires*, 1778, preface, p. iii n. A).

In these two drawings Adam creates a dream world of the imagination, little related to nature, and also little related to Claude; although in the second of them the tree and the castle in the middle ground are not unlike the dream world of Gilpin.

22

40 Watering horses

□16 Oil on canvas. 85.4 × 117.5 cm
Signed on felled tree, l.r., 'G. Morland pixt'
COLLECTIONS: bequeathed by Joseph Roe, 1931
EXHIBITED: Dowdeswell Galleries, London, 1894 (probably one of Dowdeswell's
series *Early English masters*)
LITERATURE: *The World*, February 1894; Goodison, p. 172

Another version of the composition, of the same size, signed and dated 1791, is in the Hermitage Museum, Leningrad (no. 5834). In it the two trees right and left are omitted, and the group of three buildings is replaced by a single one. The Fitzwilliam picture may be regarded as a later reworking by Morland.

The subject and the composition are characteristic of that type of picturesque genre painting in which the artist arranged thatched cottages, domestic animals and country folk in a manner which owes little to Claude, Salvator and Poussin. The picture exploits the quality of roughness which was being formulated as an essential element of the Picturesque by Richard Payne Knight and other writers in the 1790s and possibly shows the more specific influence of the Dutch school and of Ruisdael in particular.

Fitzwilliam Museum, no. 1604

Francis Wheatley 1747–1801

41 Girls washing at a stream

□28 Watercolour, Sight size 380 × 488 mm
COLLECTIONS: with Palser; F. H. H. Guillemard, M.D., Gonville and Caius
College, Cambridge, by whom bequeathed, 1933

Wheatley, who had a great success with the *Cries of London*, excelled in the style of 'cottage picturesque' which Gilpin had opposed to the grander style of scenes with castles. It was an opposition which had already been seen between the landscapes and fancy pictures of Gainsborough and the grander scenes of Wilson. The thatched cottages, donkeys and rustic figures of Morland and Wheatley lead directly to the sentimental rustic genre painting of the nineteenth century.

Fitzwilliam Museum, no. 1720

William Alexander 1767–1816

42 The crystal pool: an illustration to Cunningham's *Poems*

□23 Grey wash over pencil. 222 × 328 mm

Signed, l.l., in black ink, 'W. Alexander'; inscribed on *verso* of old mount, in brown ink:

> 'Illustration to "Cunningham's Poems"
> W. Alexander.
> Subject.
> Where the rill by slow degrees
> Swells into the Chrystal Pool.
> Shelving Rocks & Shaggy trees
> Shoot to keep the water cool.
> Cunningham Poems.
> Present.
> J. S. Cotman T. R. Underwood
> P. S. Munn W. Alexander
> J. Varley W. Munn – visitor.
> May 5. 1802'

COLLECTIONS: F. H. H. Guillemard, M.D., Gonville and Caius College, Cambridge; Sotheby's sale, 10 July 1980 (lot 6), bought together with cat. no. 43 through Stephen Somerville from the Biffen fund

LITERATURE: F. H. H. Guillemard, 'Girtin's Sketching Club', *The Connoisseur*, August 1922, pp. 191–4; Sidney D. Kitson, *The life of John Sell Cotman*, 1937, p. 32

Fitzwilliam Museum, P.D.40–1980

John Sell Cotman 1782–1842

43 The crystal pool: an illustration to Cunningham's *Poems*

□24 Grey wash over pencil on paper formerly laid down on card. 222 × 321 mm
Signed, l.r., in brown ink, 'Cotman f'
Inscribed on *verso* of card, in brown ink, in Cotman's hand:

> 'Subject.
> Where the rill by slow degrees
> Swells into a chrystal pool;
> Shelving Rocks & Shaggy Trees.
> Shoot to keep the Water cool –
> Cunningham Poems

J. S. Cotman. Presd. [?] [This could be read as an abbreviation for 'present', 'president' or 'pinxit'.] T. R. Underwood. P. S. Munn. W. Alexander. J. Varley. – Visitor W Munn May 5: t 1802.'

COLLECTIONS: as cat. no. 42 except bought with cat. no. 42
LITERATURE: as cat. no. 42
Fitzwilliam Museum, P.D.39–1980

These two drawings were both done at a meeting of the Drawing Society on 5 May 1802. In 1799 a small group of artists in London, with Girtin at their head, formed a society for the study of romantic scenery. 'The Brothers', as they called

themselves, met in turn at one of the members' rooms, the host acting as president for the evening.

'He set the subject, a verse from the poets, and from seven till ten the members drew, with the materials provided for them by their host, compositions illustrative of the set subject. The drawings were in pencil, washed with indian ink or sepia. "At ten o'clock", states the rule, "all drawing shall cease, when simple fare shall be produced with Ale and Porter." For another hour the members criticised each other's drawings. "All the drawings", it is stated, "shall be given to the President of the Night." It was laid down that the subject of the evening shall be "more particularly tending to Landscape"' (Kitson, *op. cit.*, p. 29).

The last meeting recorded in the surviving minute book was held on 11 January 1800. However, it is evident that the group was still active when these two drawings were made in 1802.

The passage from Cunningham is characteristic of the highly romantic poems which were chosen. Ossian was a favourite source. 'Shaggy trees' reflects the quality of shagginess which had been established in the 1790s as one of the essentials of the Picturesque.

The two drawings are typical picturesque compositions. Cotman's, with jagged rocks in the foreground and impending precipices in the background, suggests a sublimity which is not to be found in the quotation. Alexander's is a truer illustration of the mood of the poem.

Joseph Wright of Derby 1734–1797

44 Matlock Tor

□34 Oil on canvas. 72.4 × 98.7 cm (lined; dimensions of the painted surface). *c.* 1775
Formerly known as *Dovedale*
COLLECTIONS: Haskett Smith, London; his sale, Christie's, 28 May 1864, no. 32, bought in; Haskett Smith, Kent; bought from Roland, Browse and Delbanco, London, from the Fairhaven fund, 1948
LITERATURE: repr. *Illustrated London News*, 214 (1949), p. 282; *Arts Quarterly*, 18 (1955), p. 269; Benedict Nicolson, *Joseph Wright of Derby*, 2 vols., 1968, II, p. 158, pl. 249; Goodison, pp. 294–5, pl. 21

The dramatic limestone scenery of Matlock and Dovedale, which was only excelled by Gordale Scar, made them popular places of pilgrimage for travellers in search of sublime aspects of the Picturesque. Gilpin's *Scenery at Matlock* (cat. no. 73) is probably a view of Matlock Tor.

The composition of this picture makes very stark use of the picturesque tree, half dead in the Dutch-inspired manner, to balance the mass of dark rocks on the right.

Fitzwilliam Museum, PD.8–1948

The *Liber Veritatis*

The main facts about the *Liber Veritatis* were set out in three articles by Marcel Röthlisberger and Michael Kitson in the *Burlington Magazine*, 101 (1959), and summarised by Kitson in the notes to the catalogue of the exhibition *The Art of Claude Lorrain*, Hayward Gallery, London, 1969, and in *Claude Lorrain: the Liber Veritatis*, 1978. It 'consists of a bound book of 195 original drawings by Claude, preceded by his self-portrait . . . five extra genuine drawings were added at the end in the 18th century to make up a round 200 . . . Although pictures painted before 1635 are not in it and although a few minor ones are omitted later, the book was created throughout in chronological order and is a virtually complete record of Claude's work as a painter' (Kitson, *C.L.*, p. 53).

The *Liber Veritatis* 'was bought by the 2nd Duke Devonshire soon after 1720. It probably remained at Devonshire House, London, at least until 1835 . . . but by 1850 it had been removed to Chatsworth' (Kitson, *C.L.*, pp. 53–4). It was ceded to the nation in August 1957, given to the British Museum, and exhibited there in 1977 after being unbound.

The publication of the Boydell-Earlom book (cat. no. 45) in 1777 immediately made a remarkable impact on artists in Britain. Not only were the engravings widely copied, but they made the works of Claude readily accessible as patterns for both ideal and topographical landscape compositions. The influence is clearly seen in Sandby's *Views in Wales* (cat. no. 48) and was later to be the principal stimulus for Turner's *Liber Studiorum* (cat. nos. 53–8). The influence of Claude, which can be seen in so many of the works in this exhibition, is perhaps as much due to familiarity with Earlom's prints as with the original works of the master.

The picturesque formulae which were evolved by Gilpin were, as he admitted, sometimes simplifications of compositions in the *Liber Veritatis* (*Five essays*, p. 173 – cat. no. 76).

The 195 drawings in the original collection and 5 engravings from other drawings were engraved in sepia mezzotint by Richard Earlom between 1774 and 1777, and, together with the self-portrait of Claude engraved by Josiah Boydell, were published by Messrs Boydell and Co., Cheapside, as a folio book in two volumes in 1777. The Latin title *Liber Veritatis* was used for the first time for Boydell's book. It contained a dedication to the Duke of Devonshire, a short life of Claude, presumably written by John Boydell and based on Sandrart, an 'Advertisement' giving transcriptions of the notes on the backs of four of the drawings, and a catalogue of the prints giving titles and incomplete lists of original patrons and present owners.

A further series of similar mezzotints by Earlom from other drawings by Claude was published by Boydell between 1802 and 1810. One hundred of these were published as the third volume of a second edition of the *Liber Veritatis* in 1819 (cat. no. 46).

This official second edition was anticipated by a second complete edition of 209 engravings based on Earlom which was pirated by Ludovico Caracciolo and published by Francesco Bourlie, Rome, 1815. A selection of 24 plates from the *Liber Veritatis*, engraved in mezzotint by various artists from Earlom's prints, was published by W. B. Cooke as *Beauties of Claude Lorraine*, 1825.

45 *The Liber Veritatis or a collection of prints after the original designs of Claude le Lorrain . . . 2 vols.*

London: Boydell, 1777. Folio
PLATES: 201 sepia mezzotints: 200 engraved by Earlom, frontispiece by Josiah Boydell. Imprints 1774–7
LITERATURE: Kitson, *L. V.*, pp. 30f; L. Caracciolo, *Liber Veritatis di Claudio Gellée*, Rome, 1815; W. B. Cooke, *Beauties of Claude Lorrain*, 1825; Mme Pattison, *Claude Lorrain*, 1824, pp. 129–30; Manwaring, p. 81; Kitson and Röthlisberger in *Burlington Mag.*, 101 (1959), p. 17; Röthlisberger, *Paintings*, p. 41; Kitson, *C.L.*, pp. 75–6

Fitzwilliam Museum
DISPLAYED: title page and frontispiece, *Claude le Lorrain*, engraved by Josiah Boydell from the self-portrait in the original *Liber Veritatis*. The print is altered to a rectangle from the original oval drawing, and is reversed. It is uncertain whether the drawing is actually by Claude (Kitson, *L.V.*, pp. 44–5)

45a Vol. 1, pl. 90, *A landscape at sun-set, with cattle. A view of Ponte Molle near Rome,*
□3 1645. For details of the original drawing see Kitson, *L.V.*, pp. 109–10, and see cat. no. 2

This, a composition which particularly appealed to English taste, was perhaps the most popular of Earlom's plates. The farm buildings with the round tower and the bridge appear again and again in British landscapes (see cat. nos. 26, 51) as also does the principal tree.

45b Vol. 2, pl. 170, *A landscape with cattle: Apollo and Mercury*, 1666. Earlom's title:
□30 *Apollo and Battus.* For details of the original painting see Kitson, *C.L.*, no. 35, pl. 34, of the drawing, Kitson, *L.V.*, p. 158
 The mythical subject is treated as a pastoral scene, where gods differ little from classical shepherds. The subject and the composition bear close affinities with *Liber Veritatis* no. 128, of 1653, which also depicts Apollo and Mercury. The tree is the prototype of a hundred years of the framing-trees cliché in British landscape; and the highly lighted buildings on the eminence, of Gilpin's constantly repeated castle in the middle ground.

46 *The Liber Veritatis . . . 3 vols.*

Vols. 1–2, reissue of the 2 vols. of Boydell's 1777 edition. Frontispiece added to vol. 2; portrait of Richard Earlom engraved in mezzotint by T. Lupton from a painting by G. Stewart
Vol. 3, published London: Hurst Robinson and Co., successors to Boydell, 1819. Folio
PLATES: 101; 100 sepia mezzotints, engraved by Earlom; frontispiece, portrait of John Boydell, stipple engraving by B. Smith from a drawing by C. Burckhardt. Imprints 1802–17

The hundred new prints were from drawings by Claude in English collections, including thirty-eight of the drawings bought by Richard Payne Knight and now in the British Museum, and several nature drawings. According to Kitson (*L.V.*, p. 30), about a quarter of the drawings reproduced are not by Claude.

DISPLAYED: pl. 50, *A study*, from a drawing in the collection of Earl Spencer (see cat. no. 47)

Claude Gellée called le Lorrain 1606–1682

47 Landscape

Brown wash. 162 × 268 mm
Verso; drawing of tree; inscribed, by a later hand, 'C. Lorance c. 1640'
COLLECTIONS: Lord Spencer; Hibbert; Lord Knutsford, sale, Sotheby's, 11 April 1935, (lot 108); bought for Paul Oppé; Miss Armide Oppé
EXHIBITED: R.A., 1938, no. 529, and 1949, no. 477; Amsterdam, 1951, no. 174; Arts Council, London, 1952, no. 28; R.A., 1953, no. 372; R.A., *Oppé collection*, no. 334
LITERATURE: Röthlisberger, *Drawings*, p. 168, pl. 353 R. Repr. as pl. 50 in Earlom's *Liber Veritatis*, III (cat. no. 46)

This nature drawing of great simplicity entirely executed in wash is of a range of hills seen over a wide, gently undulating valley. As a composition it is completely different from any of the landscapes in Claude's original *Liber Veritatis*. The usual three planes are not clearly defined as the valley merges into the background hills. There are no romantic buildings in the middle distance. The foreground forms a dark band across the lower sixth of the drawing; there are no ideal groups, no figures, no flocks and no framing trees. The gentle contours of the hills suggest those of the British Isles. The composition has far more in common with the broader landscapes of the Cozenses, Girtin and De Wint than with picturesque British landscapes deriving from more familiar aspects of the *Liber Veritatis*.

Lent from a private collection

Paul Sandby 1725–1809

48 *Views in Wales*

Published by the artist
Issued in three parts:

Pt 1. *XII views in aquatinta from drawings taken on the spot in South-Wales dedicated to the honourable Charles Greville and Joseph Banks Esquire* . . . 1775
Aquatint title page and 12 dark sepia aquatints with heavy framing 'wash'

borders; engraved title on borders; drawn and engraved by Sandby except pl. 12, which is from a drawing by L. Wynn. Imprints 1774–5

Pt 2. *Twelve views in North Wales* (title on pl. 1)
12 sepia aquatints; engraved titles, drawn and engraved by Sandby. Imprints 1776

Pt 3. *XII views in Wales, 1776* (engraved on tail board of cart in view, pl. 1)
12 sepia aquatints, drawn and engraved by Sandby. Imprints 1777

LITERATURE: Peter Hughes, 'Paul Sandby and Sir Watkin Williams-Wynn', *Burlington Mag.*, 114 (1972), pp. 459–67, and 'Paul Sandby's tour of Wales with Joseph Banks', *ibid.*, 117 (1975), pp. 452–7; Abbey, no. 511; Prideaux, pp. 98–109, 351; Kitson, *L.V.*, pp. 31, 38

Part 1 of the *Views in Wales* was the first book of views executed in aquatint to be published in England. The Hon. Charles Greville, to whom it was dedicated, acquired details of the process from J. B. Le Prince and passed them on to Sandby.

The *Views in Wales* plates closely resemble those of Earlom's *Liber Veritatis*, 1777, with which they are almost contemporary. Their similarity is to be seen not only in the way the medium is used (although Sandby uses aquatint not mezzotint) and the sepia colour of the plates, but also in the composition. Sandby was undoubtedly familiar with Earlom's plates, the earliest of which are dated 1774.

□32 DISPLAYED: Pt 3, pl. 6, *Traeth Mawr in the road to Caernarvon from Festiniog* (see cat. no. 49)

49 Traeth Mawr, on the road to Carnarvon from Festiniog

Indian ink and watercolour. 337 × 520 mm
Engraved in aquatint as pt 3, pl. 6 of *Views in Wales* (cat. no. 48)
COLLECTIONS: William Sandby, by whom bequeathed, 1904
LITERATURE: Binyon, IV, p. 20, no. 117

As this drawing was prepared for reproduction, it is a more accurate topographical record of the view than many of Sandby's landscape drawings, such as cat. nos. 50 and 51.

Lent by the Trustees of the British Museum (1904–8–19–26)

50 Snowdon

□33 Watercolour over pencil. 136 × 200 mm
Signed, l.l., 'Paul Sandby fecit'
COLLECTIONS: as cat. no. 49
LITERATURE: Binyon, IV, p. 10, no. 51a

Lent by the Trustees of the British Museum (1904–8–19–106)

51 Snowdon

Watercolour over black chalk. 152 × 236 mm
COLLECTIONS: as cat. no. 49
LITERATURE: Binyon, IV, p. 10, no. 51b
Lent by the Trustees of the British Museum (1904–8–19–107)

These two drawings of Snowdon on one mount are typical of a great many of Sandby's small landscape compositions, delicately drawn and tinted with watercolour washes. They are based on actual Welsh scenes, but in fact rearranged to form 'ideal' landscapes. In the first, which is the more Claudian of the two, Sandby has actually taken the Tiber, the Ponte Molle and the round-towered farmhouse from the *Liber Veritatis* and planted them in the middle of the Welsh mountains.

52 Conway Castle

Pen and black ink, watercolour over traces of black chalk, varnished. 177 × 246 mm
COLLECTIONS: as cat. no. 49
LITERATURE: Binyon, IV, p. 9, no. 43

This is Welsh landscape seen through Claude-tinted spectacles. Sandby has achieved in watercolour some measure of the tranquil glow of Claude's golden age. The choice and arrangement of the elements are also similar to those which Gilpin used in his diagrammatically simple picturesque compositions.

Lent by the Trustees of the British Museum (1904–8–19–56)

Joseph Mallord William Turner 1775–1851

53– Six plates from the *Liber Studiorum*
58 *Fitzwilliam Museum*

53 Pl. 8, *The castle above the meadows*, EP, Feb.Y 20, 1808
No title on plate
Mezzotint by Charles Turner

54 Pl. 13, *The bridge in middle distance*, E.P, June 10. 1808
No title on plate
Aquatint and mezzotint by Charles Turner

55 Pl. 25, *Hindhead Hill. On the Portsmouth Road*, M, Jan.Y 1. 1811
Mezzotint by Robert Dunkerton

□31 56 Pl. 28, *Junction of Severn and Wye*, EP, June 1811
No title on plate
Aquatint and mezzotint by J. M. W. Turner

30

57 Pl. 43, *The bridge and goats*, E.P, April 23. 1812
No title on plate
Aquatint and mezzotint by Frederick Christian Lewis

58 Pl. 45, *Peat bog, Scotland*, M, April 23. 1812
Mezzotint by George Clint

LITERATURE: Stopford Brooke, *Notes on the 'Liber Studiorum' of J. M. W. Turner, R.A.*, 1885; Alexander J. Finberg, *The History of Turner's 'Liber Studiorum' with a new catalogue raisonné*, 1924; C. F. Bell, *'Liber Studiorum': J. M. W. Turner*, 1904; Martin Butlin and Andrew Wilton, *Turner 1775–1851*, Tate Gallery exhibition catalogue, 1974; Richard Norton, 'The *Liber Studiorum* and other mezzotints', *Print Collector's Quarterly*, 3 (1913), pp. 414–33; John Pye and John Lewis Roget, *Notes and memoranda respecting the 'Liber Studiorum' of J. M. W. Turner, R.A.*, 1879; W. G. Rawlinson, *Turner's 'Liber Studiorum'*, 1878, 1906; Emil H. Richter, 'Turner and the *Liber Studiorum*', *Print Collector's Quarterly*, 3 (1913), pp. 394–413; Prideaux, pp. 94, 96, 97, 107

The *Liber Studiorum*, imitating in both title and medium Richard Earlom's prints after the drawings in Claude's *Liber Veritatis*, was originally intended to consist of a series of one hundred engravings reproducing designs by J. M. W. Turner. The outlines of the designs were usually etched by the artist, who in some cases (as pl. 28) also completed the engraving. A total of seventy-one plates was eventually published, and a further twenty were completed or partially prepared.

According to the prospectus of 1807 it was 'intended in this publication to attempt a classification of the various styles of landscape, viz., the historic, mountainous, pastoral, marine, and architectural', the respective styles being indicated by the capital letters 'H', 'M', 'P', 'M', 'A' on the upper margins of the prints. A sixth category, 'EP', is something of a mystery as Turner never explained what he intended the initials to stand for. 'Epic Pastoral', 'Elegant Pastoral' and 'Elevated Pastoral' have been suggested. EP is the section in which Turner most closely followed Claude. The four EP prints displayed are all essays in the manner of Claude – Turner 'outpainting' the master. Stopford Brooke says of pl. 13, 'The landscape itself is half Italian and half English ... The whole thing is unsatisfactory'; and of pl. 43, 'Half nature then half convention, half Turner half pseudo-Claude, the drawing is like a Gothic building with a Palladian porch, and as disagreeable.' There is nothing of the pseudo-Claude in the two 'mountainous' prints.

Although the *Liber Studiorum* was undoubtedly inspired by the *Liber Veritatis*, it differs in being a demonstration of the great styles of landscape painting as mastered by Turner; it is not a graphic catalogue of the artist's work.

59 Thomson's Aeolian harp

□29 Oil on canvas. 166.7 × 306.0 cm

COLLECTIONS: Probably bought by James Morrison in the 1820s (no firm evidence for this exists); first documented in the Morrison collection by Waagen, 1857; by descent to the Trustees of the Walter Morrison picture settlement, from whom accepted by H.M. Treasury in lieu of death duties and allocated by them to the City of Manchester Art Galleries, 1978

EXHIBITED: Turner's Gallery, London, 1809, no. 6; International Exhibition, London, 1862, no. 330 (entitled *Italy*); R.A., 1882, no. 41; Grosvenor Gallery, London, 1914–15, no. 75 (as *Autumnal morning*)
LITERATURE: for a full bibliography see Butlin

Exhibited at the Turner Gallery in 1809, with the following lines by Turner:

> On Thomson's tomb the dewy drops distil,
> Soft tears of Pity shed for Pope's lost fame,
> To worth and verse adhere sad memory still,
> Scorning to wear ensnaring fashion's chain.
> In silence go, fair Thames, for all is laid;
> His pastoral reeds untied, and harp unstrung,
> Sunk is their harmony in Twickenham's glade,
> While flows the stream, unheeded and unsung
> Resplendent Seasons! chase oblivion's shade,
> Where liberal hands bid Thomson's lyre arise;
> From Putney's height he nature's hues survey'd,
> And mark'd each beauty with enraptur'd eyes.
> The kindly place amid thy upland groves
> Th' Æolian harp, attun'd to nature's strains,
> Melliferous greeting every air that roves
> From Thames' broad bosom or her verdant plains,
> Inspiring Spring! with renovating fire,
> Well pleas'd, rebind those reeds Alexis play'd,
> And breathing balmy kisses to the Lyre,
> Give one soft note to lost Alexis' shade.
> Let Summer shed her many blossoms fair,
> To shield the trembling strings in noon-tide ray;
> While ever and anon the dulcet air
> Shall rapturous thrill, or sigh in sweets away.
> Bind not the poppy in the golden hair,
> Autumn! kind giver of the full-ear'd sheaf;
> Those notes have often echo'd to thy care
> Check not their sweetness with thy falling leaf.
> Winter! thy sharp cold winds bespeak decay;
> Thy snow-fraught robe let pity 'zone entwine,
> That gen'rous care shall memory repay,
> Bending with her o'er *Thomson's* hallow'd shrine.

James Thomson's poem *An ode on Aeolus's harp* was first published in 1748. However, Butlin has pointed out that Dr Adele Holcomb had drawn his 'attention to the fact that Turner's choice of subject was probably suggested to him by reading William Collins' *Ode occasion'd by the death of Mr Thomson*, which was written in 1749. The theme of Collins' (1721–59) ode, in which a poet's sylvan grave is decorated by nymphs, is clearly shown in Turner's picture and does not occur anywhere in Thomson's poetry', to Butlin's 'knowledge (the pedestal of the tomb is inscribed "THOMSON"). Collins' ode also mentions Thomson's "airy harp", which a footnote explains is the harp of Aeolus, and Turner introduces the buildings of Richmond along the Thames, again following the advertisement for

Collins' poem. "The Scene of the following stanzas is suppos'd to lie on the Thames near Richmond" (where Thomson lived shortly before his death). Turner's lines, invoking the four seasons, not only make an obvious reference to Thomson's famous poem [*The Seasons*], but also suggest that the figures in his picture are meant to represent the four seasons' (Butlin, p. 56).

Turner's picture pays homage both to Claude and to Thomson, and in doing so it enshrines the link between the 'picturesque poets' and the 'Italian' landscape painters. The nymphs representing the four seasons (see Wilson's *Apollo and the seasons*, cat. no. 21) are decorating Thomson's tomb with an Aeolian harp, an instrument upon which 'Nature' plays the music. The view from Richmond Hill includes Pope's Twickenham villa, and by a happy chance it is the prospect described in such picturesque terms by Captain Birt (cat. no. 85).

Lent by the City of Manchester Art Galleries (1979.7)

John Varley 1778–1842

60 *A treatise on the principles of landscape design . . .*

London: Sherwood, Gilbert and Piper, n.d. Folio
PLATES: 16 sepia aquatints, 2 on a plate, from drawings by Varley, engraved by F. C. Lewis (12), G. Lewis (2), J. Gleadah (2). Imprints 1816–21. The plates were issued separately, each with a leaf of explanatory text, at 5s. apiece
LITERATURE: Prideaux, pp. 202, 305; Abbey, *Life*, no. 187

The text forms a comprehensive treatise on the principles and practice of landscape painting. In it Varley defines the principles of 'cooking' nature. The painter surmounts 'obstacles, by the omission or concealment of those objects which in nature are inconsistent with the general sentiment . . . he can obscure those objects which cannot, though unpleasant to the eye in a view, be dispensed with, and increase the effect of those on which the subject principally depends'. The plates show a series of arrangements of Varley's stock of objects suitable for a picturesque composition (see cat. nos. 61, 122).

□35 DISPLAYED: pl. 1, *Principles of light and shade*: no. 1, *Dolbadern Tower, in Wales*, and no. 2, both facing p. 1, 'Introduction' and 'Explanations'. Of no. 1, Varley says, 'The view resembles the neighbourhood of Lamberris Lake, with Dolbadern Tower, North Wales' (see cat. nos. 100e, 135), thereby making it clear that he has rearranged the elements of the actual scene. He has done this on Claudian principles: '. . . the subjects generally painted by Claude', he explains, 'are views of open country, with great distances, wherein the depth of shade was generally reserved for the fore-ground, and the light and tender tints for the distances and skies, and which was best calculated for their display, as it leads the eye towards them'. No. 2, he adds, has more in common with the landscapes of Rembrandt

33

61 Mountain landscape

Watercolour and bodycolour. Sight size 215 × 280 mm
COLLECTION: Gillian Howell

Varley had the reputation of being an inspiring teacher. As such he had a far-reaching influence on watercolour painting in England. David Cox, Copley Fielding, Finch, W. H. Hunt, John Linnell, Mulready, Turner of Oxford, Samuel Palmer and De Wint were amongst those who profited by his help.

In the course of his teaching Varley produced large numbers of drawings which tended to be mechanical in execution and repetitive in subject and design, as models, of which his pupils in turn made many accomplished copies. In these drawings endless arrangements were made of stock elements. This one shows a Welsh mountain, a shining lake, a tufted tree with too few leaves and branches, some sheep and a pensive shepherd, all taken from stock, arranged in a Claudian pattern and rendered in rich colour. It is Claude reduced to a simple formula. Nevertheless Varley has conveyed a feeling of romantic atmosphere and luminous distance with considerable subtlety.

Lent by Gillian Howell

William Gilpin 1724–1804

62 *Observations on the River Wye, and several parts of South Wales, &c. relative chiefly to picturesque beauty; made in the summer of the year 1770*

London: printed for R. Blamire, 1782. Octavo
PLATES: 15 oval tinted aquatints from drawings by Gilpin
LITERATURE: Barbier; Templeman; Hardie, p. 120; Prideaux, p. 337; Abbey, no. 546; Upcott, p. 350

Gilpin recorded a series of tours in England, Scotland and Wales, made in 1769–76, in search of 'picturesque beauty', a term which he invented. These records were subsequently published as six books, each entitled *Observations on ... relative chiefly to picturesque beauty ...*

The 'Tour of the Lakes' in MS. was widely circulated among Gilpin's friends, who constantly encouraged him to publish. The *Wye Tour* was the first to be published and was an immediate success. Of it Gilpin writes, 'The following little work proposes a new object of pursuit; that of not barely examining the face of a country; but of examining it by the rules of picturesque beauty; that of not merely describing; but of adapting the description of natural scenery to the principles of artificial landscape; and of opening the sources of those pleasures, which are derived from the comparison' (pp. 1–2). The *Wye Tour* and Gilpin's other *Observations* contain much often contradictory picturesque theory.

DISPLAYED: pl. 14, facing p. 67, *Dinevawr-castle*. The composition is in three Claudian planes: a dark foreground with figures, a highlight on the castle in the middle distance, and mountains in the distance. It is one which Gilpin used again and again, both in semi-topographical views, such as this one, and in imaginary scenes such as the illustrations in *Forest scenery* of the 'withered top' and the 'curtailed trunk' (see cat. nos. 66, 67)

63 *Observations on the River Wye ...* Third edition

London: printed for R. Blamire, 1792. Octavo
PLATES: 17 aquatint plates coloured by Gilpin and mounted on light-brown paper; 4-page 'Advertisement' in Gilpin's hand, giving instructions on tinting prints or black and white drawings bound in
William Gilpin's bookplate, library no. 100; D. R. Sharpe's bookplate; signed 'Sam¹. Rogers'; inscribed 'Bought by William Sharpe at Sam¹. Rogers' sale for £2.8.'
COLLECTIONS: sold Christie's, 6 May 1802 (lot 123), for 2½ gns.; Samuel Rogers;

William Sharpe; D. R. Sharpe; Charles Tomrley; acquired from Mrs Tomrley, July 1966

EXHIBITED: Kenwood, *William Gilpin*, 1959, no. 37a
LITERATURE: Barbier, p. 81n

This volume (like cat. nos. 66, 69, 70) was prepared by Gilpin for the 1802 sale arranged at Christie's 'for the endowment of a parish-school at Boldre, near Lymington, in Hampshire'.

DISPLAYED: pl. 16, facing p. 109, *Dinevawr-castle*. As the result of the tinting the highlight on the castle has been obscured, and one on a tree has been introduced in the left foreground, completely altering the balance of the composition

64 *Observations, relative chiefly to picturesque beauty, made in the year 1772, on several parts of England; particularly the mountains, and lakes of Cumberland, and Westmoreland.* 2 vols.

London: printed for R. Blamire, 1786. Octavo

PLATES: 30, from drawings by William and Sawrey Gilpin. Vol. 1, 11 oval aquatints (10 tinted), 1 etching, 2 coloured plans; vol. 2, 12 (10 oval) tinted aquatints, 2 etchings, 1 coloured plan

LITERATURE: Barbier; Templeman; Abbey, no. 183; Prideaux, p. 337

The MS. 'A tour through England; more particularly the mountainous parts of Cumberland and Westmorland . . .' was bound in 8 vols., containing 208 drawings and 41 sketch maps and panoramas. It was condensed to form the published *Tour of the Lakes*.

DISPLAYED: vol. 1, facing p. 227, *Gatesgarth-dale*. 'This print was intended to give some idea of the kind of rocky scenery, of which Gatesgarth-dale is composed; and of that solemnity, which it assumed, when we saw the sweeping clouds pass over its summit: but I am sorry to say, it does not express the idea so well as I could wish . . . The clouds are ill made-out: the distant rocks are worse; and the figures, as a scale to the perspective, are twice as large as they ought to be' ('Explanation of the prints', II, p. vi). Gatesgarth-dale, generally known as Honister Pass, leading from Buttermere to Borrowdale, remains one of the most sublime scenes in the Lake District.

64a Vol. 2, facing p. 221, *Scenery at Matlock*. 'This print is meant to give some idea of
□41 that kind of continuation of rocky scenery which is found at Matlock, along the banks of the Derwent' ('Explanation of the prints', II, p. ix) (see cat. no. 73)

65 *Voyage en différentes parties de l'Angleterre, et particulièrement dans les montagnes & sur les lacs du Cumberland & du Westmoreland; contenant des observations relatives aux beautés pittoresques . . .* Ouvrage traduit de l'Anglois sur la troisième édition, par M. Guédon de Berchere. 2 vols.

Paris: Defer de Maisonneuve; London: Blamire, 1789. Octavo

PLATES: 29 engravings, adapted from plates of 2nd edn
LITERATURE: Templeman, p. 302

Gilpin's works were popular on the continent. *An essay upon prints*, 1768, was published during his lifetime in German, French and Dutch. This is one of several German and French translations of the *Tour of the Lakes*, the most popular of his books. It is actually translated from the second edition, 1788, and not, as wrongly stated on the title page, from the third edition (1792).

DISPLAYED: title page

66 *Remarks on forest scenery, and other woodland views, (relative chiefly to picturesque beauty) . . .* Second edition. 2 vols.

London: printed for R. Blamire, 1794. Octavo
PLATES: 30 of the original plates have been removed and replaced by the original drawings by William and Sawrey Gilpin, mounted on grey paper. William Gilpin's bookplate, library no. 43
COLLECTIONS: sold Christie's, 6 May 1802 (lot 120) (see cat. no. 63), bought in by William Gilpin at £29.8s.
EXHIBITED: National Book League, London, *Mirror of Britain*, 1957, no. 144; Kenwood, *William Gilpin*, 1959, nos. 69, 70
LITERATURE: Barbier, p. 87n
DISPLAYED: vol. 1, p. 9, *The withered top*

67 Another copy (3rd edn), vol. 1, pl. 3, *The curtailed trunk*. 'For the use, and beauty of the *withered top*, and *curtailed trunk*, we need only appeal to the works of Salvator Rosa . . .' 'The *withered top* just breaks the lines of an eminence: the *curtailed trunk* discovers the whole; while the lateral branches, vigorous and healthy in both, hide any part of the lower landscape, which, wanting variety, is better veiled' (vol. 1, pp. 8–9)

68 *Observations on several parts of the counties of Cambridge, Norfolk, Suffolk, and Essex. Also on several parts of North Wales; relative chiefly to picturesque beauty, in two tours, the former made in the year 1769. The latter in the year 1773.* Published by his trustees for the benefit of his school at Boldre

London: printed for T. Cadell and W. Davies, 1809. Octavo
PLATES: 20 tinted aquatints (19 oval) from Gilpin's drawings
LITERATURE: Barbier; Templeman; Prideaux, p. 337; Upcott, p. xxxviii; Abbey, no. 15
DISPLAYED: pl. 1, facing p. 10, *Cambridge*. This plate demonstrates Gilpin's complete disregard for topographical accuracy. The building in the middle distance, which is presumably King's College chapel, is almost identical with Ely cathedral in pl. 3, *Ely-church*; and the view of Cambridge closely resembles pl. 6, *Distant view of Norwich*. 'Cambridge makes no appearance at a distance.

King's-college chappel, is the only object, which presents itself with any dignity, as we approach' (p. 10)

69 'Instructions for examining landscape; illustrated by a few drawings'

Book of drawings. 205 × 280 mm (drawings about 158 × 250 mm)

32 drawings; pencil and monochrome wash laid down on grey cartridge paper and board with 19 pages of 'instruction' in Gilpin's hand on Whatman paper (watermarks 1794)

William Gilpin's bookplate. WG blind stamp (Lugt, suppl., no. 226a) on each drawing

COLLECTIONS: sold Christie's, 6 May 1802 (lot 134), to Sir Robert Harvey for Thomas Bernard for 23 gns.; Spencer George Perceval, by whom bequeathed, 1922

EXHIBITED: Kenwood, *William Gilpin*, 1959, no. 105

LITERATURE: Barbier, p. 93

These drawings (like cat. no. 70 and eight other sets with manuscript notes) were prepared by Gilpin for the 1802 sale (see cat. no. 63).

The notes differentiate between the 'natural' view and the 'artificial' one. The thirty-two drawings are all 'artificial'. The instruction is for viewers of picturesque landscape rather than for artists.

Fitzwilliam Museum, no. 3674

□38 DISPLAYED: no. 18. This, despite the ubiquitous highly lit building in the middle ground, is a most unusual composition for Gilpin. In the manuscript he stresses the importance in execution of interesting the 'imagination' as well as the 'eye'. 'When we see a pleasing scene, we cannot help supposing, there are other beautiful appendages connected with it, tho concealed from our view. If therefore we can interest the imagination of the spectator, so as to create in him an idea of some beautiful scenery beyond . . . we give a scope to a very pleasing deception. It is like the landscape of a dream.' In the drawing the two men sitting by the river 'may be supposed to see the continuation of a landscape, down the valley . . . and this gives a sort of clue to the imagination. The windows of a castle on a hill . . . may be supposed also to command the same kind of ideal view.' The unbalanced composition suggests a dream view round the corner, and the curiously dream-like character of the bridge leading into the unseen world beyond the picture is reminiscent of the nightmare staircases and bridges of Piranesi's *Carceri* prints. 'This mode of picturing things unseen gives painting a new power by thus pressing the imagination into its service' (pp. 14–16)

70 'Various circumstances of Lake Scenery'

Book of drawings; title inscribed on paper label on cover. 320 × 420 mm (drawings about 160 × 252 mm)

24 drawings; pen, pencil and monochrome wash mounted on cartridge paper and bound with 4 pages of description of the views in Gilpin's hand

William Gilpin's bookplate, library no. 68. WG blind stamp (Lugt, suppl., no. 226a) on each drawing

COLLECTIONS: sold Christie's, 6 May 1802 (lot 973), to Sir Robert Harvey for 16 gns.

EXHIBITED: Kenwood, *William Gilpin*, 1959, no. 97

This volume is also one of the sets of drawings prepared by Gilpin for the 1802 sale.

DISPLAYED: MS. first page of the description of the views

71 Landscape with ruined castle

□37 Black ink, grey and light brown wash over black chalk. 361 × 269 mm
WG blind stamp (Lugt, suppl., no. 226a)
COLLECTIONS: J. R. Holliday, by whom bequeathed, 1927
EXHIBITED: Kenwood, *William Gilpin*, 1959, no. 72

The view is Gilpin's favourite, a castle on an eminence in the middle distance (see cat. nos. 62, 63, 66, 67); but in this case it is a vertical, not a horizontal composition.

Fitzwilliam Museum, no. 1355

72 Waterfall

□39 Pen and brown ink, grey, brown and blue wash with bodycolour. 160 × 250 mm
WG blind stamp (Lugt, suppl., no. 226a) Inscribed, *verso*, 'Sale 6 June 1804'
COLLECTIONS: bought from Graham Pollard

The use of colour, restrained though it is, is rare in Gilpin's work. See the 'Advertisement' inserted in a copy of the *River Wye* (cat. no. 63). 'Water-coloured drawings when harmoniously and modestly tinted, are certainly the most beautiful kind of drawings . . . But we so rarely see a drawing in water-colours harmoniously, and modestly tinted, that in general we are better pleased with simple black & white.'

The subject is similar to view XXI in 'A fragment', a MS. description of an imaginary tour, illustrated with twenty-four of Gilpin's characteristic imaginary views (Barbier, pp. 95, 138, 149, 177–80, pls. 13–16).

73 Scenery at Matlock

□40 Leaf from a sketch-book. Pen and brown ink with grey wash. 160 × 200 mm. 1772
Inscribed, in Gilpin's hand, 'Scenery at Matlock', 'Road', '1'

Gilpin visited Matlock on his return from the Lakes in 1772, when this sketch was probably made. The view is reproduced in the *Tour of the Lakes* (cat. no. 64). He made rough sketches on the spot, and 'these graphic notes were used each evening to make more intelligible sketches before the day's impressions were lost. The penwork goes into wild loops and the grey and brown washes are dashed in' (Barbier, p. 51).

74 *The last work published of the Rev. William Gilpin, M.A. . . . representing the effect of a morning, a noon tide, and an evening sun. In thirty designs from nature*

London: Edward Orme, 1810. Quarto
Known as *Gilpin's day* from the half-title
8 pages of descriptive notes
PLATES: 30 tinted aquatints; engraved by Hamble and Dubourg from drawings by Gilpin
LITERATURE: Barbier; Templeman; Hardie, p. 120; Prideaux, p. 337; Abbey, *Life*, nos. 130, 131

'At the 1802 sale, James Forbes F.R.S. purchased several lots, including lot 92, "twenty-four Landscapes bound, entitled Morning, Noon and Evening, with a written description of each." From these and six other drawings J. Hamble and M. Dubourg made aquatints which were published by Edward Orme in 1810 in this form' (Barbier, p. 84). The plates were reused by J. H. Clark for a drawing book, *Gilpin's day*, 1811 and 1824 (cat. no. 160).

DISPLAYED: pl. 18, one of 5 plates described by Gilpin as 'instances of Landscapes under meridian Suns, chastised by different degrees of mist, and cloudy weather' (p. 7)

Picturesque theory

It was not till the last decade of the eighteenth century that the theory of the Picturesque became a matter for close analysis and ponderous argument. The four principal writers to contribute to the debate were William Gilpin, Richard Payne Knight, Uvedale Price and Humphry Repton. Gilpin was concerned with the application of the Picturesque to travel and to the viewing of nature, but the other three were primarily concerned with landscape gardening and so their works are not within the scope of this exhibition. However, books by two of them, with illustrations related to picturesque landscape, are included.

The subject of picturesque theory has been very fully discussed by modern writers, notably by Hipple, but also by Manwaring, Hussey, Pevsner and many others. Gilpin's contribution has been analysed by Templeman and Barbier (see bibliography). A book on the English style, a study of the Picturesque in architecture and garden design, by David Watkin, is to be published.

William Gilpin 1724–1804

75 *Three essays: On picturesque beauty; On picturesque travel; and On sketching landscape: to which is added a poem, On landscape painting*

London: printed for R. Blamire, 1792. Octavo
PLATES: 7 aquatints (5 tinted, 1 coloured, 1 line) from drawings by Gilpin
LITERATURE: Hipple, ch. 13; Barbier; Templeman; Prideaux, p. 337; Abbey, *Life*, no. 129

This is the earliest published work on the theory of the Picturesque. The poem *On landscape painting* is a series of instructions to painters. It is in fact a metric drawing book, perhaps the only one.

DISPLAYED: first of 2 pls. facing p. 19 (see cat. no. 76)

76 *Five essays on picturesque subjects. Three essays . . .* (see cat. no. 75). To these are now added two essays, giving an account of the principles and mode in which the author executed his drawings. Third edition

London: printed for T. Cadell and W. Davies, 1808. Octavo
PLATES: 14: 9 aquatints (1 coloured), 5 soft-ground etchings from drawings by Gilpin and others. Plates for the 2nd and 3rd edns. prepared by Samuel Alken
LITERATURE: Hipple, ch. 13; Barbier; Templeman
DISPLAYED: second of 2 pls. facing p. 19. 'It is the intention of these two prints to

illustrate how very adverse the idea of *smoothness* is to the *composition* of a landscape. In the second of them the *great lines* of the landscape are exactly the same as in the first; only they are *more broken*' ('Explanation of the prints', p. i). The first print shows 'a smooth knoll coming forward on one side, intersected by another smooth knoll on the other; with a smooth plain perhaps in the middle, and a smooth mountain in the distance . . . the very idea is disgusting' (p. 19); while the second shows the same scene transformed into one of Gilpin's standard compositions by means of jutting forms and rugged rocks, clothed with shaggy boskage, two foreground figures and his ubiquitous ruined castle. Gilpin's reaction to unadorned mountaintops is shown by his comment on Snowdon, which he found 'a bleak, dreary waste; without any rich furniture, either of wood, or well-constructed rock' (*Observations on . . . North Wales*, p. 155, cat. no. 68)

Richard Payne Knight 1750–1824

77 *The landscape: a didactic poem*

London: Bulmer, 1794. Quarto
PLATES: 2 etchings from designs by Thomas Hearne (1744–1817)
LITERATURE: Manwaring, pp. 81, 156–8; Hussey, pp. 31–2, 68, 161, 166–78; N. Pevsner in *Art Bulletin*, 31 (1949), pp. 300–5, repr.; Hipple, pp. 247–83, repr.; Gage, p. 21, repr.; Kitson, no. 182

The landscape followed Gilpin's various works on the Picturesque as an important contribution to the theory of the subject, later worked out in detail in Payne Knight's *Analytical enquiry into the principles of taste*, 1805. He was a notable connoisseur and collector. Claude was his favourite painter, 'Nature's own pupil, favrite child of taste', and he bought more than a hundred of Claude's nature drawings, which are now in the British Museum. Thirty-eight of these were reproduced in vol. 3 of Earlom's *Liber Veritatis*, 1802–17 (cat. no. 46).

Lent by the Cambridge University Library (Zz.17.29²⁶)
DISPLAYED: pl. 1, A house 'dressed in the modern style'; pl. 2, A house 'undressed' (represented by a photograph)

These are the only two illustrations to *The landscape*. The first is a comment on the 'system of picturesque improvement employed by the late Mr Brown and his followers'. It caricatures the plain 'Palladian' house, the naked serpentine water, the bald shaved lawns and the well-formed clumps of trees, and contrasts them with the surroundings of the second house, which conforms with Payne Knight's ideas of the Picturesque – a romantic medieval house, a turbulent stream, 'loose and rang'd groups of trees', rough and shaggy contours and rugged rocks.

Payne Knight built his own castle house at Downton on the Rock in Herefordshire, and an engraving of it from a drawing by Hearne in Britton and Brayley's *Beauties of England and Wales*, 1805, is remarkably like this print of the 'dressed' house.

42

78 *Sketches and hints on landscape gardening*

London: printed by W. Bulmer & Co. and sold by Boydell and Nicol. Dedication
 dated 1794. Oblong folio (290 × 390 mm)
PLATES: 16 aquatints: 10 coloured, 14 with overslips
LITERATURE: Manwaring, pp. 159–60; Hussey, pp. 164–5; Hipple, pp. 224–37;
 Hardie, pp. 127–8; Prideaux, p. 359; Tooley, no. 400; Abbey, no. 388

This was the first of Repton's published books based on the MS. 'Red Books'
which he prepared for his clients to show them the capabilities of their estates.
They were illustrated with skilfully executed watercolours which showed by
means of hinged overslips the scene before and after improvement.

Repton pointed out the impossibility of applying picturesque principles to
garden design, for the painter assembles his elements from a fixed viewpoint,
remains static and has a limited field of vision, whereas the landscape gardener has
a variable viewpoint and an unlimited field of vision.

Lent by Emmanuel College, Cambridge (Graham Watson Collection)
DISPLAYED: pl. 2, between pp. 30 and 31, *View at Welbeck*. Coloured aquatint,
 with folding overslip. On the overslip Repton and his team are shown surveying
 the grounds. They are using an instrument which looks very like a modern
 surveyor's level

William Combe 1741–1823 and Thomas Rowlandson 1756–1827

79 *The tour of Doctor Syntax, in search of the Picturesque. A poem*

London: R. A. Ackermann's Repository of Arts, 1812. Octavo
PLATES: 30 coloured aquatints, vignette title page; from drawings by
 Rowlandson
First edition in book form; previously published in the *Poetical Magazine* under
 the title 'The schoolmaster's tour', 1809–11
LITERATURE: Abbey, *Life*, no. 214; Hardie, pp. 113, 167–70, 310, 316; Prideaux,
 p. 131; Tooley, no. 426

The tour of Doctor Syntax was an undisguised satire on the tours of Doctor Gilpin.
'Doctor Syntax's tour to the Lakes' is the page heading. Enormously popular
from the outset, *Doctor Syntax* went into many editions, a series of china figures of
Syntax were produced by the Derby factory (see cat. no. 84), 'shop windows
displayed Syntax hats, Syntax wigs and Syntax coats. A racehorse, too, was
called by the name of Doctor Syntax and was honoured by having its portrait
painted by James Ward, R.A. By 1822 his winnings in cups, plates and money
exceeded those of any other racer known' (Hardie, p. 168). The book's success
produced a host of sequels, parodies, imitations, and translations.

DISPLAYED: frontispiece and title page. The engraved title exploits the 'owls and
 ivy' aspect of the Picturesque described by Kenneth Clark in his chapter 'Ruins
 and Rococo' in *The Gothic Revival*, 1928, which has little to do with 'Italian'
 landscape influences but hints at the Gothic novel

79a Another copy (3rd edn), *Doctor Syntax sketching the lake*, facing p. 111. The climax
□43 of the tour was when Syntax, like Gilpin, reached Keswick and Derwentwater

80 *Le Don Quichotte romantique, ou voyage du Docteur Syntaxe, à la
recherche du pittoresque et du romantique.* Par M. Gandais

Paris: for the author, and Pélicier, 1821. Octavo
PLATES: 24 uncoloured lithographs, vignette title page; adapted by Malapeau
 from Rowlandson's originals
LITERATURE: Hardie, p. 168; Tooley, no. 426
□44 DISPLAYED: frontispiece and title page. Rowlandson's original vignette has been
 entirely changed by Malapeau to form the word 'pittoresque'

81 *Die Reise des Doktor Syntax um das Malerische aufzusuchen*

Berlin, 1822. Quarto

PLATES: 30 coloured lithographs, vignette title page; adapted by F. E. Rademacher from Rowlandson's originals
LITERATURE: Hardie, p. 168; Tooley, no. 426

Dr Syntax was also translated into Danish by K. L. Rahbek as *Doctor Syntaxes Reise efter det Maleriske*, Copenhagen, 1820, published curiously enough without illustrations

□45 DISPLAYED: frontispiece and title page. Rowlandson's original vignette has been entirely changed by Rademacher to form the word 'Malerische'

82 *The third tour of Doctor Syntax, in search of a wife: a poem*

London: R. Ackermann's Repository of Arts, 1820–1. Octavo
Issued in 8 monthly parts
PLATES: 24 coloured aquatints, vignette title page; from drawings by Rowlandson
LITERATURE: Abbey, *Life*, no. 267; Hardie, pp. 169, 312, 316; Prideaux, p. 332; Tooley, no. 429

The first tour of Doctor Syntax was followed in 1820 by the second tour, *In search of consolation*, and by the third in 1820–1. Subsequent tours such as *Doctor Syntax in Paris*, 1820, *The tour of Doctor Syntax through London*, 1820, and *The tour of Doctor Prosody in search of the Antique and Picturesque*, 1821, were Syntax imitations; that is to say, they were not the work of Combe and Rowlandson.

DISPLAYED: frontispiece and title page. The attractive titles with coloured aquatint vignettes are a feature of the Syntax series

Thomas Rowlandson

83 Dr Syntax drawing the waterfall at Ambleside, while his man Patrick is eating voraciously

Watercolour. 133 × 202 mm
EXHIBITED: Abbot Hall, Kendal, *The view finders*, 1980, no. 75

This is one of a group of drawings in the V. & A.'s Dyce bequest which Rowlandson prepared as illustrations for *The tour of Dr Syntax*, but it was one of several not reproduced in the book.

Lent by the Victoria and Albert Museum, London (Dyce 813)

84 Dr Syntax sketching

Porcelain figure covered with a clear glaze. Height 130 mm

Derby, either Stevenson and Hancock, 1863–6, or Sampson Hancock, after 1866. Modelled by Edward Keys

MARK: Crossed swords and dots, flanked by the letters 'S' and 'H' with above a crown and below a 'D'

COLLECTIONS: Glaisher bequest

One of a series of Derby figures of Dr Syntax attributed to Edward Keys by John Haslam in his *The old Derby china manufactory*, 1876, p. 180. Keys left Derby in 1826. The figure was still in production at the King Street factory in 1934 and was listed and illustrated in the 1934–5 catalogue, painted in enamel-colours.

Fitzwilliam Museum, C.3066–1928

Edward Birt

85 *Letters from a gentleman in the North of Scotland to his friend in London . . .* 2 vols.

London: printed for S. Birt, 1754. Octavo
PLATES: 7 etchings, by F. Garden and T. Jefferys
Bookplate of Macintosh, Chief of Clan Chattan

Captain Birt was a surveyor officer in the Hanoverian army in the Highlands in the 1730s. The letters are not dated, except for letter 26, dated '173–', 'relating to the Military Ways among the mountains, began in the year 1726'. Since the editor in a note to the reader (vol. 1, p. iii) explains that the letters came to his hand after a space of between twenty and thirty years, they must have been written between about 1724 and 1734.

Birt was 'one of the first Englishmen who caught a glimpse of the spots which now allure tourists from every part of the civilised world' (T. B. Macaulay, *The history of England*, IV (1914), p. 1584). In his descriptions of the mountains, Birt assumes the accepted Augustan attitude of the early eighteenth century, that they were hideous, barren wastes unaided by the hand of man. The disparaging epithets such as 'most horrid' and 'rude and offensive' have in this copy been heavily underscored by an irate Victorian reader and annotated with remarks like 'Mere ignorance'.

DISPLAYED: vol. 1, title page; vol. 2, pp. 14, 15. 'Now what do you think of a poetical Mountain, smooth and easy of Ascent, cloath'd with a verdant flowery turf, where shepherds tend their Flocks; sitting under the shade of tall Poplars, &c. In short, what do you think of *Richmond* Hill, where we have pass'd so many hours together, delighted with the beautiful Prospect.'

If this idyllic passage was actually written in the early 1730s and not altered by the editor, it must be one of the earliest descriptions of a prospect as a picture by Claude, about twenty years before John Brown's description of Keswick in his letter to Lord Lyttelton (cat. no. 1).

John Dalton 1709–1763

86 *A descriptive poem, addressed to two ladies, at their return from viewing the mines near Whitehaven . . .*

London: for J. and J. Rivington and R. and J. Dodsley, 1755. Quarto
LITERATURE: Manwaring, p. 110; Hussey, pp. 97–8; Nicholson, pp. 27–9

Written in 1753, the probable year of John Brown's visit to Keswick (see cat. no. 1) and the year after the publication of Bellers' engraving of Derwentwater (cat. no. 136), the poem is addressed to the Misses Lowther. Dalton contrasts the sylvan charms of their native Lowther with the family mines near Whitehaven. But

> If, grown familiar to the sight,
> Lowther itself should less delight,
> Then change the scene: To nature's pride,
> Sweet Keswick's vale, the muse will guide.

There follows a description of Keswick, Borrowdale and Skiddaw in picturesque clichés. Dalton shows himself to be sensitive to the Sublime:

> Horrors like these at first alarm,
> But soon with savage grandeur charm
> And raise to noblest thought the mind
> . . .
> I view with wonder and delight.
> A pleasing, tho' an awful sight . . .

DISPLAYED: pp. 20, 21

Thomas West c. 1720–1779

87 *A guide to the Lakes: dedicated to the lovers of landscape studies, and to all who have visited, or intend to visit the lakes in Cumberland, Westmorland and Lancashire.* By the author of the antiquities of Furness

London: for Richardson and Urquhart, and Kendal: W. Pennington, 1778. Octavo

LITERATURE: Manwaring, p. 194; Nicholson, pp. 63–6, 67; Upcott, p. 123

The earliest guide to picturesque mountain scenery. 'The design . . . is to encourage the taste of visiting the lakes, by furnishing the traveller with a Guide; and for that purpose are here collected and laid before him, all the select stations, and points of view noticed by those who have made the tour of the lakes' (pp. 2–3). These 'stations' are enumerated and described in the text. They are shown on Crosthwaite's *Plans of the Lakes* (cat. no. 89). West recommends the use of the landscape mirror (see cat. no. 96). He plans his tour so that 'the change of scenes is from what is pleasing, to what is surprising, from the delicate and elegant touches of CLAUDE to the noble scenes of POUSSIN, and, from these, to the stupendous romantic ideas of SALVATOR ROSA' (pp. 13–14).

The guide was republished in 1780, revised and enlarged by William Cockin, who added addenda which included Dr Brown's letter (cat. no. 1), an extract from Dr Dalton's poem (cat. no. 86), Mr Gray's journal and Mr Cumberland's *Ode to the sun* (Mrs Radcliffe's description of the scenery in a ride over Skiddaw was added to

48

the sixth edition, 1796), thereby forming an easily accessible anthology of picturesque writing about the Lakes. The guide, which reached an eleventh edition in 1821, was for half a century the most generally read work on the Lakes.

Lent by King's College, Cambridge (Bicknell Collection)

Peter Crosthwaite 1735–1805

88 *Proposals for publishing by subscription four most accurate plans, with ornaments, descriptions etc. of the grand lakes of Windermere, Ullswater, Derwent, and Pocklington's Island*

Handbill, 1 p. 230 × 140 mm
LITERATURE: J. Fisher Crosthwaite in *Trans. Cumberland Association for the Advancement of Literature and Science*, pt 3 (1877–8); Nicholson, pp. 107–9

Crosthwaite, born at Crosthwaite, near Keswick, after leading a seafaring life, returned to his native vale in 1779. There he directed his energies to exploiting, in a variety of ways, the craze for picturesque travel to the Lakes. In 1780 he opened a museum in Keswick, which became an important tourist attraction and survived until 1870. He is best remembered for his maps of the Lakes.

Lent by King's College, Cambridge (Bicknell Collection)

89 *Plans of the Lakes*

7 engraved folding maps, bound together. No title; no text
London: the author, various dates. Various sizes
LITERATURE: facsimile with introduction by William Rollinson, Newcastle upon Tyne, 1968

Lent by King's College, Cambridge (Bicknell Collection)
DISPLAYED: *An accurate map of the matchless Lake of Derwent, near Keswick, Cumberland with West's eight stations*, 1800. 'Surveyed etc. by P. Crosthwaite, Admiral at Keswick Regatta; who keeps the Museum at Keswick, & is Guide, Pilot, Geographer & Hydrographer to the Nobility and Gentry, who make the Tour of the Lakes.' Engraved by S. Neele. Published 10 June 1783 and republished with additions 1788, 1794, 1800, 1809, 1863.

An earlier version of this map, engraved by H. Ashby, was published in 1782.
The map shows West's stations (see cat. no. 87) numbered 1–8, with additional stations provided by the author. Crow Park, West's second station, the viewpoint for Smith's view of Derwentwater (cat. no. 137), is shown incorrectly as Station 1. The map displays much miscellaneous information of interest to tourists and seven small vignettes of buildings and natural objects

89a *Another copy*
Lent by King's College, Cambridge (Bicknell Collection)

DISPLAYED: *[Map of] Pocklington's Island*. 'Joseph Pocklington invenit et delineavit, 1783.' Engraved by H. Ashby. Published 16 June 1783; republished with additions 1788, 1799, 1800, 1809

Pocklington's Island, now known as Derwent Island, was purchased by the eccentric Mr Pocklington in 1781, who built on it a series of picturesque follies including a church, a Druid circle, a boathouse like a gothic chapel, a battery and a fort.

In the Keswick Regatta, August 1781, Peter Crosthwaite organised an elaborate sham naval battle, 'The Storming of Pocklington's Island'. (A description from the *Cumberland Pacquet*, 6 September 1782, is included as a note in the third and subsequent editions of West's *Guide*. In the Library of King's College (Bicknell Collection) there is a copy of the second edition of West's *Guide* with a manuscript marginal note of the complete battle order for the engagement as recounted to the writer by 'Admiral' Crosthwaite in 1783.)

James Plumptre 1770–1832

90 'A Narrative of a Pedestrian Journey through some parts of Yorkshire, Durham and Northumberland to the Highlands of Scotland and home by the Lakes and some parts of Wales in the summer of 1799'. 3 vols.

MS.
LITERATURE: Moir, *passim*

Plumptre recorded two other tours: 'A Journal of a Tour, through part of North Wales in the year 1792' (C.U.L. Add. MSS. 5802) and 'A Journal of a Tour to the Source of the River Cam made in July 1800 by Walter Blackett Trevilyan Esq. A.B. of St. John's College, and the Revd. James Plumptre A.M. Fellow of Clare Hall, Cambridge' (C.U.L. Add. MSS. 5819).

Plumptre covered 2,236 miles, of which 1,774¼ were on foot. He was away from Cambridge from 30 April to 14 September 1799. He reached Loch Rannoch and Inverary in the Highlands, and on the return journey spent twelve days in the Lake District, making the ascent of Skiddaw.

Lent by the Cambridge University Library (Add. MSS. 5814)

91 A list of travelling requisites

Written on both sides of a small sheet of paper, left loose in one of the volumes of the 'Pedestrian Journey'

Plumptre designed a suitable travelling costume for himself and his companion. His 'Knick-Knacks', as he called them, included a Gray's glass and a Claude Glass, both of which he records using with great effect during the descent from Skiddaw. Other requisites were two volumes of Cowper's poems, a drawing book, a compass

50

and a pedometer, a magnifier for botany, a telescope and a barometer. The clothes list included breeches with a special pocket for knife, fork and pedometer, and two nightcaps.

Lent by the Cambridge University Library (Add. MSS. 5814–5816)

92 *The Lakers. A comic opera in three acts. By J.P.*

London: Cadell and Davies, 1798. Octavo
LITERATURE: Moir, pp. 143–4; Nicholson, pp. 109–11

The Lakers, which was never performed, is a satire on the travellers to the Lakes. Miss Beccabunga Veronique, a keen botanist, sketcher and writer of Gothic romances, indulges in all the more extravagant affectations of the Picturesque. 'Give me my glasses,' she cries. 'Where's my Gray? Oh! Claude and Poussin are nothing. By the bye, where's my Claude Lorraine? I must throw a Gilpin tint over these magic scenes of beauty.'

As *The Lakers* was published in 1798, Plumptre must have visited the Lakes before the tour of 1799 (cat. no. 90).

Lent by Cambridge University Library (6.79.2³)

Charles Smith (mapseller)

93 *Smith's new and accurate map of the lakes, in the counties of Cumberland, Westmoreland, and Lancaster*

London: for C. Smith, July 1802. Sold by W. Pennington, Kendal
Folding coloured map, dissected and mounted on linen, in marbled paper slip case.
 600 × 485 mm; scale approx. $\frac{1}{2}$ inch = 1 mile
Previously published 1800

This was probably the earliest pocket map of the Lakes intended for tourists. It contains a list of inns which supply post horses and carriages.

Lent by King's College, Cambridge (Bicknell Collection)

Jonathan Otley 1766–1856

94 *The district of the Lakes.* By J. Otley, Keswick 1818. Second edition, 1823

Coloured folding map, mounted on linen, in marbled paper slip case. Engraved by
 J. and G. Menzies, Edinburgh. 320 × 265 mm; scale approx. $\frac{1}{4}$ inch = 1 mile
Graphic table of the heights of principal hills on the map. 'The tourist's guide',

'The Keswick guide', 'The Laker's guide', 'The mountain guide' printed and mounted on *verso*

LITERATURE: *A memoir of Jonathan Otley* by Dr D. Leitch, Derwent Bank, 1882; J. Upton Ward, 'Jonathan Otley, the geologist and guide', *Trans. Cumberland Association for the Advancement of Literature and Science*, pt 2 (1876–7)

Otley, born near Grasmere, settled at Keswick and became a watchmaker, surveyor and guide for tourists. He was an authority on local phenomena and fact. He accompanied John Dalton, the scientist (not the John Dalton of cat. no. 86), and Adam Sedgwick, much of whose work on the geology of the Lake District he anticipated.

'In 1817 I constructed a map of the district which I had engraven and published in 1818. It was chiefly sold folded for the pocket' (Otley in a letter to Thomas Sanderson of London, 1840).

In 1823 he published his *Concise description of the English Lakes*, which was the standard tourist's guide for many years (9th edn 1857).

Lent by King's College, Cambridge (Bicknell Collection)

Kirkwood and Son (Publisher)

95 Kirkwood & Son's travelling map of Scotland

Edinburgh, Perth and London, 1810
Coloured map, dissected and mounted on linen, in leather slip case. 693 × 560 mm
Various tables and information on map. Mounted on *verso*: table of distances and routes of Pennant, Garnett, Lettice and Campbell. These are traced with coloured lines on the map and refer to four books: Thomas Pennant, *A tour in Scotland*, 1769; T. Garnett, *Observations on a tour through the Highlands and part of the Western Isles of Scotland . . . 1800*; I. Lettice, *Letters on a tour through various parts of Scotland, in the year 1792*, 1794; Alexander Campbell, *A journey from Edinburgh through parts of North Britain*, 1802

The notes on the routes and the title on the slip case are dated 1812, the date of the issue of the map in this form.

96 A Claude Glass

Blackened glass in a velvet-lined leather case. 150 × 180 × 15 mm
COLLECTIONS: Wellcome Collection; Science Museum, London; on permanent loan to the Fitzwilliam, 1981
LITERATURE: Manwaring, pp. 182, 186, 194, 232; Hussey, pp. 48, 107; R. J. Gettens and G. L. Stout, *Painting materials*, 1943, pp. 286–7; J. Hagstrum, *The sister arts*, 1958, p. 141; Röthlisberger, *Paintings*, p. 41n; Kitson, *C.L.*, no. 185

The Claude Glass was a darkened convex mirror which was widely used by artists and travellers in search of the Picturesque. In it the selected view could be seen condensed, framed and lowered in tone. Gray in his journal of a tour of the Lake District in 1769 (West's *Guide*, 2nd edn, 1780) frequently refers to how 'the glass play'd its part'. He describes it as 'a plano-convex mirror, of about four inches diameter, on a black foil, and bound up like a pocket-book'. Gilpin seems to have carried different kinds of Claude Glass. They were 'combined of two or three different colours, and if the hues are well sorted, they give the object of nature a soft mellow tinge, like the colouring of that changing master'. The changing pictures he saw in his mirror when riding in a chaise were 'like visions of the imagination, or the brilliant landscapes of a dream. Forms and colours in brightest array, fleet before us; and if the transient glance of a good composition, happen to unite with them, we should give any price to fix and appropriate the scene.' West recommends the use of two glasses, one on dark foil for sunny days, and one on silver for cloudy weather.

Nothing illustrates better the vogue for seeing nature as a picture than the use of Claude Lorrain Glasses, which has much in common with using the viewfinder of a camera.

Fitzwilliam Museum, on permanent loan from the Science Museum, London

Thomas Rowlandson 1756–1827

97 *An artist travelling in Wales*

□46
II Coloured aquatint by H. Merke, 1799. Plate size 267 × 325 mm
Published by Ackermann, London
COLLECTIONS: bequeathed by Charles Brinsley Marlay, 1912
LITERATURE: British Museum, *Catalogue of political and personal satires preserved in the Department of Prints and Drawings in the British Museum*, 11 vols., 1870–1954, VII, no. 9445, p. 584

Rowlandson made a tour of Wales in 1797 with Henry Wigstead (see cat. no. 140). There may well be an element of personal reminiscence in this comment on the trials of the touring picturesque artist.

Fitzwilliam Museum (34.14.301)

Philippe Jacques de Loutherbourg 1740–1812

98 *Skiddaw: in Cumberland a summer's sunset*

'From the original picture in the possession of Mr R. P. Jones. Engraving, by Thomas Morris (pupil of the late Mr Woollett) & W. Thomas'

London: Colnaghi and Richard Price Jones, 1787. Plate size 408 × 590 mm
Republished 1789
LITERATURE: Joppien, no. 34

A reference to '[William] Hutchinson's *Tour to the Lakes in 1773 & 1774*' and a description of Skiddaw are engraved on the plate in English and French: 'But Here! where nature has so lavishly distributed Her Sportive Excellencies is one Constant Scene of Boundless beauty and must afford a luxurious feast to the Contemplative mind from that Awful Grandeur which every way surrounds it.'

Although Skiddaw is not, as suggested by de Loutherbourg, the highest mountain in Great Britain, it was the only one of the higher summits in the Lake District which could easily be ascended on a pony. Most of the more enterprising 'Lakers' made the ascent. Mrs Radcliffe in *Description of the scenery in a ride over Skiddaw, 1794*, 1795 (and West's *Guide*, 6th edn, addenda, XI, pp. 305–11) paints pictures as sublime in their picturesque imagination as passages in *The mysteries of Udolpho*. On the summit of Skiddaw, which de Loutherbourg described as 'a barren Plain covered with loose slate', Mrs Radcliffe found that she 'stood on a pinnacle, commanding the whole dome of the sky'.

De Loutherbourg's picture shows a coach approaching the mountain (probably on the road to Keswick) with a sense of agitated movement which at once suggests the drama of the hazards of travel in search of the Picturesque. The composition is both held together and augmented by the strong spiral of the grotesquely rough road. It is similar to the spiral lanes of Gainsborough, who it is thought may have been accompanied by de Loutherbourg when he visited the Lakes in 1783.

Lent by the Trustees of the British Museum (1871-8-12-2428)

J.B.E.

99 'Notes of a tour to the Lakes in the summer of 1828 . . . by J.B.E.'

MS. journal of a tour from Aldershot to the Lakes in a calf-bound notebook; pen and ink drawings in the MS.

The route is marked on maps bound in, one of which is Otley's *The district of the Lakes*, 1818 (cat. no. 94)

Lent by King's College, Cambridge (Bicknell Collection)
DISPLAYED: Monday 21 July, Lowood to Grasmere, drawing of 'Scene from Low Wood. N.W. end of Windermere', with key to the principal mountains (see cat. no. 100a)

100 Picturesque writing paper: a selection of pictorial letter headings

Steel engravings

100a *Windermere Lake, from Low Wood Inn*
Engraved by A. W. Graham from a drawing by T. Allom

54

100b *Derwent Water, from Castle Head, Cumberland*
Engraved by S. Lacey from a drawing by T. Allom

100c *Dungeon Gill, Westmorland*
Engraved by W. Tombleson from a drawing by T. Allom

100d *Bolsover Castle Derbyshire*
J. and F. Harwood, 14 May 1841

100e *Snowdon and the Lake of Llanberis*
J. and F. Harwood, 6 July 1841

100f *Matlock High Tor*
J. Harwood, 7 January 1848

100g *The summit of Snowdon from the Llanberris ascent*
Published by H. Humphreys, Caernarvon

100h *Summit of Snowdon, Caernarvonshire*
Engraved and published by Newman and Co.

100i *The High Tor, Matlock*
Engraved by Newman and Co., May 1871

100j *Head of Windermere Lake looking towards Brathay*
W. Banks and Sons. Published by J. Garnett, Windermere

Examples a, b and c were originally plates in Rose's *Westmorland, Cumberland . . .* 1832 (cat. no. 157). The other engravings were first published as illustrations to various guide-books and in small volumes of views. Although the second Newman engraving is dated 1871, thirty-nine years later than the Allom prints, the style is still the same. In the second half of the nineteenth century, printers like Garnett of Windermere published a wide variety of maps, views, guides, other books, and stationery of picturesque interest for sale to tourists. Reproductions of some of these prints are still used for postcards.

James Bourne 1773–1854

101 Beeston Castle, Cheshire

□57 Watercolour over faint traces of pencil with highlights scratched in the paper, laid down. 238 × 334 mm

Inscribed, *verso*, in Holliday's hand, 'Beeston Castle / Cheshire / J. Bourne / 41 Margaret Street, Cavendish Square'

COLLECTIONS: J. R. Holliday, by whom bequeathed, 1927

EXHIBITED: Usher Art Gallery, Lincoln, *James Bourne*, 1958, no. 43

In 1808 Bourne showed two views entitled *Near Beeston Cheshire* at the R.A. This may be one of them.

Bourne published in about 1796 *Interesting views of the lakes of Cumberland, Westmoreland and Lancashire* illustrated with twelve actual watercolours. There are copies in the British Museum, the Armitt Library, Ambleside, and the Wordsworth Library, Grasmere. Few other copies exist.

Fitzwilliam Museum, no. 1218

John Constable 1776–1837

102 The Vale of Newlands: very stormy afternoon, 1806, 21 or 22 September

□51 Grey wash over pencil. 156 × 239 mm

Verso: pencil, 2 sketches – one of the lakes, one of trees encircled

Inscribed, *verso*, in pencil, in Constable's hand, 'Sunday 22 Sept 1806 – Vale of Newlands / very stormy afternoon / Sunday.' and in brown ink, in David Lucas' hand, 'by John Constable R.A. had / from his son Alfred Constable / David Lucas.'

COLLECTIONS: Alfred Constable: David Lucas; H. S. Theobald sale, Christie's, 25–30 April 1910 (lot 1096); John Charrington, by whom given, May 1910

EXHIBITED: Arts Council of Great Britain tour, 1976

LITERATURE: R. B. Beckett, *John Constable's correspondence*, 1962–8, v, p. 4; Ian Fleming-Williams, *Constable landscape watercolours and drawings*, 1976, p. 34, fig. 24; Reg Gadney, *John Constable: a catalogue of drawings and watercolours in the Fitzwilliam Museum, Cambridge*, 1976, no. 5

Beckett pointed out the uncertainty about Constable's inscription 'Sunday 22

Sept.', for 22 September 1806 was not a Sunday but a Monday (letter from R. B. Beckett to J. Goodison, 24 June 1954 – Fitzwilliam Museum files).

Beckett (*op. cit.*) refers to this drawing as follows: 'The next few days (after 21 September 1806) were probably spent in Keswick, with excursions in the vicinity when the weather was fine enough. A drawing of the Vale of Newlands in grey wash is somewhat uncertainly dated the 22nd September, which is described as another stormy day. This view seems to have been taken from a spot not far from that part of the lower slopes of Cat Bells where Constable must have sat to note down the view over Derwentwater which he later used for a finished painting.' This picture, now in the National Gallery of Victoria, Melbourne, Australia (Felton Bequest, 1926), has had its attribution doubted by Robert Hoozee.

Fitzwilliam Museum, no. 3310

103 Windermere, 1806

□49 Watercolour over pencil with highlights created by sparing the paper, laid down. 203 × 379 mm

COLLECTIONS: Isabel Constable sale, Christie's, 1892 (possibly lot 190), as *A lake scene*, bought by Shepherd Bros. (£1.5s.0d.); bought from them in 1894 by T. W. Bacon, by whom given, 1950

EXHIBITED: Arts Council of Great Britain tour, 1976

LITERATURE: Tate Gallery catalogue *Constable: paintings, watercolours and drawings*, 1976, p. 63, no. 69; Gadney, *op. cit.*, no. 4

In September and October of 1806 Constable was persuaded by his maternal uncle, David Pike Watts, to visit the Lake District, where he stayed for nearly two months. He visited Langdale, Windermere, Thirlmere, Derwentwater and Borrowdale, making some seventy drawings and watercolours, twenty-three of which are in the V. & A. (Graham Reynolds, *Catalogue of the Constable collection in the Victoria and Albert Museum*, 2nd edn, 1973, nos. 72[1]–94). Many of these have notes on the back, such as 'Stormy Day – Noon'; 'evening – stormy with slight rain'; 'Noon Clouds breaking away after Rain'; 'twilight after a very fine day'. On the back of *Sketch at Borrowdale* (V. & A. 192.1888) he has written '25 Sep.[r] 1806 – Borrowdale – fine clouday day tome [to me?] very mellow like – the mildest of Gaspar [?] Poussin and Sir G[eorge] B[eaumont] & on the whole deeper toned than / this drawing –'

Constable departed from the well-worn tracks of the picturesque travellers, climbing to such remote places as Esk Hause and the top of Dale Head (V. & A. 184.1888). In his sketches he also departed from the conventions of picturesque topography, recording the mountains and the weather as he saw them at the particular moment.

He never returned to the Lake District; indeed, his only other visit to North Country scenery had been to Derbyshire in 1801. Leslie reports that he had heard Constable say that 'the solitude of mountains oppressed his spirits' (Leslie, p. 25).

Fitzwilliam Museum, P.D.77–1950

104 Landscape with mountains

Watercolour over black chalk with highlights created by scratching the paper.
165 × 250 mm
COLLECTIONS: G. Robinson; J. R. Holliday, by whom bequeathed
LITERATURE: *English landscape painting*, 1903 (special publication of *The Studio*), pl. DC23 (there called *Welsh mountains*)
EXHIBITED: Fitzwilliam Museum, 1927

Cox's early work was greatly influenced by his master John Varley, and much of his own work for pupils and drawing books is very similar to Varley's. However, he developed a freedom of style and of technique in later drawings which is beautifully demonstrated in this watercolour of mountains. He was particularly fond of the mountainous scenery of North Wales, which inspired some of his best work.

Fitzwilliam Museum, no. 1272

John Robert Cozens 1752–1797

105 The valley of Ober-Hasli on the Aar

□62 Pen, black ink, blue-grey and grey wash on paper, laid down. 243 × 180 mm
COLLECTIONS: Richard Payne Knight; ? John Towneley, sale, 1–15 May 1816; the Hon. R. Allanson-Winn; Malcolm Laing; 'property of a lady', sale, Sotheby's 10 May 1950 (lot 75 (repr.)); Agnew, from whom bought from the Fairhaven fund, 1953
LITERATURE: C. F. Bell, 'Sketches and drawings of J. R. Cozens', *Walpole Society*, 1947, p. 6, no. 28 A1; Oppé, pp. 127–9

One of a number of views in the Ober-Hasli valley, Switzerland, three of which are in the British Museum, purchased in 1900 from Allanson-Winn. The twenty-four drawings of Swiss scenery now in the British Museum, together with this drawing and over thirty others, now widely dispersed, appear to have come from an album inscribed 'Views of Swisserland, a present from R. P. Knight and taken by the late Mr. Cozens under his inspection during a tour in Swisserland in 1776'. They may have been drawn on the occasion of Cozens' visit to Switzerland, August–September 1776, although the uniformity of their execution has led both Bell and Oppé to suggest that they were drawn, not on the spot, but in the studio, presumably worked up from sketches actually made *in situ*.

It would be difficult to justify Constable's saying that 'Cozens is all poetry' by means of this modest near-monochrome drawing, which has little of the poetic quality of Cozens' better-known full-scale watercolours. Very few of his landscapes are of English subjects, but in this view of a dramatic Swiss gorge he evokes the romantic sublime, which artists saw in Gordale Scar; indeed the

composition of the precipices is very like that of many views of Gordale (compare cat. no. 132).

Fitzwilliam Museum, P.D.27–1953

Henry Gastineau 1791–1876

106 Landscape with a church and a castle

☐54 Watercolour with highlights created by scratching in the paper, laid down; the upper left and lower right corners are replacements. 209 × 208 mm
COLLECTIONS: Percy Johnson, by whom given, 1922

Gastineau made large numbers of highly competent drawings for topographical publications. He excelled in depicting wild and romantic scenery, as can be seen in Jones's *Wales illustrated, c.* 1831, and the Halls' *Hibernia Illustrata* (cat. no. 158).

This is a 'copy-book' Claude–Gilpin composition; only the group of two cows departs from Gilpin's principle that it requires three to make a picturesque group, a maxim which was fully appreciated by Jane Austen, whose Elizabeth Bennet observed, 'You are charmingly grouped and appear to uncommon advantage. The picturesque would be spoilt by admitting a fourth.'

Fitzwilliam Museum, no. 1065

Julius Caesar Ibbetson 1759–1817

107 Ullswater from the foot of Gowbarrow Fell

☐52 Oil on canvas. 58.4 × 88.6 cm
Signed, inscribed and dated, l.r., 'J. Ibbetson of Masham Sept. 1808'; inscribed on *verso* of canvas, in paint, 'Ullswater Cumberland taken from Gowbarrow looking up the Lake painted by Julius C. Ibbetson Masham Yorks'
COLLECTIONS: Mary, Marchioness of Thomond; F. D. Reynolds (of Dublin), his posthumous sale, Christie's, 15 July 1893 (lot 23), bought by Vokins; bequeathed by Charles Brinsley Marlay, 1912
LITERATURE: Rotha Mary Clay, *Julius Caesar Ibbetson 1759–1817*, 1948; Williams, pp. 188–90; Hardie, *Water-colour*, I, pp. 151–4; Constable, *Marlay*, p. 40, no. 50; Goodison, p. 128, pl. 27; *Burke*, p. 389

Ibbetson, born at Masham, Yorkshire, settled, about 1800, in the Lake District, where he lived for at least five years, in Ambleside and then Troutbeck. He was befriended by Sir George and Lady Beaumont. 'His range covered topographical landscape, genre, balloon ascents and caricature' (Burke, p. 389); and a large number of his works are of mountainous scenes in the Lake District and Wales. There are several versions of this view of Ullswater, which seems to have been one

of his favourites. He frequently included groups of figures and animals in his landscapes, often Morlandish in character, and of considerable interest as studies of costume and rural activities. Benjamin West referred to him as 'the Berghem of England'.

There is a great superficial similarity between the works of Ibbetson and de Loutherbourg (Grant, I, pp. 109–10).

Fitzwilliam Museum, M.50

John Laporte 1761–1839

108 View of a ferry, Keswick Lake

□55 Bodycolour. 374 × 526 mm
Signed, l.r., 'J. Laporte'
COLLECTIONS: Major Henry Broughton, 2nd Lord Fairhaven; bought from his executors from the Fairhaven fund

Although Laporte did much topographical work, most of his exhibited drawings (like this one), though of named places, are primarily pictorial in intention. He was an active drawing master, at one time giving lessons to Dr Thomas Monro, and published a book of instructions, *The progress of a water-coloured drawing* (cat. no. 179).

Fitzwilliam Museum, PD.5–1975

Frederick Christian Lewis 1779–1856

109 The Thames from Richmond Hill

Watercolour and bodycolour over black chalk outline. 216 × 274 mm
Inscribed, *verso*, 'F. C. Lewis. From Richmond Hill'
COLLECTIONS: Charles Ricketts, R.A., and Charles Haslewood Shannon, R.A., by whom bequeathed, 1937

Lewis was primarily a topographical artist and an accomplished and prolific engraver (see cat. nos. 57, 60, 153). He was the father of John Frederick Lewis (1805–76), best known for his pictures of the Near East.

Fitzwilliam Museum, no. 2108

Alexander Naysmith 1758–1840

110 Loch Doon, Ayrshire

□53 Oil on canvas. 45.2 × 61.0 cm

COLLECTIONS: James Harrison; his sale, Christie's, 6 April 1973 (lot 129), bought Perman; bought from Agnew from the Fairhaven fund, 1974
EXHIBITED: Hazlitt, Gooden and Fox, London, *Landscapes from the Fitzwilliam*, 1974, no. 38
LITERATURE: Christie's sale catalogue (see above); Hazlitt, pl. 16

Naysmith exhibited landscape paintings from 1807, the great majority of which were of Scottish subjects and frequently of wild and mountainous scenes in the Highlands. Here the mountains are suffused with the mellow glow of Claude's Arcadia.

Fitzwilliam Museum, PD.2–1974

Patrick Naysmith 1787–1831

111 View of Loch Lomond

Bodycolour. 409 × 530 mm (oval)
COLLECTIONS: Major Henry Broughton, 2nd Lord Fairhaven; bought from his executors from the Fairhaven fund, 1975

Fitzwilliam Museum, PD.1–1975

William Payne exhibited 1776–1830

112 Landscape with a waterfall

42 Watercolour with traces of black chalk. 470 × 323 mm
I COLLECTIONS: Colnaghi, from whom bought from the Biffen fund, 1958

Payne, the inventor of Payne's Grey, was a prolific watercolourist and active drawing master. His scenes are almost always idealised, and literal topographical drawings are rare. This one shows the characteristics of his best work. It conveys a splendid feeling of dashing movement, as the leader of the party comes in perilously close contact with the forces of nature while crossing the cataract on one of Payne's precarious rustic bridges. The skill of his brushwork (without the help of pen or pencil) is demonstrated by the vigorous brush strokes in the foreground, which gradually become more delicate as they recede into the distance.

Fitzwilliam Museum, PD.57–1958

113 Mountain landscape

Watercolour, brush and black ink with highlights created by scratching in the
 paper. 157 × 226 mm
COLLECTIONS: Alfred A. de Pass, by whom given, 1933, in memory of his son
 Crispin of Trinity Hall, Cambridge, who fell in the Great War in 1918
Fitzwilliam Museum, no. 1665

114 Lake scene

□56 Watercolour, brush and brown ink over black chalk on card. 186 × 273 mm
COLLECTIONS: as cat. no. 113
Fitzwilliam Museum, no. 1663

These two attractive drawings came to the Museum with an attribution to John
Baverstock Knight (1785–1859). Iolo Williams first suggested that they might be
by Robertson.
 A drawing in the British Museum (BM. 1943.11.13.113) and a group of drawings
in the Victoria and Albert Museum by Robertson (see Hardie, *Water-colour*, III,
p. 165, pl. 194; Williams, p. 221, pls. 352, 353) are clearly by the same hand as the
Fitzwilliam drawings and quite unlike those generally attributed to Baverstock
Knight, whose style is related to the styles of Towne and White Abbott.
 There is considerable confusion over Robertson. Williams refers to him as 'J.
Robertson (exhibiting 1815–1836) who is said to have been a drunken drawing
master', whose drawings 'often bear the forged signature of David Cox'. His
drawings have also been attributed to R. R. Reinagle and to William Glover.
 Robertson's finished drawings are rarely strictly topographical, though they
are based on topographical sketches (there are two albums in the British Museum
containing about two hundred watercolour sketches which are studies of English,
Italian or Swiss scenery) and, like these two, are composed on generally Gilpin–
Claudian lines (note the round tower from the *Liber Veritatis*). All his drawings
'have an air of swagger, but they are the work of a man who, with limitations in
imaginative power, had sure command of pen and brush, a sound knowledge of
Nature and a firm grasp of the essential qualities of design' (Hardie, *Water-colour*,
III, p. 165).

Thomas Rowlandson 1756–1827

115 A landscape with a river, ruins on a hillside

□47 Pen and ink and watercolour, laid down on a blue-washed mount. 157 × 224 mm
III COLLECTIONS: H. Gregg; his daughter Mrs T. Glover Kensit; by family descent
 to C. K. Norman, by whom given, 1935

Amongst Rowlandson's numerous watercolour drawings there are many which are pure landscape such as those made on his Welsh tour in 1797. His characteristic line is always in itself picturesque, and in this particular drawing with trees that lean towards the centre of the picture and a highly picturesque ruin on the rock, he seems to be satirising Gilpin.

Fitzwilliam Museum, no. 1740

Paul Sandby 1725–1809

116 A view of Old Shrewsbury Bridge

☐60 Bodycolour, watercolour and black ink over traces of black chalk. 625×467 mm
VI COLLECTIONS: Major Henry Broughton, 2nd Lord Fairhaven, from whose
executors purchased from the Fairhaven fund, 1976

This splendid exhibition piece is on a scale and of a grandeur which is quite different from most of Sandby's topographical drawings. It is worked up to a finish unlike his modest watercolour drawings (see cat. nos. 50, 51, 52); the character and composition are far more Dutch than Claudian, as witness the tree with its gnarled roots, which follows the precept of Uvedale Price that it is 'not the smooth young beech, nor the fresh and tender ash, but the rugged old oak, or knotty wych elm that are picturesque; nor is it necessary they should be of great bulk; it is sufficient if they are rough, mossy, with a character of age, and with sudden variations in their form' (*Essays on the Picturesque*); and the figures suggest the romantic world of hermits and penitents, giving the drawing a Salvatorian air which is rare in Sandby's work. The careful delineation of the architecture of the bridge is comparable with Sandby's drawings of Windsor Castle.

Fitzwilliam Museum, PD.8–1976

Thomas Sunderland 1744–1823

117 Muncaster Castle, Cumberland

☐50 Pen and brown ink, blue, grey and brown wash. 235×310 mm
COLLECTIONS: sold Sotheby's, 5 May 1948, as part of 6 portfolios of drawings of
country houses and castles by Sunderland; bought from Agnew, 1950

The washes, which are graded from pale blue in the sky to dark brownish-grey in the foreground, are characteristic of Sunderland, who rarely used strong colour in his drawings. His tones are not unlike those of J. R. Cozens.

The atmospheric effect of soft light in the middle distance diffused through clouds is achieved by the grading of the washes and by the contrast between the silhouetted tower and the distant view.

118 Lough Rigg, Ambleside

Watercolour, pen and ink on paper laid down on card. 156 × 237 mm
Inscribed, l.l., 'No. 5. F.Towne / 1786'. Inscribed, on *verso* of card, in the artist's
hand, 'No. 5 / Loff Rigg near Ambleside Westmoreland / drawn on the spot by /
Francis Towne / 1786 / morning light from the right hand'
COLLECTIONS: Merivale (part of a sketch-book); with Agnew, from whom
bought by the Friends of the Fitzwilliam 1921

The two peaks which appear in the distance are the Langdale Pikes (see cat. no.
37). Nature has been 'cooked' by Towne to introduce them where he wanted them
in his composition.

Fitzwilliam Museum, no. 1051

119 Raven Cragg with part of Thirlmere

□58 Watercolour, pen and ink on paper laid down on card. 157 × 236 mm
IV Inscribed, l.c., 'No.31.F.Towne / delt.1786.' Inscribed, on *verso* of card, in the
artist's hand, 'Light from the left hand / 12 o clock / No.31 / Raven Cragg with
part of Thirlmere Lake / in the Vale of St. John in Cumberland / Drawn by
Francis Towne / August 17th 1786 / London / Leicester Square / 1786 [?]'
COLLECTIONS: Merivale (part of a sketch-book); with Agnew, from whom
bought, 1921
Fitzwilliam Museum, no. 1052

Two further drawings of the Vale of St John are known, one exhibited at Agnew's,
1973, no. 16, inscribed, 'No.30 Cumberland. In the Vale of St. John by the side of
the Lake of Wyburn. Light from the right hand ½ past 10 o'clock – August 17
1786.F. Towne'; the other, also dated 17 August 1786 and numbered 34, drawn at
3 o'clock, is in the Museum of Art, Rhode Island School of Design, Providence,
R.I.

Towne toured the mountains on three occasions: Wales in 1777, the Alps on his
return from Italy in 1781 and the English Lakes in 1786. He was fascinated by the
bare structure of mountain form, which inspired much of his best work, notably
the drawings of the source of the Arveiron in the valley of Chamonix (the most
striking of these in the Oppé collection is illustrated in colour as the frontispiece of
Laurence Binyon's *English water-colours*). *Raven Crag* and *Lough Rigg* (cat. no.
118) are characteristic of his Lake District drawings. The anatomy of rock and
mountain is lovingly constructed with delicate outline in brown ink washed over
with cool, translucent watercolour. Although Towne's drawings are never exact
records of the natural scene, he employed none of the conventions of picturesque
composition. The light that falls on his hills is not the light of nature, but the light
which he required for the construction of his pictures. Though his drawings are
closely related technically to those of the picturesque topographers working in
line and wash, the result is completely different and very personal.

64

120 Hardraw Fall

□59
V

Watercolour over traces of pencil outline, with highlights created by scratching in the paper. 292 × 415 mm

COLLECTIONS: William Quitter; sold Christie's, 18 May 1889 (lot 95), bought by Vokins; E. Steinkopf, sold Christie's, 24 May 1935 (lot 55), bought by Fine Art Society, who sold it to Sir Jeremiah Colman, 1935; his sale, Christie's, 25 March 1935 (lot 12), bought by Fine Art Society, who sold it to J. E. Bullard, 1955, by whom bequeathed, 1961

EXHIBITED: R.A., 1889, no. 16 in Turner section; Fitzwilliam Museum, *Turner*, 1975, no. 17; City of York Art Gallery, *Turner in Yorkshire*, 7 June–20 July 1980

LITERATURE: Sir Walter Armstrong, *Turner*, 1902, II, p. 256; W. G. Rawlinson, *The engraved work of J. M. W. Turner, R.A.*, 1908–13, I, p. 102, no. 182; M. Cormack, *J. M. W. Turner, R.A.: a catalogue of drawings and watercolours in the Fitzwilliam Museum, Cambridge*, 1975, no. 17; A. Wilton, 'Turner at the Fitzwilliam Museum', *Master Drawings*, 14, no. 3 (1976), pp. 302–6; *idem, The life and work of J. M. W. Turner*, 1979, no. 574

ENGRAVED: S. Merriman and J. Pye, 1818, in Whittaker, *History of Richmondshire*, 1819–23, I, p. 413

One of a series of 20 watercolour views which were engraved to illustrate the *History of Richmondshire* by the Rev. Dr T. D. Whittaker, the antiquarian and topographer, and published by Longman's between 1819 and 1823. Turner received the commission in 1816, originally for a larger series of at least 120 to cover the whole of Yorkshire. A committee was chosen to select views, and after he had executed the 20 finished watercolours between 1816 and 1818 at a fee of 25 gns. each, the large project was abandoned, having proved too costly (the engravers were paid between 60 and 80 gns. for each plate). Some drawings were later used in *Picturesque views in England and Wales*, begun by Heath in 1827. The group marks a high point in Turner's early career and contains some of his finest work for illustration.

Preliminary pencil drawings are in the 'Yorkshire 5' sketch-book in the British Museum, pp. 15 and 28a. Both of these were first identified as of Hardraw Fall or Force by C. F. Bell. Hardraw (or Hardrow) Force is near Hardraw itself, one mile north of Hawes on a stream which runs into the river Ure.

Fitzwilliam Museum, PD.227–1961

John Varley 1778–1842

121 View from a doorway of Warkworth Castle, looking down the river
□48 Coquet towards the Hermitage

Watercolour over traces of black chalk. 354 × 288 mm

Signed, l.l., 'J. Varley' and dated '1825'

COLLECTIONS: Arthur W. Young, M.A., Trinity College, by whom bequeathed, 1936

EXHIBITED: Hackney Library, London, *John Varley: a bicentenary exhibition*, 18 Aug.–8 Oct. 1978, no. 27

Varley was one of the most skilful and prolific members of the English watercolour school. As he constantly produced large numbers of drawings for pupils and for immediate sale to pay his debts, the standard of much of his work is far below that of his better landscapes. Between 1799 and 1802 he made two or more visits to North Wales, where the mountains made a considerable impression and remained a fruitful source of inspiration for the rest of his career. In 1803, on his last tour in search of the Picturesque, he visited Yorkshire and Northumberland. It was probably on this tour that he made sketches of Warkworth Castle.

In this drawing he combines two of the principal aspects of the Picturesque – ruins and landscape; and by framing the prospect of the river Coquet in the window of the ruined castle he emphasises that the prospect is a picture.

Fitzwilliam Museum, no. 1791

122 Landscape with a lake

□36 Watercolour with highlights created by scratching in the paper. 285 × 460 mm
Signed and dated, l.c., 'J. Varley 1816'. Inscribed, *verso*, 'view on the Modego Spain / by J. Varley 1816 / from a sketch by Major Dumerery'
COLLECTIONS: Alfred W. Rich, by whom given, 1918

Professional artists were often called upon to improve an amateur sketch made upon the spot. Varley was evidently as ready to work up someone else's sketch of a scene with which he was not himself familiar as he was to create a landscape from his own stock in trade. The result differs little from his own idealised views of Welsh and other scenes; indeed the drawing is extremely like the *Mountain landscape* (cat. no. 61) exhibited as an example of Varley's Claudian formula.

Fitzwilliam Museum, no. 929

123 View from the top of Cader Idris

□75 Pen, ink and watercolour. Sight size 175 × 253 mm
Inscribed by Varley and signed, *verso*, 'View from the Top of Cader I[d]ris / J Varley'

This view from the summit of a mountain with the horizon so close to the top of the picture is utterly uncharacteristic of Varley or indeed of any artist of the period. It appears to be direct observation of nature (like Constable's views of the Lake District), in which case Varley must have climbed the mountain. (Wilson's paintings of Llyn y Cau (see cat. no. 23) indicate that he probably also made the ascent.) His *Sunrise from the top of Snowdon*, which Paul Oppé lent to the British exhibition at the R.A. in 1934, is evidence that Varley probably also made the

ascent of that much more generally visited peak. In both cases the scene inspired a drawing which departs completely from his usual picturesque arrangements of elements. The bleak and forbidding surface of the mountain in the foreground is portrayed with brown pen outline and rich, dark washes which are reminiscent of Girtin, whom he would have met at Dr Munro's.

124 Chelsea, 1824

□89 Watercolour over traces of black chalk. 184 × 275 mm
Signed and dated, l.l. 'J. Varley, 1824'
COLLECTIONS: F. H. H. Guillemard, M.D., Gonville and Caius College, Cambridge, by whom bequeathed, 1933

This is a highly finished watercolour of the type that was prepared for reproduction in drawing books, and as such it is very like some of the drawings of Varley's pupil David Cox. It has none of the summary quality of many of Varley's drawings.

Fitzwilliam Museum, no. 1719

Cornelius Varley 1781–1873

125 Studies of Welsh mountains

Watercolour. 377 × 262 mm
Inscribed in pencil, l.l., in the artist's hand, 'Snowdon Llanllyne', and in another hand, 'C. Varley'
Verso: watercolour, *Study of Snowdon*, inscribed in pencil, l.r., in the artist's hand, 'Snowdon'
COLLECTIONS: Sir Frank Brangwyn, R.A., by whom given, 1943

Cornelius Varley was far less prolific than his elder brother John. Although his work never reaches the heights of John's best watercolours, it is never as summary nor as inhibited by the conventions of Claudian picture-making as a great many of his brother's run-of-the-mill drawings. The Welsh mountains were a favourite subject, and these two sketches show his freedom from picturesque convention and his confident use of broad, fresh watercolour washes.

Fitzwilliam Museum, no. 3237

The Sublime

Philippe Jacques de Loutherbourg 1740–1812

126 *Halte de guerriers*

Line engraving with etching by Christian de Mechel, 1778. Plate size $519 \times$ 592 mm. No publisher's imprint

Salvator Rosa's work was the source for all eighteenth-century artists interested in the subject of *banditti* – a subject which particularly appealed to de Loutherbourg. Between 1763 and 1766 he produced a series of engravings of soldier *banditti* based on Rosa's series of *60 piccole stampe di varia misura e soggetti*. De Loutherbourg like Salvator had a gusto for mountain landscape, rocky and treacherous, remote from all human contacts and therefore appropriate for the habitation of *banditti*.

This is a type of Salvatorian scene which was also dramatically portrayed by Vernet. In the words of Joseph Burke, 'The crucial link between Vernet and the grand manner was Philippe Jacques de Loutherbourg, the father of Drury Lane picturesque.' He also writes that Diderot described de Loutherbourg as 'an accomplished imitator of Berchem, Wouverman, and Vernet' (Burke, pp. 382, 384).

De Loutherbourg had close associations with the theatre. Within two years of his arrival in England in 1771, Garrick appointed him principal stage and scenery designer at Drury Lane. He was a master of dramatic effects and scored a great success in 1781 with the production of his Eidophusikon, a miniature stage in which scenes such as *Satan arraying his Troops on the Banks of the Fiery Lake, with the raising of the Palace of Pandemonium; from Milton* were produced. (See Austin Dobson, *At Prior Park and other papers*, 1912, app. B, 'Exhibitions of the Eidophusikon'; and W. T. Whitby, *Artists and their friends in England*, I, p. 353, II, pp. 352–3.)

Fitzwilliam Museum, 33.A.6.149

127 *The romantic and picturesque scenery of England and Wales*

London: Robert Bowyer, 1805. Folio
Title and text in English and French
PLATES: 18 coloured aquatints, engraved by W. Pickett (see cat. no. 181) and coloured by John Clark (see cat. nos. 171–3, 175) from drawings by de Loutherbourg. Imprints 1805–6
LITERATURE: Prideaux, p. 343; Williams, p. 185; Burke, p. 385; Abbey, no. 9; Tooley, nos. 305, 306; Upcott, p. xxxiv

This is the first time the word 'romantic' appears together with 'picturesque' in the title of a book. In view of de Loutherbourg's love of theatrical drama, it is not

68

surprising to find that there is a dash of 'Drury Lane picturesque' in most of the plates. This is very evident in the three exhibited. Six of the eighteen are of wild mountainous scenes in the Lakes and North Wales.

Fitzwilliam Museum

□73 DISPLAYED: pl. 15, *Snowdon*, facing a page of text. The same view of Snowdon from Llyn Nantlle as that painted by Richard Wilson (see cat. no. 22). Wilson depicts it as a scene of Arcadian tranquillity, rearranged to conform with the Claudian formula, whereas de Loutherbourg has taken equal liberties with nature to produce a wild and stormy Salvatorian scene

127a Another copy, pl. 11, *Ironworks, Colebrook Dale*, facing a page of text

□69 De Loutherbourg, visiting Coalbrookdale in 1800, was immediately attracted by the sublime character of the industrial scene and made a number of quick pen and ink sketches on cardboard, from which he subsequently painted several pictures. The most splendid of these is *Coalbrookdale by night*, 1801, in the Science Museum, South Kensington (repr. Joppien, no. 52).

De Loutherbourg, the lurid colouring of the print dramatically evokes the satanic character of the scene, which today has become a popular open-air museum of industrial archaeology.

128 Cataract on the Llugwy near Conway

Watercolour. 222 × 311 mm
Framed with pl. 17 of *Romantic and picturesque scenery*; same title as drawing
LITERATURE: Williams, p. 185, pl. 284; Hardie, *Water-colour*, I, pl. 69
EXHIBITED: Kenwood, *Philippe Jacques de Loutherbourg 1740–1812*, 1973, no. 34

The drawing was almost certainly de Loutherbourg's model for the plate. The juxtaposition of drawing and print demonstrates how faithfully a coloured aquatint could reproduce a tinted drawing.

Cataracts, with their dramatic display of movement, particularly appealed to de Loutherbourg. Rüdiger Joppien points out (Kenwood catalogue, 1973) that the group of figures with backs to the viewer, and totally absorbed in nature's display, play a similar role to the figures in C. D. Friedrich's well-known picture *The chalk cliffs of Rügen*. Like the figures in some of Gilpin's drawings (see cat. no. 69), they lead the imagination of the viewer to a scene which is not actually in the picture.

Lent by the Victoria and Albert Museum, London (170–1890)

Julius Caesar Ibbetson 1759–1817

129 A phaeton in a thunderstorm; 'the flash of lightning'
□65 Often referred to as *Aberglaslyn: the flash of lightning*

Oil on canvas. 67.2 × 92.7 cm

Inscribed, at the centre of the base, in black paint, 'Julius Ibbetson pinx 1798'

A label on the back records: 'An actual scene The Hon^{ble} Robert Greville[s] Phäeton Between Pont Aberglaslyn & Tan y / Bleh crossing the Mountain Rhge / in a Thunder Storm Painted by Julius Ibbetson who was passer [i.e. passenger].'

COLLECTIONS: Major G. St John Mildmay, sale, Christie's, 28 May 1914 (lot 128); Williams; sale, Christie's, 12 Feb. 1932 (lot 148); Clayton; sale, Christie's, 12 July 1935 (lot 132); Leek; bought for Temple Newsam from the Corporation Fund, 1945

EXHIBITIONS: C.E.M.A., 1941; Leeds, 1948, no. 20, and Bristol and York, no. 19; Rotterdam, *English landscape painters*, 1955, no. 41; Kenwood, *Julius Caesar Ibbetson*, 1957, no. 25

LITERATURE: Rotha Mary Clay, *Julius Caesar Ibbetson 1759–1817*, 1948, p. 36, pl. 34; Burke, p. 389, pl. 117b

In the summer of 1792 Robert Fulke Greville (son of Earl Brooke, later Earl of Warwick), himself a talented amateur artist, made a tour of North Wales accompanied by two draughtsmen, Ibbetson and John 'Warwick' Smith. Both artists made watercolour drawings of the dramatic incident when the party was caught in a thunderstorm in the Pass of Aberglaslyn. They both illustrated the scene from the same imaginary viewpoint. The similarity of the composition and of the theatrical light, the exaggerated shapes of the rocks, the situation of the phaeton and the predicament of driver and prancing horses indicates that either one artist based his illustration on that of the other or they both drew on a common source.

The composition closely resembles de Loutherbourg's *Avalanche* of 1803 in the Tate Gallery.

Six years after the event Ibbetson painted his picture of the scene. In its theatricality it is very like de Loutherbourg's visions of the dramatic instant – his avalanches and his storms. The sudden theatrical illumination of a scene by a flash of lightning was a favourite device to evoke sensations of the Sublime (see cat. nos. 19, 134, 141, 160, 175). Ibbetson's picture, in which he depicts himself about to secure the fragile phaeton by placing a stone under a wheel, is like one of those dreams where the dreamer views himself from a distance.

Sublime scenes of this sort did not come naturally to Ibbetson, many of whose works were distinctly Claudian. His *Tivoli* (Clay, *op. cit.*, p. 74, pl. 78), which is reputed to have been started by Sir George Beaumont and finished by Ibbetson, was referred to by George Thomson of Edinburgh in a letter to Ibbetson as his 'Claude–Ibbetson'.

Lent by Leeds Art Galleries, Temple Newsam House (5.1/45)

Francis Oliver Finch 1802–1862

130 A hermit in a landscape

□68 Watercolour and bodycolour with gum arabic over traces of black chalk outline, laid down. 218 × 285 mm

COLLECTIONS: Sir Frank Brangwyn, R.A., by whom given, 1943

Finch was one of John Varley's many pupils. Although he worshipped Claude, this drawing, with its dead trees, jagged overhanging rocks and pathetic hermit, is almost a parody of a Salvator. As is often the case in the works of Salvator, the distant view of lake and mountain could be in the English Lake District. Similarities between this picture and Ricci's *Rocky landscape with penitents* (cat. no. 13) is striking. Compare the half-dead tree, the lopsided composition with overpowering rocks on the right, the slender cross and the kneeling penitent. Finch's landscapes are generally romantic 'ideal' classical compositions with a temple or a castle in the middle distance.

Fitzwilliam Museum, no. 3261

James Ward 1783–1859

131 Gordale Scar

□61 Oil on canvas. 38 × 56 cm

COLLECTIONS: provenance unknown. Bought for the Leeds Art Collection from the Harding fund, 1942

A sketch for the large picture painted for Lord Ribblesdale, exhibited at the Royal Academy in 1815, no. 255, and now in the Tate Gallery. There are oil and water-colour sketches of the subject in the Tate Gallery and other oil sketches in the City Art Gallery, Bradford, and in the Yale Center for British Art, New Haven, Conn.

Gordale Scar is a remarkable cleft in the carboniferous limestone near Malham in the Yorkshire Pennines. It was close to one of the popular routes to the Lakes, and many of the picturesque travellers made the short detour to enjoy its Salvatorian grandeur.

Thomas Gray visited Gordale Scar on 13 October 1769 and wrote to Dr Wharton of the 'principal horror of the place' (Mr Gray's journal, quoted as addendum III to West's *Guide*, 2nd edn, 1780 – see cat. no. 87).

Edward Dayes the topographical artist exclaimed,

'Good heavens, what a scene, how awful! how sublime! Imagine blocks of lime-stone rising to the immense height of two hundred yards, and in some places projecting upwards of twenty over their bases; add to this the roaring of the cataract, and the sullen murmurs of the wind that howls around; and something like an idea of the savage aspect of the place may be conceived.

'. . . The lover of drawing will be much delighted with this place: immensity and horror are its inseperable companions, uniting together to form subjects of the most awful cast. The very soul of Salvator Rosa would hover with delight over these regions of confusion.' (*The works of the late Edward Dayes*, 1805, pp. 63, 64)

Ward's enormous gloomy picture in the Tate interprets exactly the 'immensity and horror' of the place. The white bull which occurs also in this sketch adds another vigorous touch of sublimity, for bulls, so constantly included by Ward in

his landscapes, were generally accepted as the most sublime of the domestic animals.

Leeds Art Galleries, Temple Newsam House (2/42)

William Westall 1781–1850

132 *Views of the caves near Ingleton, Gordale Scar, and Malham Cove, in Yorkshire*

London: John Murray, 1818. Folio
PLATES: 12 uncoloured aquatints drawn and engraved by William Westall. Issued coloured and uncoloured
LITERATURE: Abbey, no. 369

Westall was one of the few artists who exploited the sublime possibilities of the interior scenery of the limestone caverns or 'pot-holes' of the Pennines, which could dramatically suggest Pandemonium and the nether regions.

□63 DISPLAYED: pl. 12, *Gordale Scar*. Of all the scenes regularly visited by travellers in search of the Picturesque, Gordale Scar most vividly evoked Salvator. In this print the cataract can be clearly seen gushing from a window in the rock; the sublime scale of the precipices is enhanced by the diminutive figures, but the overhang of the rocks is hardly exaggerated

John Martin 1789–1854

133 The bard

□66 Oil on canvas. 213.5 × 154.8 cm
COLLECTIONS: Robert Frank; acquired by the Laing Art Gallery, Newcastle upon Tyne, through the N.A.-C.F., 1951
EXHIBITIONS: R.A., 1817, no. 37; British Institution, London 1818, no. 252; Egyptian Hall, Piccadilly, London, 1822; Newcastle upon Tyne, 1951, no. 176; R.A., 1951–2; Whitechapel Gallery, London, 1953; Newcastle upon Tyne, *John Martin*, 1970, no. 3, pl. 2; Hazlitt, Gooden and Fox, London, *John Martin*, 1975, no. 11, pl. 11
LITERATURE: Mary L. Pendered, *John Martin, painter*, 1923, pp. 78, 87–8; Thomas Balston, *The Life of John Martin . . .*, 1947, pp. 36, 43, 45, 66, 278; Boase, p. 106, pl. 40b; F. I. McCarthy, 'The Bard of Thomas Gray: its composition and its use by painters', *National Library of Wales Journal*, 14 (Summer 1965), p. 111, pl. 10; Feaver, pp. 29–32, 55, 151, 153, 187, 219, no. 18, pl. 14

The painting illustrates Thomas Gray's *Ode II*, which was founded on a Welsh

tradition that Edward I, when he had completed the conquest of that country, ordered the bards put to death. It begins:

> 'Ruin seize thee, ruthless King!
> Confusion on thy banners wait,'

and ends:

> 'Enough for me: With joy I see
> The different doom our Fates assign.
> Be thine Despair, and scept'red Care,
> To triumph, and to die, are mine.'
> He spoke, and headlong from the mountain's height
> Deep in the roaring tide he plung'd to endless night.

Martin's wildly romantic picture illustrates both the climax of the shift between 1750 and 1800 from the pastoral Picturesque to the romantic Sublime – the triumph of Savage Rosa over Virgilian Claude – and the early-nineteenth-century association of landscape with literary themes.

The Welsh bard, which was a favourite theme for romantic artists, had already been treated by de Loutherbourg, Richard Bentley, Thomas Jones and Fuseli.

Lent by the Laing Art Gallery, Tyne and Wear County Council Museums (TWCMS: 6C.6976)

134 *The deluge*

☐64 Mezzotint, engraved after his own design by Martin, 1828
Unfinished proof before letters on India paper. Plate size 476 × 712 mm
COLLECTION: given by the Friends of the Fitzwilliam, 1974
EXHIBITED: Alexander Postan Fine Art, London, *Master of the mezzotint*, 1974, no. 5; Hazlitt, Gooden and Fox, London, *John Martin*, 1975, no. 53, pl. 58; Fitzwilliam Museum, *Principal acquisitions 1973–78*, 1978–9
LITERATURE: Balston, pl. 5; Fitzwilliam Museum, *Annual report 1974*, pl. 12; Feaver, pls. 65a, 163

Martin's nightmare visions of cataclysmic events are the apotheosis of sublime 'horror'. They evolve from scenes like *The raising of the Palace of Pandemonium*, which concluded the second showing of de Loutherbourg's Eidophusikon in 1781. A reviewer of the Royal Academy exhibition in 1824 described John Martin's pictures as 'Loutherbourg outheroded' (see Burke, p. 385n). The composition of the inky black clouds swirling round a central pool of unearthly light is similar to Turner's *Hannibal and his army crossing the Alps*; and the cataract of falling rocks to de Loutherbourg's *Avalanche*, both in the Tate Gallery.

Martin assembled, probably in the early 1830s, in an album (now in the V. & A.), about 150 choice details from his works, as a kind of *Liber Studiorum*. One of the details was part of this mezzotint of *The deluge* isolating the rock-fall and the flash of lightning (Feaver, p. 208, pl. 163).

Fitzwilliam Museum, P.9–1974

Samuel Buck 1697–1779 and Nathaniel Buck

135 *The west view of Dolbadern Castle, in the county of Caernarvon*

Etching, drawn, engraved and published by Samuel and Nathaniel Buck, 9 April
 1742. Plate size 193 × 375 mm
Numbered 77
LITERATURE: Upcott, p. xxxiii

The Buck brothers produced five hundred or more views of ruined abbeys and
castles and of cities and towers. This extensive series of prints (published as
Antiquities) began in 1720. In their preface to this work they claimed to have
visited and drawn the actual buildings. By the 1740s, in pursuit of castles, they
had been drawn deep into the mountains. But they showed a complete lack of any
interest in the form of the landscape or of arranging the scene according to any
picturesque principles. The ruin of Dolbadern Castle 'seated under Snowden Hill'
became a favourite subject for topographical artists, and it is interesting to
compare the Bucks' pre-picturesque print with countless pictures of the same
scene, such as Turner's Royal Academy Diploma painting *Dolbadern Castle* (see
also cat. no. 100e). The Bucks' lack of interest in the landscape is demonstrated by
the false scale which exaggerates the size of the castle. Even if they did make the
drawing themselves on the spot, they showed a remarkable ineptitude in
recording the scene.

William Bellers fl. 1761–1773

136 *A view of Derwent-water, towards Borrodale . . . October the 10th, 1752*

□71 Etching and line engraving, printed 'after Nature' and sold by William Bellers
 Engraved by Jean Baptiste Claude Chatelin (Chatelain) and Simon François
 Ravenet. 'The figures by Boitard jun.' (J. Hodgson, *The Beauties of England
 and Wales*, XV: *Westmorland*, 1814, p. 243). Plate size 367 × 534 mm
LITERATURE: Upcott, p. 126; Hussey, p. 110

This is the first of a series of six prints of views of the Lakes published by Bellers;
the other five are *Derwentwater from Vicar's Island*, 1753; *Hawswater*, 1753;
Winandermere near Ambleside, 1753; *Ulswater towards Poola Bridge*, 1753; *Head
of Ulswater towards Patterdale*, 1754.
 The view of Derwentwater towards Borrowdale, issued at least a year before Dr
Brown wrote his letter to Lord Lyttelton, is the earliest print of British mountain
scenery to adopt the picturesque conventions derived from the 'Italian' landscape
painters.

The six prints, with two more, were republished by John Boydell in 1774 as *Eight Views of Lakes in Cumberland after paintings by W.B.* They were skilfully engraved by members of Boydell's team of fashionable engravers, Canot, Chatelain, Grignion, Mason, Müller and Ravenet. The French influence was strong, as can be seen in Boitard's modish figures, probably inspired by those of Gravelot. The prints were widely distributed in London and must have brought the picturesque beauties of the Lakes to the notice of sophisticated circles in the metropolis.

Lent by King's College, Cambridge (Bicknell Collection)

Thomas Smith (Smith of Derby) d. 1767

137 *A view of Darwentwater &c. from Crow-Park*

□72 Etching and line engraving, painted and engraved by Thomas Smith, 1767. Plate size 362×530 mm
Published by Boydell, London
LITERATURE: C. Le Blanc, *Manuel de l'amateur d'estampes*, 4 vols., Paris, 1854–90, III, p. 547; Upcott, p. 126; Hussey, pp. 110, 225

Forty views of the Peak by Smith engraved by Vivarés was published by Boydell in 1760.

Smith visited the Lakes in about 1752/3. He published views of Windermere, Thirlmere and Derwentwater in 1761. These were republished with a fourth view (of Ennerdale) by John Boydell in 1767.

The viewpoint from Crow Park is West's Station 2 (see cat. nos. 87, 89). 'Smith judged right when he took his print of the lake from hence, for it is a gentle eminence, not too high, on the very margin of the water, and commanding it from end to end, looking full into the gorge of Borrowdale' (Gray's journal, 1769, addendum III of West's Guide, 2nd edn, 1780, p. 207).

The print combines elements of beauty, horror and immensity – Claude, Salvator and Poussin – with an unusual strain of fantasy not dissimilar to the vogue for 'chinoiserie' in the decorative art of the period.

Lent by King's College, Cambridge (Bicknell Collection)

Edward Daniel Clarke 1769–1822

138 *A tour through the South of England, Wales, and part of Ireland, made during the summer of 1791*

London: Minerva Press, 1793. Octavo
PLATES: 12 uncoloured aquatints, some from drawings by H. Spence
LITERATURE: Abbey, no. 3

Almost all the copies were destroyed soon after publication.

Clarke was Cambridge University Librarian from 1817 until his death in 1822.

DISPLAYED: pl. 8, *The Devil's Bridge near the great fall of the Monach*, from a drawing by Henry Spence. Clarke did not find the mountains above the Devil's Bridge picturesque. 'The beautiful verdure of the woods rises to the highest brink of this tremendous chasm, and then abruptly stops: All above are mountains, bleak and horrid.' He exploits the sublime nature of the chasm: 'The intrepid female, who acted as our guide, conducted me, at the hazard of my life, between the arches which compose the bridge'

William Sotheby 1757–1833

139 *A tour through parts of Wales, sonnets, odes, and other poems, with engravings from drawings taken on the spot*, by J. Smith

London: Blamire, 1794. Quarto

PLATES: 13 coloured aquatints from drawings by John 'Warwick' Smith engraved by S. Alken

LITERATURE: Manwaring, p. 115; Tooley, no. 462; Abbey, no. 513

The *Tour*, which is a poem in two parts, is written in the romantic manner of Gray's *Ode II* (see cat. no. 133). Sotheby is more concerned with Merlin, Cadwallader and lofty Taliessen than with picturesque landscape. He follows the patriotic trend of extolling travel in Britain in preference to continental tours:

> I hail
> Thee, Albion! favoured isle. Sublimely rise
> Towering o'er bleak Helvetia, rocks on rocks . . .

He also conforms to picturesque fashion in references to Claude and Salvator. While lauding the immensity of the view from Snowdon he invokes

> Thou, who aspirest
> To imitate the soft aërial hue
> That shades the living scene of soft chaste *Lorraine*;
> Here, when the breath of autumn blows along
> The blue serene, gaze on the harmonious glow
> Wide spread around, when not a cloud disturbs
> The mellow light, that with a golden tint
> Gleams through the grey veil of thin haze, diffused
> In trembling undulation o'er the scenes.

And roaming through 'pathless glens . . . Where Melincourt's loud echoing crags resound' he exclaims, 'Not bolder views Salvator's pencil dashed in Alpine wilds romantic'.

The plates are conventional picturesque views typical of 'Warwick' Smith which bear little relation to the poems.

76

□82 DISPLAYED: pl. 4, *Melincourt cascade*, facing p. 17. The composition and the correctly picturesque group of three wooden figures have more in common with Gilpin than with Salvator.

139a Another copy, pl. 12 (uncoloured), *Druidical remains in Anglesey*, facing p. 39. The gentleman in the middle of the scene appears to be viewing the cromlech backwards over his shoulder in some sort of reflecting glass, with a flap controlled by a cord in his left hand

Henry Wigstead

140 *Remarks on a tour to North and South Wales in the year 1797 . . . With plates from Rowlandson, Pugh, Howitt &c. (aquatinted by I. Hill)*

London: W. Wigstead, 1800. Octavo
PLATES: 22 coloured aquatints
LITERATURE: Prideaux, p. 356; Abbey, no. 517

Rowlandson accompanied Wigstead on this tour, on which they both made a number of landscape sketches. Many of Rowlandson's are now in the National Library of Wales at Aberystwyth. Only nine of the plates in the book are from drawings by Rowlandson, and of these only three are landscapes.

DISPLAYED: engraved title page

140a Another copy, pl. 8, *Nantz Mill*, from a drawing by Rowlandson; imprint 1799

John Stoddart 1773–1856

141 *Remarks on local scenery and manners in Scotland during the years 1799 and 1800.* 2 vols.

London: William Miller, 1801. Octavo
PLATES: 32 coloured aquatints, engraved by Merigot from drawings by John Stoddart, John Claude Nattes, Hugh William Williams, and Girtin
The 32 plates and the engraved vignette from the title page of vol. 1 were republished *c.* 1825, coloured and mounted on card, in a portfolio labelled *Stod[d]art's picturesque views in Scotland*
LITERATURE: Prideaux, p. 353; Abbey, nos. 483, 484
DISPLAYED: pl. 27, *Birnam Wood*, vol. 2, facing p. 199. 'The hill of Birnam itself, though little more than a naked crag, is rendered interesting, by bearing the traces of the poet. I need scarcely add, how much the force of all such sensations is augmented by accidental circumstances – by the strong lights and shades of

tempest, the flash of the lightning, the roar of the wind, and all the attendant circumstances of horror . . . Such was the origin of the drawing by Mr. Williams, from which the annexed plate is taken.'

The sublime effects of storm and lightning were probably suggested by associations with Macbeth rather than by the actual circumstances under which the artist saw the view. These effects have been heightened by very heavy use of watercolour, with the assistance of bodycolour, white and varnish.

Benjamin Heath Malkin 1769–1842

142 *The scenery, antiquities, and biography of South Wales.* Embellished with views, drawn on the spot and engraved by Laporte (see cat. nos. 108, 179)

London: for Longman and Rees, 1804. Quarto
PLATES: 12 soft-ground etchings covered with grey or ochre washes of various shades with white highlights
DISPLAYED: frontispiece, *The fall of the Rhydoll*

Edward Pugh d. 1813

143 *Cambria Depicta: a tour through North Wales illustrated with picturesque views.* By a nature artist

London: for E. Williams, 1816. Quarto
PLATES: 71 coloured aquatints from drawings by E. Pugh engraved by T. Cartwright, I. Havell, D. Havell, I. Hassel, T. Bonnor. Imprints 1813–16
LITERATURE: Prideaux, p. 348; Abbey, no. 521

This work owes its origin to a conversation which Pugh had with Alderman Boydell at the Shakespeare Gallery. 'Mr Boydell lamented that the landscape painters whom he had employed in Wales confined the efforts of their pencils to the neighbourhood of Snowdon: thus multiplying copies upon copies of the same sketches, and frustrating the worthy Alderman's intention of publishing a just series of Welsh views' (p. iii).

DISPLAYED: pl. 68, *The perilous situation of Robert Roberts*, facing p. 413. The scene depicts how the guide, Roberts, 'was miraculously saved from a death, the most horrid which can be conceived, by the intrepidity of a young man who was then with us'. The plate tells the story of the dramatic rescue in a slightly comical way which detracts from the sublime nature of the incident

144 *A voyage round Great Britain, undertaken in the summer of the year 1813 . . . 8 vols.*

London: for Longman etc., 1814–25. Quarto
Vols. 1–2, text by Richard Ayton; vols. 3–8, text by William Daniell
Vols. 1–2 issued in monthly parts in printed paper wrappers
PLATES: 308 coloured aquatints, drawn and engraved by William Daniell
LITERATURE: Thomas Sutton, *The Daniells, artists and travellers*, London, 1954, pp. 121–36, 165–72; Iain Bain, *William Daniell's 'A voyage round Great Britain'*, 1966; Martin Hardie, 'Thomas and William Daniell', *Walker's Quarterly*, nos. 35–6 (1932); Thomas Stephenson, 'English colour prints of the nineteenth century', *Proceedings of the National Print Society*, 1 (1936); Prideaux, pp. 245, 279, 280, 326; Hardie, pp. 133, 138, 139, 304; Abbey, no. 16; Tooley, no. 177; Upcott, p. xxxv

Daniell, who was accompanied as far as Whitehaven by Ayton, made a complete circuit of the coast of England, Wales and Scotland (including the Hebrides and Orkney) in a clockwise direction from Land's End to Land's End. During the voyage, he made rough pencil sketches on the spot, to which he occasionally added colour notes. (Of these, 107 drawings in two notebooks are now in the British Museum.) 'Afterwards he appears to have worked up sepia wash drawings to guide him in the biting in of the various tone strengths on the plates' (Bain, p. 17). He also prepared finished watercolour drawings (see cat. no. 146), sometimes made on an actual print for the trade colourists to work from.

Tooley (no. 157) describes the published aquatints as 'a magnificent series of plates, almost all of equal quality. Magnificent as a record and exquisite in its presentation. The most important book on British Topography.'

'Such a succession of beautiful colour plates is scarcely to be found elsewhere,' says Prideaux (p. 279), 'they are unsurpassed both in delicacy of drawing and tinting.' The subtle transparency of the colour allows the aquatint ground to show through and contribute to the final effect in a way which is not to be seen in earlier, more heavily coloured prints.

In the introduction it is explained that the purpose of the book is to acquaint readers 'with the character of their own shores, where most conspicuous for boldness and picturesque beauty' and 'to illustrate the grandeur of [Britain's] natural scenery'.

DISPLAYED: pt 1, as issued, consisting of: (1) printed paper wrapper, 1814; (2) 2 quarto gatherings (title page, introduction and pp. 1–10 of text); (3) 2 coloured aquatints, *The Lands-end, Cornwall*, and *The long-ships light house off lands end, Cornwall*; (4) 1 uncoloured aquatint (pictorial dedication); (5) three tissue guards (watermark J. Whatman 1811)

144a Another copy
□78 *Lent by Cambridge University Library (Eb.19.2–)*
DISPLAYED: pl. 58 (vol. 3), *Culzean Castle, Ayrshire*, facing p. 7; imprint 2 Dec. 1816. Adam's Culzean Castle, which is now the property of the National

Trust of Scotland, still retains the romantic and picturesque appearance of Daniell's view (cf. cat. nos. 38, 39). The precipitous island in the distance is Ailsa Craig

Six unbound plates:
144b Pl. 81 (vol. 3), *The Island of Staffa from the east*; imprint 1 Oct.
144c Pl. 93 (vol. 3), *Ardnamurchan point, Argylshire*; imprint 2 March 1818
144d Pl. 94 (vol. 3), *Scoor Eig, on the Isle of Eig*; imprint 2 April 1818
144e Pl. 105 (vol. 4), *Near Kylakin, Skye*; imprint 1 Feb. 1819
144f Pl. 131 (vol. 4), *Unapool in Kyles-cu Assynt*; imprint 1 March 1820
144g Pl. 228 (vol. 7), *North Foreland Light House*; imprint 1 Aug. 1823

145 *A voyage round the North and North-West of the coast of Scotland, and the adjacent islands . . .*

London: printed by W. Lewes, n.d. Quarto
PLATES: 42 coloured aquatints, drawn and engraved by William Daniell. Imprints 1818–20. Watermarks 1818–19
LITERATURE: Prideaux, p. 333

The plates from vol. 4 of the *Voyage* were republished in this form after Daniell's death, with a new title page and one leaf of revised and abbreviated text to each plate.

The volume covers the coast from Ballachulish and Glen Coe to Thurso and includes the islands of Skye, Rasay, Harris, the Shiants and Lewis. In this section Daniell, in his search for the grandeur of natural scenery, found the combination of sea and mountain which inspired some of his best work.

□79 DISPLAYED: pl. 17, *The Coolin taken from Loch Slapin*; imprint 1 Aug. 1819 (see cat. no. 146)

146 The Coolin taken from Loch Slapin

Watercolour, laid down. 160 × 235 mm
Illegible initials, l.r. Inscribed, *verso*, 'Coolin mountains'
Engraved in aquatint as pl. 115 of the *Voyage* (cat. no. 144) and pl. 16 of *Scotland* (cat. no. 145)
COLLECTIONS: Bought from Bernard Squire Gallery, Baker Street, London (*c.* 1950) as William Daniell

This may be Daniell's model for colouring the plates. However, as the initials on the drawing do not appear to be W.D. and a pencil note on the back of the mount seems to have been tampered with, it is more probably a copy of the plate by another artist. If it is a copy, however, it is strange that the prominent drift of smoke from the fire on the shore has been omitted.

147 *Lake scenery*

No title or text
60 coloured aquatints of the Lake District, drawn, engraved and published by
William Green, at Ambleside, 1815
LITERATURE: Prideaux, p. 363; Nicholson, p. 182

William Green, a Manchester surveyor, settled at Ambleside, and devoted himself obsessively to producing views of Lake District scenery and buildings. His enormous output of prints consisted largely of soft-ground etchings or aquatints which he engraved and published himself, assisted in the colouring by his daughters.

These sixty prints are described one by one in Green's *The tourist's new guide . . . of the lakes*, 1819 (Abbey, no. 190), but they were not finished in time to be included in the book and were published separately.

Green's views are topographically accurate and make a remarkable record of mountains, lakes and particularly of buildings in the district at a time when there were many fewer trees than there are today. His foregrounds are generally arranged in the conventional picturesque manner.

In the *New guide* he describes landscape in the picturesque terms of his predecessors. His encouragement of the attitudes of romantic fantasy indulged in by the 'Lakers' is shown by his description of the qualifications of mountain guides, 'who from their infancy ought to be taught the clarionet, the bassoon and perhaps the flute and even the horn, in order to gratify the refined in musical feeling with elegant and pathetic solos, duets and trios'.

Lent by King's College, Cambridge (Bicknell Collection)

DISPLAYED: pl. 52, *Crummock Water and Buttermere* (see cat. no. 148)

148 Crummock Water and Buttermere

Leaf from a sketch-book, squared for reproduction. 104 × 173 mm

This is the sketch reproduced as pl. 52 in the sixty views of *Lake scenery* (cat. no. 147). The close resemblance between the foreground in the sketch and the print shows that Green arranged the composition on the spot and not later in the studio.

Lent by King's College, Cambridge (Bicknell Collection)

Thomas Compton

149 *The Northern Cambrian Mountains, or a tour through North Wales . . .*

London: for the author, 1817. Oblong quarto
Issued in 10 parts in printed paper wrappers

PLATES: 30 coloured aquatints, from drawings by Compton, engraved by I. Baily, T. Cartwright, D. Havell. Imprints 1815–16

LITERATURE: Tooley, nos. 85, 86; Abbey, no. 523

'The views, which were taken in two tours in the summers of 1814 and 1815 . . . have been selected as exhibiting the most characteristic features of the country. As embellishments of composition always destroy the likeness, none have been introduced into any of the views . . . The tours were performed on foot without ever having recourse to a guide' (preface). Ascents were made of Snowdon and Cader Idris.

□76 DISPLAYED: pl. 17, *South view from the summit of Snowdon*; engraved by D. Havell. A view from the summit of a mountain with the horizon so close to the top of the picture is unusual at this date, though some of the drawings of John Varley (see cat. no. 123) and of William Daniell adopt a similar high viewpoint. No concessions are made to picturesque 'embellishments of composition'

150 *The Northern Cambrian Mountains, or a tour through North Wales . . .* [a later edition]

London: Thomas Clay, 1820. Oblong quarto

PLATES: 39: 1 coloured lithograph by Walter and Hullmandel, imprint 1821; 38 coloured aquatints, 30 as 1817 (cat. no. 149) but imprints altered from 'Published by T. Compton . . .' to 'Published by T. Clay', imprints 1818, and 8 from drawings by Turner, Gandy, Robson, De Wint, Nicholson, C. V. Fielding and Prout (2 from sketches by Girtin), engraved by T. H. Fielding, imprints 1820

The copy displayed is wrongly bound with the 1817 title page.

□83 DISPLAYED: suppl. pl., *Rhaiadyr y Wennol*, engraved by T. Fielding from a drawing by Francis Nicholson (1753–1844). Although Compton's plates show few 'embellishments of composition', the presentation of this cataract adopts the traditional picturesque formula (suggested by Gilpin's work) with overhanging trees and a suitable group of figures posed in the foreground.

The engraving of the water is a particularly successful example of a skilful combination of aquatint ground with transparent watercolour wash – much more successful than any of Fielding's plates in his *Picturesque tour of the English Lakes* (cat. no. 154)

William Westall 1781–1850

151 *Views of the lake and of the vale of Keswick*

London: Rodwell and Martin, 1820. Quarto

PLATES: 12 coloured aquatints drawn and engraved by Westall

LITERATURE: Hardie, p. 145; Prideaux, p. 356; Tooley, no. 463 (6 pls. only, listed under Robert Southey); Abbey, no. 191
The book was originally published in three parts as *Views of the lakes of Cumberland*, 1819–20. A fourth part, with four plates of views of Windermere, was published in 1821. It was intended that each of the lakes would form a distinct work, but the series was abandoned after part 4. Parts 3 and 4 were published by Hurst Robinson and Co. (successors to Boydell). The book was issued with uncoloured or coloured plates. This copy was coloured after issue.

Correspondence between Westall and his friend Robert Southey indicates that Southey probably wrote the text.

□70 DISPLAYED: pl. 12, *Keswick Lake: from Barrow Common*. Coloured aquatint. The view of the head of Derwentwater, enlivened by a splendid feeling of impending storm, is drawn and engraved by Westall with considerable virtuosity – less theatrical and truer to nature than the sublime effects of weather in the prints from drawings by artists such as de Loutherbourg

151a Loose print, pl. 3, *Skiddaw*. Apart from discreetly placed cows, the idea of a
□80 picturesque foreground is abandoned. Touches of white bodycolour help vividly to evoke a bright still morning after a sharp fall of snow on the tops

Lent by Ellen Bicknell

152 *Keswick Lake from Castelet*

Uncoloured aquatint. 220 × 810 mm
Published by Ackermann, 1833; drawn and engraved by W. Westall, A.R.A.

This is one of a series of panoramic views of the Lakes by Westall which were published in the 1830s. They are faithful topographical records of a type which was to become popular in guide-books.

This print represents an extended view with an angle of vision of over 180° from Falcon Crag to the western slopes of Skiddaw. The features of the view are accurately observed and recorded, and the hills are named. Only the group of figures conforms with picturesque composition. The aquatint engraving shows a similar virtuosity to that of the best steel engravings. It is a type of illustration for which etching or steel engraving was more often employed than aquatint, and which was soon to be taken over by the camera.

Compare the portion of the view at the head of the lake with Westall's *Keswick Lake from Barrow Common* (cat. no. 151).

Frederick Christian Lewis 1779–1856

153 *Scenery of the River Dart*

London: F. C. Lewis, 1821. Folio

PLATES: 35 sepia aquatints drawn and engraved by Lewis, 3 etched vignettes. Imprints 1820–1

LITERATURE: Prideaux, pp. 342, 366; Abbey, no. 118

Lewis was a topographical artist and writer, highly skilled in the arts of stipple and aquatint engraving (see cat. nos. 57, 60, 109).

The views are 'executed to form as nearly as possible fac-similes of the drawings, and therefore calculated not only to interest the admirers of nature . . . but also to form a set of studies for the learner of landscape drawing' (title page).

The prominence of the etched line makes the plates resemble line and wash drawings. The compositions are not particularly picturesque.

DISPLAYED: pl. 6, *Benshe Tor*. This plate was one of 5 from the *River Dart* copied by John Sell Cotman in vigorous pencil sketches of about 1835 now in the British Museum. Sidney Kitson in *The Life of John Sell Cotman*, 1937 (pp. 321–2) assumes wrongly that they are evidence of a visit by Cotman to Devon late in his life. 'J. S. Cotman, Esq. Norwich' appears in the list of subscribers published in the book

Theodore Henry Adolphus Fielding 1781–1851 and J. Walton

154 *A picturesque tour of the English Lakes, containing a description of the most romantic scenery of Cumberland, Westmoreland and Lancashire . . .*

London: Ackermann, 1821. Quarto, large paper

Issued in monthly parts in printed wrappers

PLATES: 48 coloured aquatints from drawings by: Fielding 35, Walton 12, Westall 1; all engraved by Fielding

LITERATURE: Hardie, pp. 109, 312; Prideaux, pp. 275, 355; Tooley, no. 219; Abbey, no. 192

Fielding illustrated several topographical books including another volume on the Lakes, *Cumberland, Westmoreland and Lancashire illustrated*, 1822, and *Picturesque illustrations of the River Wye*, 1821 and 1841 (cat. no. 155). He also wrote treatises on painting in oil and watercolours and the theory of painting and engraving.

Hardie says of the plates in the *English Lakes*, 'The book shows the frequent use of two preliminary tints in the printing of the aquatints. In most cases the colouring is rather harsh and crude, deep browns being prevalent, with none of the transparency that is one of the beauties of aquatint' (Hardie, p. 109).

Lent by Emmanuel College, Cambridge (Graham Watson Collection)

DISPLAYED: frontispiece, *Saddleback & St. Johns Vale*, coloured aquatint from a drawing by Fielding, facing title page with coloured aquatint vignette

84

155 *A picturesque description of the River Wye . . .*

London: Ackermann, 1841. Quarto
An abridged reissue of *Picturesque illustrations of the River Wye*, 1821
PLATES: 12 coloured aquatints from drawings by Fielding
LITERATURE: Prideaux, p. 336; Abbey, no. 550

Twelve of the twenty-four plates from *Picturesque illustrations* were reused: richly coloured, cut out and laid down on pages of cartridge paper with MS. numbers and no titles or imprints.

DISPLAYED: pl. 6, *Bradwardine Bridge*. The lighting, the trees, the bridge in the middle ground and the pastoral atmosphere are in the Claudian tradition

Thomas McLean (publisher)

156 *A picturesque description of North Wales*

Author, illustrator and engraver unknown
London: Thomas McLean, 1823. Oblong quarto
PLATES: 20 coloured aquatints. Imprints 1822
LITERATURE: Abbey, no. 525

Although the artist from whose work the plates were engraved and the engraver are unknown, the quality is as high as that of comparable aquatints by such illustrators as Westall and Fielding.

□85 DISPLAYED: pl. 15, *Rhaiadr-y-Mawddach*

Thomas Rose

157 *Westmorland, Cumberland, Durham and Northumberland . . .* 3 vols.

London: Fisher, 1832. Quarto
Originally issued in parts, in printed paper wrappers, as part of *Fisher's picturesque illustrations of Great Britain and Ireland*
PLATES: 213 steel engravings, from drawings by Allom, Gastineau and Pickering. Imprints 1832–5

The plates were republished in a variety of forms with various titles, such as *The British Switzerland*. They were used for the illustration of several other books, as well as for letterheads on writing paper (see cat. no. 100).

The golden age of the steel engraving was 1830–50. Artists like Thomas Allom, 1804–72, Henry Gastineau, 1791–1876 (see cat. no. 106) and George Pickering, 1794–1857, supplied large numbers of drawings for topographical prints. In their views they showed a remarkable facility for picturesque landscape composition.

These were reasonably accurate records of the scenes they depicted arranged in what had become the conventional picturesque manner. All three artists were well served by a large number of engravers of great technical ability. (The names of twenty-six of these appear on the plates in this book.)

Lent by King's College, Cambridge (Bicknell Collection)

DISPLAYED:
157a Pt 1, engraved title page, with vignette view, *Langdale Pikes, Westmorland*; signed T. Allom and T. Jeavons, 1832
157b Pt 2, inside lower cover, 'Address' and 'Testimonials'
157c Pt 25, upper cover
157d Pt 26, facing p. 214, *View from Langdale Pikes, looking south-east, Westmorland*
☐77 and *View from Langdale Pikes, looking towards Bowfell, Westmorland*; both signed T. Allom and W. Kelsall, 1835

The prints of Allom's views are typical of good steel engravings of the period. The forms of the hills are tactfully exaggerated – what is seen by the picturesque eye rather than by the camera – clouds and light impart a sense of gentle drama, foregrounds are composed according to convention, enlivened by groups of contemporary figures in classical poses. The engraving shows great virtuosity, its delicate texture doing much to create subtle atmospheric effects.

Samuel Carter Hall 1800–1889 and Anna Maria Hall 1800–1881

158 *Hibernia Illustrata: Ireland, its scenery and character &c.* Illustrated by distinguished artists. 3 vols.

London: James S. Virtue, *c.* 1845–50. Quarto
Issued in parts, in printed paper wrappers
PLATES: 102 'exquisite' engravings on steel, 18 maps of the counties, *c.* 500 engravings on wood
Previously published by How and Parsons, 1841–3

Mr and Mrs S. C. Hall were the authors of *A week at Killarney*, published by How in 1843, and by Virtue, *c.* 1846.

DISPLAYED: Pt 5, *Approach to Killarney from the Kenmare Road*, from a drawing by W. H. Bartlett, engraved by R. Brandard; facing coloured map *The lakes of Killarney*, preceding p. 193. W. H. Bartlett, 1808–54, prepared the illustrations for a large number of topographical works. Nearly a thousand of his drawings were engraved, suggesting that he had a remarkable facility for picturesque landscape composition.

The composition and character of the plate of Killarney are very similar to Allom's Lake District views (see cat. no. 157d), but the figures are stiffer and Brandard's engraving has not the same delicacy as Kelsall's

159 Punch bowl

Porcelain decorated with underglaze – blue, brown enamel-colour and gilding. In the middle a view of King's College chapel. On the exterior 4 vignette views. On the interior 4 smaller vignette views

Derby, *c.* 1800. Diameter 310 mm

COLLECTIONS: given to the Fitzwilliam Museum by Mrs M. D. Dickson, 1932

LITERATURE: Burke; Wolf Mankewitz, *Wedgwood*, 1953; Prideaux, pp. 86–8; Victoria and Albert Museum catalogue *Wedgwood Bicentenary Exhibition 1759–1959*, 1959; P. B. Longton, 'The Imperial Russian dinner and dessert service of 1774', *Proc. of the Wedgwood Society*, 1957

The eight subsidiary views are of country houses and castles, four identified as taken from *The Copper Plate Magazine*, 1794: Cliefden House, vol. 1, pl. 20; Sherborne Castle, vol. 1, pl. 21; Gregory's, vol. 1, pl. 34; Danson Hill, vol. 2, pl. 52. The view of King's is from vol. 1, pl. 25.

The decoration of porcelain with picturesque views became popular after the famous creamware service commissioned from Josiah Wedgwood by the Empress Catherine II for La Grenouillère was exhibited in London. This was decorated with views of 'the ruins, country houses, parks, gardens and picturesque landscapes of Great Britain'. Wedgwood ransacked the stocks of prints held by Boydell, Major Cadell and Hooper and commissioned topographers, amongst whom were Anthony Devis, James Barret, 'Warwick' Smith and John Pye, to go on tour in search of suitable views. The service consisted of 952 pieces decorated with 1,282 scenes. Its exhibition in London for a month in June and July 1774 was described by J. L. Roget as 'an epoch in the history of British topographical art' (*History of the Old Water-Colour Society*, 1891, I, p. 33).

The specific reproduction of actual prints, as on this bowl, led to a general use of idealised picturesque views, usually of mountains, cottages or ruins, either painted or transfer-printed on porcelain or earthenware. It was an idiom which was frequently reduced to simple patterns of picturesque symbols, generally including framing trees.

Fitzwilliam Museum, C.20–1932

John Heaviside Clark

160 *A practical illustration of Gilpin's day, representing the various effects on landscape scenery from morning till night, in thirty designs from nature; by the late Rev. Wm. Gilpin, A.M. . . . with instructions in, and explanation of, the improved method of colouring, and painting in water colours* (see cat. no. 74)

London: Priestley and Weale, and C. Knight, 1824. Folio
PLATES: 30 coloured aquatints and explanatory text
Originally published by Edward Orme, 1811. The 1824 edn is a reissue of the
 plates with a new title page, published for 'the proprietors'
LITERATURE: Barbier, pp. 84–5; Templeman pp. 234–5; Hardie, pp. 119–20;
 Prideaux, pp. 18, 188, 331; Tooley, no. 146; Abbey, *Life*, nos. 109, 110

Clark reused Hamble and Dubourg's plates (the signatures, imprints and numbers were removed) to illustrate a drawing book. The text to each plate describes the effects through the day, from 'Dawn of day' to 'Waning moon', of haze and cloud, storm, rainbow, lightning and moonlight, followed by precise details of how to obtain the effects by use of watercolour.

The plates are heavily and often luridly coloured by hand in a way which would have horrified Gilpin. Sun and moon, rainbow and lightning flash are added. Bodycolour and a variety of technical devices, such as the use of the burnisher and the knife, are freely employed. The surrounds of the sheets of Whatman paper (watermarks 1810) on which the aquatints are printed have been washed with grey, and the framing engraved lines reinforced.

'It appears that "amateurs of painting in water colours" were expected to purchase uncoloured proofs of Gilpin's drawings and colour them according to these models' (Templeman, p. 235).

DISPLAYED: pl. 13 (Gilpin pl. 18), '*A storm*. The sudden burst of vivid light and tremulous flashings of the electric fluid, present a scene in nature awful and sublime', a form of sublimity quite alien to Gilpin

James Roberts fl. 1766–1809

161 *Introductory lessons, with familiar examples in landscape for . . . painting in water colours . . .*

London: W. Bulmer and Co., for the author, 1800. Quarto

PLATES: 7 plates: 3 soft-ground etchings, 3 coloured aquatints (1 oval), 1 coloured etching (colour chart)
LITERATURE: Hardie, *Water-colour*, II, p. 1; Williams, p. 148

Roberts for some years taught drawing in Oxford, where he was much influenced by J. B. Malchair (1731–1812), the drawing master who numbered Sir George Beaumont amongst his pupils. As explained in the title, the book propounds 'some clear and simple rules, exemplified by suitable sketches and more finished paintings', which are both 'familiar and progressive'. It is 'chiefly intended for the mere beginner'. Roberts advised the beginners to 'consult and dwell on the exquisite drawings of Turner and Girtin. The castigated purity of one, and the magic splendour of the former, will teach him to view Nature with the eye of a master' (p. 9).

This is the earliest drawing book to be illustrated with aquatints.

DISPLAYED: pl. 7, facing p. 24; engraved by Stadler from a drawing by Roberts. 'The annexed composition is copied from a drawing by that excellent master, Mr. Malchair of Oxford . . . The composition is sweetly serene, and will be of infinite service to those who are rather advanced; the colouring is remarkably chaste, and the effect produced by one general wash only, which is light oker' (p. 25). The composition and the figures are reminiscent of William Gilpin, whose 'peculiar styles' some beginners attempt, 'but, with all possible respect for that truly amiable and learned divine, they elude the grasp of the novice' (p. 9)

David Cox 1783–1859

162 *A series of progressive lessons intended to elucidate the art of painting in water colours*

London: Clay, 1811. Oblong quarto
PLATES: 13: 2 soft-ground etchings, 11 aquatints (6 coloured)
LITERATURE: Hardie, p. 119 (wrongly gives 1st edn as 1812); Prideaux, p. 210 (wrongly gives 1st edn as 1816); Williams, p. 174; Hardie, *Water-colour*, II, p. 194; Abbey, *Life*, nos. 116, 118, 119; Tooley, no. 161 (1841 edn)

Cox followed closely in the footsteps of his drawing master John Varley in supplementing his income by teaching and by the production of drawing books.

No authority appears to have recorded correctly the editions of *Progressive lessons*: Hardie, in both *English coloured books* and *Water-colour painting in Britain*, and Prideaux in *Aquatint engraving* assume incorrectly that Cox's first drawing book was the *Treatise on landscape painting*, 1814 (cat. no. 165). The editions of *Progressive lessons* are: 1st, 1811; 2nd, 1812; 3rd, 1816; 4th, 1820; 5th, 1823; [6th], 1828; [7th], 1841; [8th], 1845.

Cox's name does not appear on the title page of any edition, though it does appear on the publisher's (Ackermann) binding of the 1845 edition. It appears for the first time on the plates in the fifth (1823) edition.

In this the first edition the plates show five views treated progressively. *A bridge*

is shown in three states – outline, monochrome and colour; the other four, in monochrome and colour only.

The aquatints are crude and very inferior to Cox's later works.

This is probably the earliest drawing book to show hand-coloured rectangles in the text.

DISPLAYED: title page

163 . . . *Progressive lessons* . . . [Sixth edition]

London: Clay, 1828. Oblong quarto
PLATES: 19: 3 etchings, 4 uncoloured lithographs, 12 aquatints (9 coloured)
LITERATURE: as cat. no. 162

The plates and the text have been altered from earlier editions. Although the introductory remarks on perspective, sketching and shading with Indian ink and the plates illustrating perspective remain the same, the subjects and the descriptions of the progressive lessons are completely different. They are followed by six examples, each illustrated with a coloured plate.

□88 DISPLAYED: pls. 7, 11, 12, 13 (1 folding sheet), *View near Harlech, N.W.* Pl. 7, line drawing, 'On stone by D. Cox'; pl. 11, *1st progress*, aquatint, 'D. Cox. del.'; pl. 12, *2nd progress*, aquatint, 'G. Hunt. fec.'; pl. 13, *3rd progress – the finish*, aquatint, 'D. Cox. del.', 'G. Hunt. fec.'

The aquatints are on three different plates and differ in detail from the lithograph; for instance in the aquatints one of the figures on the bridge is wearing a top hat, and the sheep in the middle distance appear only on pls. 7 and 13, in different positions

164 . . . *Progressive lessons* . . . [Eighth edition]

'Cox on Landscape' on upper cover
London: Ackermann, 1845. Oblong quarto
PLATES: 18: 3 etchings, 4 lithographs, 11 aquatints (10 coloured)
LITERATURE: as cat. no. 162

The first part of the book is similar to the 1828 edition, but the progressive lessons are different, and seven new examples replace the six of 1828.

DISPLAYED: pl. 13, *Moel Shabbod, North Wales*, facing page of instructions for colouring, incorporating hand-coloured rectangles. The subject (signed 'David Cox') is characteristic of the artist. It is very heavily coloured with watercolour and bodycolour, which completely obscure the aquatint ground. The finished plate closely resembles a watercolour drawing and is in striking contrast with William Daniell's delicately coloured prints (cat. nos. 144, 145)

165 *A treatise on landscape painting and effect in water colours*

London: S. and J. Fuller, 1813–14. Folio

90

Issued in 12 parts, in printed paper wrappers

PLATES: 56: pts 1–4, 24 soft-ground etchings; pts 5–8, 16 sepia aquatints; pts 9–12, 16 coloured aquatints

Issued again, 1814; later editions, 1816 and 1841

LITERATURE: A. L. Baldry, *A treatise on landscape painting in water colours by David Cox*, facsimile and foreword, 1922; Hardie, pp. 118–19; Hardie, *Water-colour*, II, p. 194; Tooley, no. 163; Abbey, *Life*, no. 115; Prideaux, pp. 209–10

This large folio is Cox's most ambitious drawing book, described by Tooley as 'the best and most important of the early drawing books'. In the section 'General observations on landscape painting' (p. 1 of the *Treatise*) Cox says, 'The principal art of Landscape Painting consists in conveying to the mind the most forcible effect which can be produced from the various classes of scenery; which possesses the power of exciting an interest superior to that resulting from any other effect; and which can only be obtained by a most judicious selection of particular tints, and a skilful arrangement and application of them to differences in time, seasons, and situation.'

DISPLAYED:

165a Upper wrapper of pt 1. On lower wrapper, an advertisement addressed 'To the Public' commending the abilities of Mr Cox and explaining the nature and purpose of the work

165b Lower wrapper of pt 7, advertisement for 'Drawings let out to copy at S. and J. Fuller's, the Temple of Fancy, Rathbone Place, London', and for 'elegant work' published by them. Drawings and prints, in flowers, landscapes and figures, could be hired by subscription. Drawing masters, such as Cox and John Varley, probably prepared drawings not only as models for their own pupils but also to be hired out by agents

Inside upper cover, a 60-line poem, *The Temple of Fancy*, concluding with the punning lines:

> In short, at this TEMPLE the Public will meet
> With Articles fanciful, useful and neat,
> Which there will in tasteful profusion abound,
> And FULLER and FULLER will always be found.

Inside lower cover an advertisement for 'Protean Figure; and Metamorphic Costumes'. This was a lay figure which came with 12 different costumes, price 1 gn.

165c Pt 4, pl. 24, *Near Llanfair, North Wales*. Soft-ground etching

□90 165d Pt 6, pl. 35 (numbered pl. 11), *Hastings fishing boats returning on the approach of a storm*. Sepia aquatint, engraved by R. Reeve

165e Pt 8, pl. 39 (numbered pl. 15), *Morning, Eton College*. Sepia aquatint, engraved by R. Reeve (see cat. no. 166)

□92 165f Pt 10, pl. 56, *Storm: view on the coast of Hastings*. Coloured aquatint

□81 165g Pl. 31, *Snowdon, North Wales*. Sepia aquatint

165h Pl. 31, *Snowdon, North Wales*. Another copy of the same plate, coloured after issue

The sixteen coloured aquatints in the *Treatise* are richly washed over with watercolour, with touches of bodycolour and varnish. Although they have been

highly praised, they are not as successful as the sixteen sepia plates. They are all crude compared with Cox's actual drawings, and indeed are travesties of his better watercolours (cf. cat. no. 104). The hand-coloured print of Snowdon (no. 165h above), which was not issued coloured, is much more successful. Here the colouring enhances the tranquil pastoral atmosphere of the original print. Some of the sepia plates, notably *Hastings* (no. 165d), are splendid prints by any standards.

It is interesting that the mountain scenes in the *Treatise* have a Claudian tranquillity; Salvatorian sublime is reserved for the sea pieces, which are presented with a sense of drama reminiscent of Vernet and de Loutherbourg.

166 Eton College Chapel

□91 Brush and brown wash over pencil underdrawing. 221×340 mm
COLLECTIONS: J. R. Holliday, by whom bequeathed, 1927
EXHIBITED: Reading Museum Gallery, *Paintings of the Thames Valley*, 1968, no. 47

This drawing was the model for the aquatint engraving in Cox's *Treatise* (see cat. no. 165e). The print interprets the drawing with great fidelity.

Fitzwilliam Museum, no. 1295

167 *The young artist's companion; or, drawing-book of studies and landscape embellishments – arranged as progressive lessons*

London: S. and J. Fuller, 1825. Oblong quarto
PLATES: 65 including frontispiece, coloured soft-ground etching
The book is divided into 3 sections: 1. 'On outline', illustrated with 40 soft-ground etchings; imprints 1819–20; 2. 'On light and shade, and effect and method of laying on the tints', illustrated with 12 sepia aquatints; imprints 1820; 3. 'On colouring', illustrated with 12 coloured aquatints, engraved by T. Sutherland and R. Reeve from drawings by Cox; imprints 1821, 1823
Introductory text same as that of *Treatise on landscape painting* (cat. no. 165), to which notes on the 12 coloured plates are added
Originally published in 16 parts, in printed paper wrappers, 1819–20
LITERATURE: Hardie, p. 119; Prideaux, pp. 211, 332; Abbey, *Life*, no. 117

'Perhaps the most elaborately finished of all the plates in Cox's books; they are printed in strong effective colours, with now and then a touch of varnish in the shadows which adds to the illusion of a water-colour drawing' (Prideaux, p. 211).

□87 DISPLAYED: frontispiece. This plate of the artist's studio is very freely enlivened with watercolour and touches of white. Much detail is added to the underlying etching

168 *The principles and practice of sketching landscape scenery from nature*

> London: for the author, pt 1, 1824, pts 2–4, 1823 (on wrappers). Watermarks 1820–1, 1824–5. Oblong folio
> In 4 parts, issued in printed paper wrappers
> PLATES: 64: 16 lithographs in each part. Imprints 1814–15
> LITERATURE: Abbey, *Life*, no. 194 (1820 edn). Although the Abbey copy is dated 1820 on the title page, imprints and watermarks are the same as in this copy
> DISPLAYED: vol. 4, pl. 2, lithograph with 6 watercolour overslips or 'sliding planes'. The basic print shows 2 contrasting grounds: one, light centre graded to dark edges; the other, dark centre graded to light edges. The overslips represent 3 views, each shown with the light distributed as it is in the 2 grounds. This is an elaborate piece of book production, similar to that used for Repton's works (see cat. no. 78). (The views which cannot be shown are represented by photographs)

William Henry Pyne 1769–1843

169 *Microcosm: or, a picturesque delineation of the arts*. Second edition. 2 vols.

> London: Miller, 1806. Oblong folio
> Issued in parts by Pyne and Nattes, 1802–7, the complete book taken over by William Miller
> PLATES: 121 (including frontispiece) coloured aquatints 'accurately drawn from nature' by W. H. Pyne and aquatinted by J. Hill. Imprints 1802–7
> Other edns published 1806, 1808, 1822, 1845
> LITERATURE: Prideaux, pp. 141, 348; Abbey, *Life*, no. 177 (1808 edn)

Each plate is devoted to one rural trade or pursuit and displays several groups of figures, animals, implements, vehicles, vessels and other objects suitable for inclusion in a landscape. The explanations of the plates by C. Gray are 'essays relating to their various subjects' and include no drawing instructions.

Lent by Emmanuel College, Cambridge (Graham Watson Collection)

> DISPLAYED: vol. 1, pl. 1, *Slate quarries*, following p. 28; imprint 1804
> □86 Vol. 2, pl. 101, no. XXIV, *Travellers reposing*; imprint 1806. The travellers are vagrants or gypsies suitable for 'cottage picturesque' scenes, not elegant tourists

170 *Rudiments of landscape drawing in a series of easy examples*

> London: Ackermann, 1812. Oblong quarto

PLATES: 14. Pls. 1–5: *A castle shown in outline* (etching); *Improved outline*; *First effect* and *Second effect* (tinted soft-ground etchings); *Finished effect: coloured* (coloured aquatint). Pls. 6–8: *Outline of bridge* (soft-ground etching); *Light in front* and *Light reversed* (tinted soft-ground etchings). Pls. 9–12: 4 views – *Morning, Noon, Evening* and *Night* (coloured aquatints). Pl. 13: a cottage in 2 states (etching and aquatint). Pl. 14: scheme of colours

LITERATURE: Hardie, p. 118; Prideaux, pp. 140–3, 191, 348; Abbey, *Life*, no. 178

In introductory 'Observations on the Picturesque in paintings' the author says, 'The term *picturesque* in this little treatise will be understood to apply to such subjects as the painter selects for imitation' (p. 5).

Pyne's work as a landscape painter is in general limited to rustic scenes. He cooperated for many years with Rudolf Ackermann and wrote under the name of Ephraim Hardcastle.

DISPLAYED: the scheme of colours: 'On this plate are represented all the teints that are used by our most celebrated painters in water-colours' (p. 18). The plate is preceded by a perforated leaf so that the colours can be seen through the openings

John Clark 1771–1863

171 *The amateur's assistant, or a series of instructions in sketching from nature, the application of perspective, tinting of sketches, drawing in water-colours, transparent painting, &c. &c. To accompany the subjects which form the Portable Diorama*

London: for Samuel Leigh, 1826. Quarto
PLATES: 10: 6 etchings (4 soft-ground), 4 aquatints (1 coloured)
LITERATURE: Prideaux, pp. 189, 331; Tooley, no. 138; Abbey, *Life*, no. 111

The Portable Diorama, mentioned on the title page, 'was a contrivance invented by Daguerre and Boulton for producing by optical illusion the effects of nature when looking at architectural or landscape drawings' (Prideaux, p. 189).

DISPLAYED: pl. 9, *Landscape with castle*, facing p. 54. Aquatint, shown in stages 3 and 4 (arranged to show also stages 1 and 2, pl. 8). 'The comprehensive title of the book is hardly justified by the results. It is of little importance except to the inquirer into aquatint technique, for whom it provides a water-colour sketch printed in blue and bitten in three successive stages, a fourth stage showing the addition of slight hand-tinting' (Prideaux, p. 189)

172 Myriorama, a collection of many thousand landscapes. Designed by Mr. Clark

London: Samuel Leigh, 18 Strand, 1824

16 coloured aquatints, each 200×70 mm, mounted on card, in an 'elegant cardboard box', with coloured engraved paper label

The landscape on each card is designed in three planes (the Claudian formula) with the horizon, the top of the middle ground and the top of the foreground in exactly the same position on both vertical edges of the card, so that any two or more placed together will form a continuous picture. The number of possible arrangements is 27,922,789,888,000.

173 Myriorama, second series: Italian scenery. Designed by Mr. Clark

☐93 London: Samuel Leigh, 18 Strand, n.d.
 24 coloured aquatints, each 240×70 mm, mounted on card, in an 'elegant cardboard box', with coloured aquatint paper label
 With 4 pp. of description and advertisement

The description includes some remarkable statistics. 'The changes or variations which may be produced . . . amount to the astounding and almost incredible number of 620,448,401,733,239,439,360,000 . . . Supposing it possible to effect one of these changes every minute, night and day, it would require to produce them all 1,180,457,385,337,213,545 years, 75 days . . . Supposing the space occupied in length by each of these landscapes to be a yard . . . they would by being placed one after the other, cover the length of 352,527,500,984,795,136,000 miles . . .

 'Our young friends need therefore little fear that they, or their children, or their children's children, will exhaust the fund of amusement, which must be afforded by the endless variety of elegant scenery the Myriorama is calculated to present to their attention.'

Hodgson and Co. (publisher)

174 Polyorama, or endless changes of landscape

London: Hodgson and Co., 10 Newgate, 1824
16 coloured lithographs, each 150×75 mm, mounted on card, in a slip case with coloured engraved label

The landscapes are arranged in a similar way to those in the Myriorama (cat. nos. 172, 173).
 The artist is unknown.

John Clark 1771–1863

175 *A series of practical instructions in landscape painting in water colours . . .*

London: for Samuel Leigh, 1827. Quarto

95

In 4 parts, each part bound separately in dark-red paper with an aquatint label on the cover; illustrated with engravings, mounted on card and loose in blue paper portfolios, with aquatint labels on the covers; titles printed on labels on *verso* of cards; issued in a box covered in green leather and lettered on spine to look like a book

Part 1: 'Sketching from nature. Pencil drawing. Simple rules of perspective.'

Part 2: 'Staining of sketches. Tinting of sketches. Light and shade. Drawing in colours.'

Part 3: 'Painting in water colours. Effects at different periods of the day. Herbage. Plants, &c. for foregrounds. Architectural subjects, and groups of figures as applicable to landscape scenery.'

Part 4: 'Peculiar scenery, breadth of light and shade. Variously situated lights, animals. Characteristic scenery. Effect, touch, and finish.'

PLATES: 55 'views from nature, descriptive objects, &c. mounted in imitation of drawings'

Part 1: 8 plates: 2 etchings, 4 soft-ground etchings, 2 tinted aquatints

Part 2: 16 plates: 1 coloured etching, 1 soft-ground etching in 2 states (tinted and coloured), 14 aquatints (10 coloured)

Part 3: 12 aquatints (9 coloured)

Part 4: 19 aquatints (18 coloured)

LITERATURE: Abbey, *Life*, no. 112

Not only does the text form a comprehensive book of instruction, but the plates display a rich variety of picturesque clichés as sources for the amateur artist.

Owing to its elaborate form and the ease with which the loose plates could be dispersed, the complete work is extremely rare.

DISPLAYED:

Pt 1, pl. 4, *Four sketches: lead pencil*. Tinted aquatint. The scenes of castles on rocks in the middle ground are very Gilpinesque

Pt 1, pl. 5, *Four scenes: light shade & finish . . . lead pencil*. Tinted aquatint. The composition, with a bridge resembling the Ponte Molle, is very Claudian

Pt 2, pl. 9, *Rough sketch . . . stained*. Soft-ground etching. 'A subject sketched with a coarse pencil, or with a piece of black-lead in a port-crayon, washed with a stain of yellow'

Pt 2, pl. 14, *Rough sketch . . . tinted*. Soft-ground etching (same etching as pl. 9). 'This subject is repeated to show that the same mode of sketching admits of a variety in treatment for the Sketch-book . . . a few tints are washed in, as indigo on the distance, red ochre on the second plain; indigo and yellow-ochre on the foreground'

Pt 3, pl. 32, *Sketches of shading of groups of figures*. Aquatint, partly coloured. 'How essential figures are to landscape is sufficiently proved by Claude, Gaspar Poussin, and others, who employed the talents of friendly artists in the embellishment of their beautiful scenes'

Pt 3, pl. 34, *Groups of figures in colours*. Coloured aquatint – 'toned in agreement with three degrees of distance'

Pt 4, pl. 53, *Rochester Bridge: rainbow*. Coloured aquatint, watercolour and bodycolour. Despite the banality of the finished print the effect of the rainbow is achieved with remarkable expertise. The text (p. 21) gives detailed instructions on how to do it

Pt 4, pl. 55, *Scene near Portello . . . storm*. Coloured aquatint, watercolour, body-colour and varnish. 'The subject exhibits an attempt to represent a stormy effect, with wildness of scenery, and to heighten the objects of terror by the introduction of banditti'. This is Salvator Rosa reduced to a crude formula

John Hassell d. 1825

176 *Aqua Pictura. Illustrated by a series of original specimens from the works of . . . all the most approved modern water coloured draftsmen*

London : for the author. Introduction dated 1812. Oblong folio
PLATES : 15, each in 4 states. 1 page of description to each plate. Imprints 1812–13
LITERATURE : Abbey, *Life*, no. 140; Tooley, nos. 248–9; Hardie, pp. 121, 133; Prideaux, pp. 211–12

In the preface Hassell says, '. . . the Proprietor of the present work proposes to give, in progressive Series, *a drawing of every celebrated water coloured draftsmen of the present age and to publish one specimen, in four stages, on the first day of every month*'. Each specimen was illustrated with an etching to represent the drawing, an aquatint to represent the drawing finished with Indian ink or sepia, the same with a yellow wash to represent a warm monochrome drawing and the aquatint finished in colour to represent the finished watercolour. The text explains in detail the process of drawing and colouring adopted by each artist, colours being indicated by rectangles of actual colour.

Although this method represents accurately the process of a tinted drawing built up in three stages – line, monochrome tones and colour – it does not necessarily represent the actual methods of the artists concerned. Hassell must have indulged his imagination to a considerable extent.

The artists illustrated include Munn, Francia, John Varley, Cristall, Girtin, Cox, De Wint, and de Loutherbourg. In later editions specimens by Turner, Owen and Glover were added.

DISPLAYED : *Moel y Shaboed, Carnarvonshire*. 'From an original drawing by J. Christal in the possession of the proprietor of this Work'. Imprint 1812. Faces a page of description with coloured rectangles

177 *The camera ; or, art of drawing in water colours . . .*

London : for W. Simpkin and R. Marshall, 1823. Small quarto
PLATES : 3 folding plates, drawn, etched and engraved in aquatint by Hassell
LITERATURE : Hardie, p. 121; Prideaux, pp. 212, 339; Abbey, *Life*, no. 142

Hassell was a friend of George Morland, whose life he wrote in 1806. 'He was one of the first to apply colour to aquatints and in his *Tour of the Isle of Wight*, published in 1790, he has experimented by washing a single tint of blue, green or reddish colour by hand over the finished aquatint. This is the method employed by Gilpin, except that Hassell varies his colours' (Hardie, p. 121).

DISPLAYED: folding frontispiece. Coloured aquatint (arranged to show part of etching of first stage). This is the third of 3 stages of a complete landscape by which 'the whole process of water-coloured drawing' is 'familiarly exemplified in drawing, shadowing, and tinting a complete landscape in all its progressive Stages' (from title)

Henry Alken 1784–c. 1850

178 *Illustrations for landscape scenery*

London: S. and J. Fuller, 1821. Oblong folio
No title, no text
PLATES: 26 soft-ground etchings, drawn and engraved by Alken
LITERATURE: Abbey, *Life*, no. 89 (24 plates only); Hardie, p. 178

Henry Alken was primarily a sporting artist, and a skilled engraver in aquatint. Hardie lists forty-one books illustrated with aquatints by Alken of sporting subjects.

The plates in *Illustrations* each show several groups of people or animals suitable for inclusion in landscapes. Many of them are of sporting subjects, and horses appear in most of them.

DISPLAYED: pl. 17, *Banditti*. The subjects of this plate forsake the sporting and rural world of the others for the sublime world of Salvator

John Laporte 1761–1839

179 *The progress of a water-coloured drawing*

London: for the author, *c.* 1802. Oblong quarto
PLATES: 14: 1 plate coloured in 14 states. Watermarks: plates 1800, text 1801
LITERATURE: Abbey, *Life*, no. 149 (*c.* 1811, watermarks 1810); Williams, pp. 61–2, 217–18

'The intention of this little Work is to enable young People, where an eminent Master cannot be had, to cultivate the delightful Art of Drawing in Colours with System and Advantage' (title page).

The original soft-ground etching shows the outline drawing; each state is then progressively coloured to no. 14, which shows the finished drawing. No. 14 therefore was coloured thirteen times, making a total number of ninety-one hand colourings for each copy of the book.

A combination of soft-ground etching and watercolour was one of the favourite media of Laporte. The plates are wrongly catalogued by Abbey as 'coloured aquatints'.

Laporte was an active topographical artist (see cat. no. 108) and 'an eminent Master' of drawing.

DISPLAYED: no. 10, facing page of instructions

179a Another copy (later edition, n.d.)
DISPLAYED: no. 14, the finished drawing

180 Manuscript copy of *The progress of a water-coloured drawing*
The whole book including the title page and text has been laboriously copied by a student and bound.

DISPLAYED: no. 10 and photograph of a MS. page of text

William Pickett fl. 1792–1820

181 *Twenty-four plates divided into ninety-six specimens . . . Intended to facilitate the improvement of the student, and to aid the practitioner, in landscape composition . . .*

London: T. Clay, 1812. Oblong folio
Title; no text
PLATES: 24 coloured aquatints, 4 specimens on each plate
LITERATURE: Abbey, *Life*, no. 168

The plates provide a series of specimens of cottages, bridges, castles, churches, windmills, waterfalls etc. suitable for use in landscape composition.
William Pickett was employed in engraving a large number of aquatints for book illustration, including those for de Loutherbourg's *Romantic and picturesque scenery* (cat. no. 127).

□84 DISPLAYED: pl. 15, *Water falls*

Index of artists, engravers and authors

(Numbers refer to catalogue entries; *LV* = notes on the *Liber Veritatis*; PT = notes on picturesque theory)

Abbott, John White, 114
Ackermann, Rudolph, 170
Adam, James, 39
Adam, Robert, 38–9, 144a
Alexander, William, 42, 43
Alken, Henry, 178
Alken, Samuel, 76, 139
Allom, Thomas, 100, 157, 158
Ashby, H., 89
Austen, Jane, 106
Austin, William, 15
Avril, Jean-Jacques, père, 19
Ayton, Richard, 144
Bailey, I., 149
Banks, W., and Sons, 100
Barret, James, 159
Bartlett, William Henry, 158
Beaumont, Sir George, 26, 27, 103, 107, 129, 161
Beckford, William, 28
Bellers, William, 86, 136
Benazech, Pierre Paul, 18
Bentley, Richard, 133
Berchem, Nicolas, 107, 126
Birt, Captain Edward, 59, 85
Boitard, Louis Philippe, jun., 136
Bonnor, T., 143
Bourdon, Sebastien, 9
Bourne, James, 101
Bouton, 171
Boydell, John, 24, 25, 136, 137, 143, 159, *LV*
Boydell, Josiah, 45, 46, *LV*
Brandard, R., 158
Brayley, Edward Wedlake, 77
Britton, John, 77
Brown, John, 1, 85, 86, 87, 136
Brown, Lancelot, 77
Buck, Nathaniel, 135
Buck, Samuel, 135
Burckhardt, C., 46
Campbell, Alexander, 95
Canaletto, 14
Canot, Pierre Charles, 136
Caracciolo, Ludovico, 3, *LV*
Cartwright, T., 143, 149
Chatelain, Jean-Baptiste Claude, 136
Clark, John, 171–3, 175
Clark, John Heaviside, 74, 160
Clarke, Edward Daniel, 138
Claude Gellée, le Lorrain, 1, 2–4, 7, 9, 12, 17, 20, 21, 26, 27, 28, 39, 40, 45–7, 52, 58, 59, 60, 61, 77, 85, 87, 92, 96, 106, 110, 129, 130, 137, 139, 175, *LV*
Clint, George, 58

Cockin, William, 87
Collins, William, 59
Combe, William, 79–82
Compton, Thomas, 149–50
Constable, John, 27, 102–3, 105, 123
Cotman, John Sell, 42, 43, 153
Cox, David, 61, 104, 124, 162–7, 176
Cozens, Alexander, 28–33, 47
Cozens, John Robert, 32, 47, 105, 117
Cristall, Joshua, 176
Crosthwaite, Peter, 87, 88–9
Cumberland, Richard, 1, 87
Cunningham, John, 42, 43
Daguerre, Louis Jacques Mandé, 171
Dalton, John (poet), 86, 87
Dalton, John (scientist), 94
Daniell, William, 144–6, 149, 164
Dayes, Edward, 131
de Berchere, M. Guédon, 65
de Loutherbourg, Philippe Jacques, 17, 37, 98, 107, 126–8, 129, 133, 134, 151, 165, 176, 181
de Mechel, Christian, 126
De Wint, Peter, 47, 61, 150, 176
Devis, Anthony, 159
Diderot, Denis, 126
Dubourg, M., 74, 160
Dughet, Gaspard, 1, 7–8, 9, 12, 20, 40, 87, 92, 103, 137, 175
Dumerery, Major, 122
Dunkerton, Robert, 55
Earlom, Richard, 2, 45–6, 48, 58, 77, *LV*
Fielding, Anthony Vandyke Copley, 61
Fielding, C. V., 150
Fielding, Theodore Henry Adolphus, 150, 154–5
Finch, Francis Oliver, 61, 130
Francia, François Louis Thomas, 176
Friedrich, C. D., 128
Fuseli, Henry, 133
Gainsborough, Thomas, 10, 11, 34–7, 41, 98
Gandais, M., 80
Gandy, Joseph Michael, 150
Garden, F., 85
Garnett, T., 95
Garrick, David, 126
Gastineau, Henry, 106, 157, 158
Gellée, Claude, *see* Claude Gellée
Gilpin, Sawrey, 64, 66
Gilpin, William, 2, 11, 17, 39, 41, 44, 45, 52, 62–74, 75–6, 77, 79, 92, 96, 106, 115, 128, 139, 150, 160, 161, 177, *LV*, PT
Girtin, Thomas, 43, 47, 123, 141, 150, 176
Gleadah, J., 60
Glover, John, 176

Glover, William, 114, 176
Graham, A. W., 100
Gravelot, Hubert François, 136
Gray, C., 169
Gray, Thomas, 87, 92, 96, 131, 133, 137, 139
Green, William, 147–8
Greville, the Hon. Robert, 129
Grignion, Charles I., 136
Hall, Anna Maria, 106, 158
Hall, Samuel Carter, 106, 158
Hamble, J., 74, 160
'Hardcastle, Ephraim', see Pyne, W. H.
Harwood, J. and F., 100
Hassell, John, 143, 176–7
Havell, D., 143, 149
Havell, I., 143
Hearne, Thomas, 77
Hill, I. ? or J., 140, 169
Hodgson, J., 136
Hodgson and Co., 174
Howitt, Samuel, 140
Hullmandel, Charles Joseph, 150
Hunt, George, 163
Hunt, William Henry, 61
Hutchinson, William, 98
Ibbetson, Julius Caesar, 27, 107, 129
Jeavons, Thomas, 157a
Jefferys, T., 85
Jones, Thomas, 133
Kelsall, W., 157d
Keys, Edward, 84
Knight, John Baverstock, 114
Knight, Richard Payne, 40, 46, 77, 105, LV, PT
Lacey, Samuel, 100
Lambert, George, 16
Laporte, John, 108, 142, 179–80
Le Prince, Jean Baptiste, 48
Leslie, C. R., 27, 103
Lettice, I., 95
Lewis, Frederick Christian, 57, 60, 109, 153
Lewis, G., 60
Lewis, John Frederick, 109
Lingelbach, J., 10
Linnell, John, 61
Lorrain, Claude, le, see Claude Gellée
Lupton, T., 46
Lyttelton, Lord, 1, 85, 136
Macaulay, Thomas Babington, 85
McLean, Thomas, 156
Magnasco, Allesandro, 13
Malapeau, 80
Malchair, John Baptist, 161
Malkin, Benjamin Heath, 142
Marlow, William, 26
Martin, John, 133–4
Mason, James, 136
Menzies, J. and G., 94
Merke, H., 97
Merriman, S., 120
Miller, J. S., see Müller, J. S.
Morland, George, 11, 40, 41, 177
Morris, Thomas, 98
Müller, Johann Sebastian, 136

Mulready, William, 61
Munn, Paul Sandby, 42, 43, 176
Munn, W., 42, 43
Munro, Thomas, 108, 123
Nattes, John Claude, 141
Naysmith, Alexander, 110
Naysmith, Patrick, 111
Neele, S., 89
Newman and Co., 100
Nicholson, Francis, 150
Otley, Jonathan, 94, 99
Owen, Samuel, 176
Palmer, Samuel, 61
Payne, William, 112
Payne Knight, Richard, see Knight, Richard
 Payne
Pennant, Thomas, 22, 23, 95
Pether, William, 29d, 29e, 30
Pickering, George, 157, 158
Pickett, William, 127, 181
Piranesi, Giovanni Battista, 69
Plumptre, James, 90–2
Pocklington, Joseph, 89
'Poussin', see Dughet, Gaspard
Poussin, Nicolas, 7, 9
Price, Uvedale, 116, PT
Prout, Samuel, 150
Pugh, Edward, 140, 143
Pye, John, 120, 159
Pyne, William Henry ('Ephraim Hardcastle'),
 169–70
Radcliffe, Ann, 87, 98
Rademacher, F. E., 81
Rahbek, K. L., 81
Ravenet, Simon François, 136
Reeve, R., 165, 167
Reinagle, Ramsay Richard, 114
Rembrandt Harmenszoon van Rijn, 60
Repton, Humphry, 78, 168, PT
Ricci, Marco, 12–13, 14, 130
Ricci, Sebastiano, 13
Roberts, James, 161
Robertson, James, 113–14
Robson, George Fennel, 150
Rooker, E., 23
Rooker, M., 23
Rosa, Salvator, 1, 5–6, 7, 9, 12, 13, 17, 40, 67,
 87, 126, 130, 131, 132, 137, 139, 175, 178
Rose, Thomas, 100, 157
Rowlandson, Thomas, 79–83, 97, 115, 140
Rubens, Peter Paul, 27
Ruisdael, Jacob, 11, 40
'Salvator', see Rosa
Sandby, Paul, 48–52, 116, LV
Sedgwick, Adam, 94
Smith, Charles, 93
Smith, George, of Chichester, 24, 25
Smith, John, of Chichester, 25
Smith, John 'Warwick', 129, 139, 159
Smith, Thomas, of Derby, 89, 137
Sotheby, William, 139
Southey, Robert, 151
Spence, Henry, 138

Stadler, J. C., 161
Stewart, G., 46
Stoddart, John, 141
Sunderland, Thomas, 117
Sutherland, T., 167
Thomas, Walter, 98
Thomson, George, 129
Thomson, James, 1, 21, 59
Tombleson, William, 100
Towne, Francis, 114, 118, 119
Turner, Charles, 53, 54
Turner, Joseph Mallord William, 3, 21, 53–9,
 120, 134, 135, 150, 176, *LV*
Turner, William (of Oxford), 61
Underwood, Thomas Richard, 42, 43
Varley, Cornelius, 125
Varley, John, 42, 43, 60–1, 104, 121–4, 125, 130,
 149, 162, 176
Vernet, Claude-Joseph, 5, 17–19, 126, 165
Vivarés, François, 137
Walter, H., 150

Walton, J., 154
Ward, James, 79, 131
Watts, David Pike, 103
Wedgwood, Josiah, 159
West, Benjamin, 107
West, Thomas, 1, 87, 89, 96, 98, 131, 137
Westall, William, 132, 151–2, 154
Wheatley, Francis, 41
Whittaker, the Rev. T. D., 120
Wigstead, Henry, 97, 140
Williams, Hugh William, 141
Wilson, Richard, 21–3, 41, 123, 127
Wood, John George, 168
Woolett, William, 22, 24, 25, 98
Wootton, John, 20
Wouverman, Philip, 126
Wright, Joseph, of Derby, 44
Wynants, Jan, 10
Wynn, L., 48
Zuccarelli, Francesco, 14–16

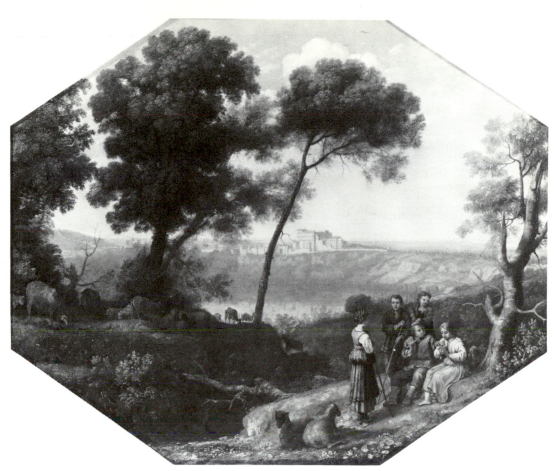

Plate 1: cat. no. 3

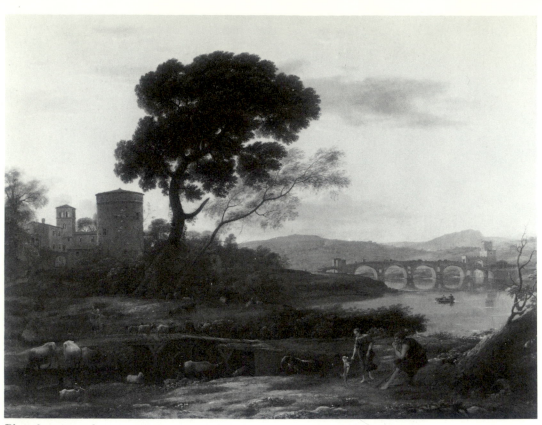

Plate 2: cat. no. 2
Plate 3: cat. no. 45a

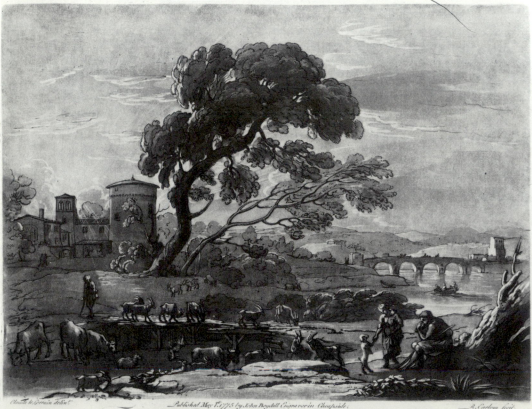

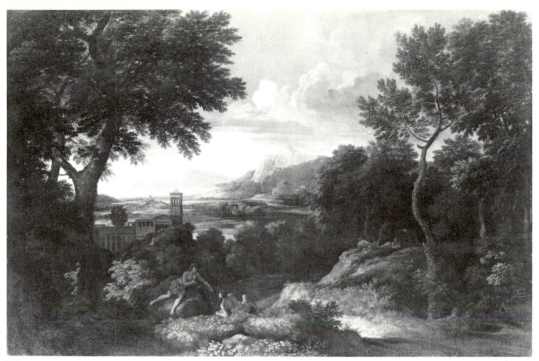

Plate 4: cat. no. 7

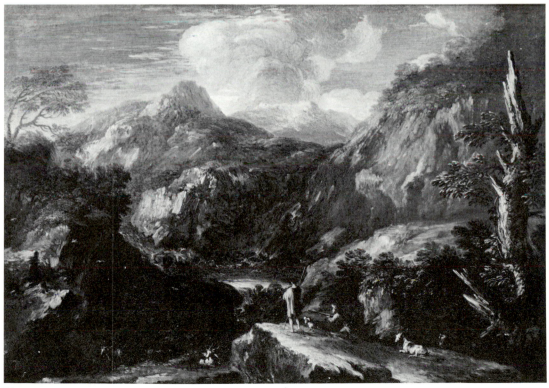

Plate 5: cat. no. 5

Plate 6: cat. no. 4

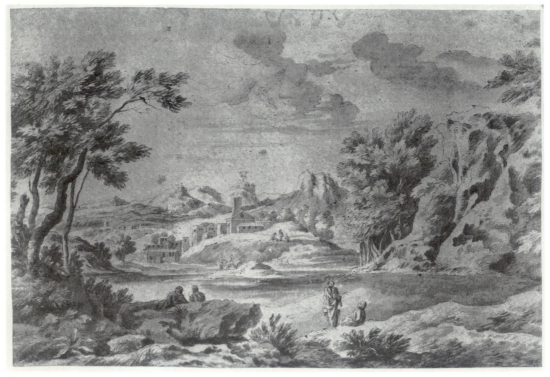

Plate 7: cat. no. 8

Plate 8: cat. no. 27

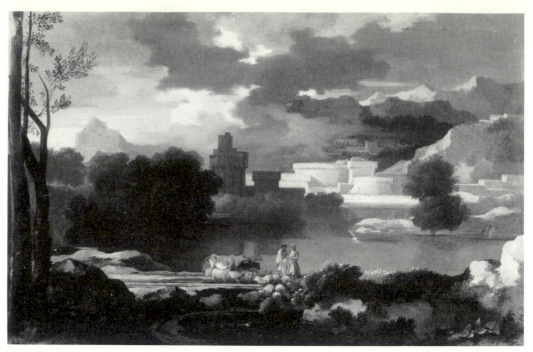

Plate 9: cat. no. 9

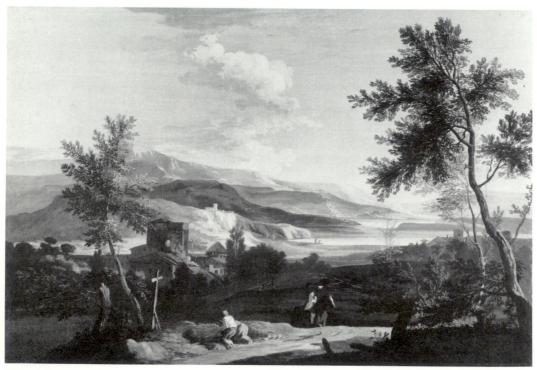

Plate 10: cat. no. 12

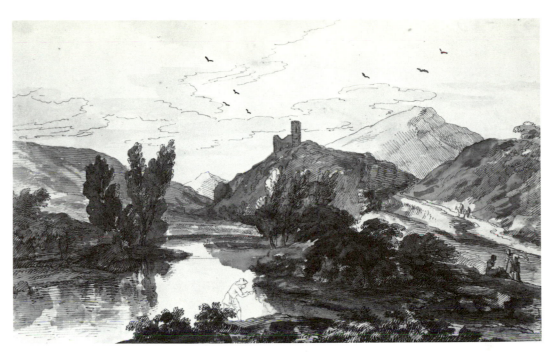

Plate 11: cat. no. 16

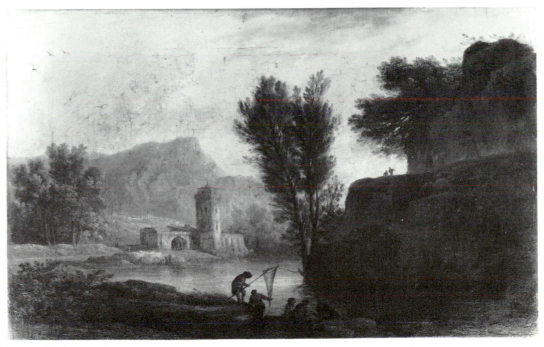

Plate 12: cat. no. 17

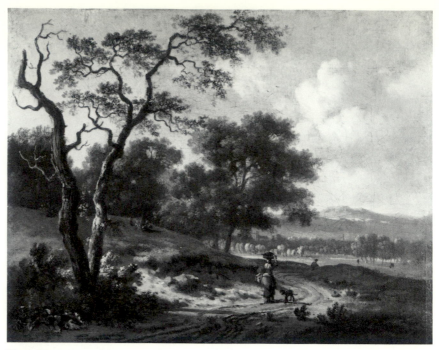

Plate 13: cat. no. 10

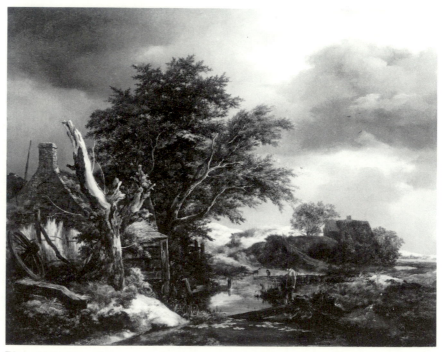

Plate 14: cat. no. 11

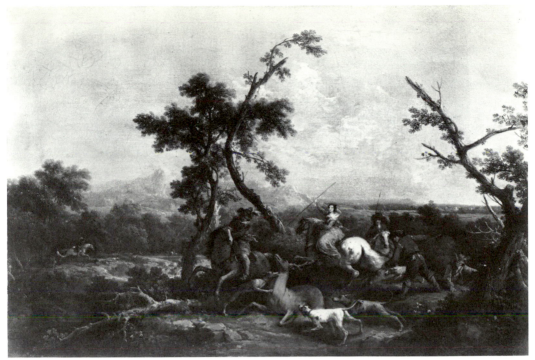

Plate 15: cat. no. 14

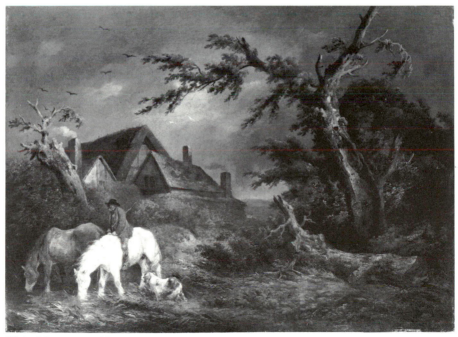

Plate 16: cat. no. 40

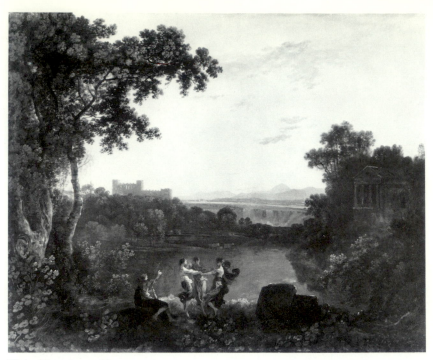

Plate 17: cat. no. 21

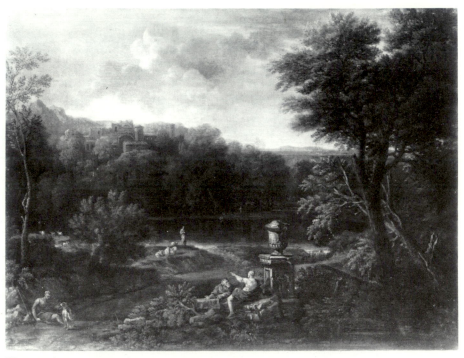

Plate 18: cat. no. 20

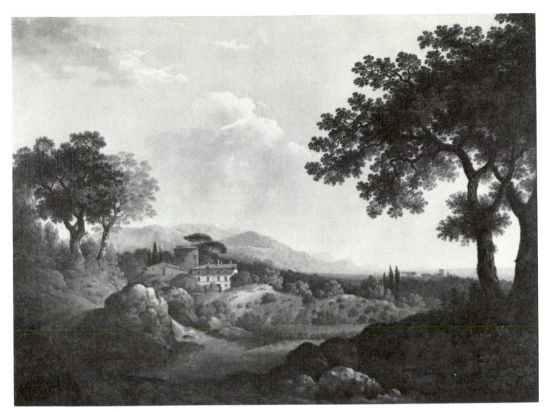

Plate 19: cat. no. 26

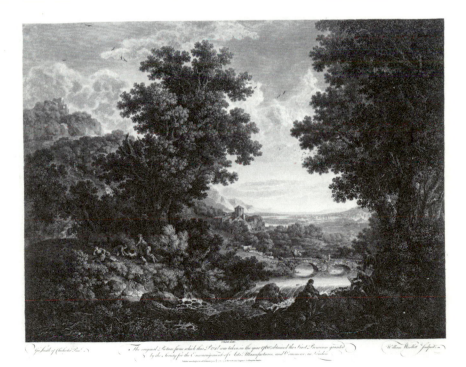

Plate 20: cat. no. 24

Plate 21 : cat. no. 33

Plate 22 : cat. no. 30

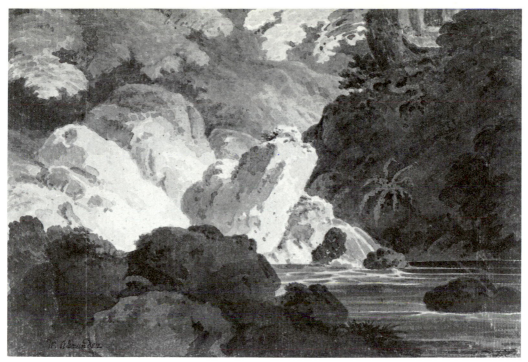

Plate 23: cat. no. 42

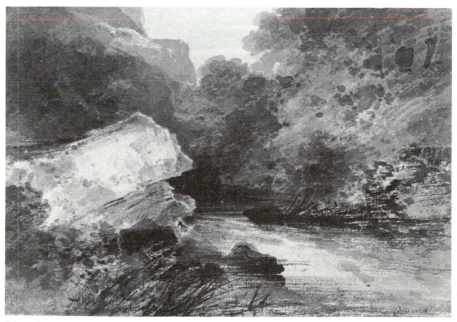

Plate 24: cat. no. 43

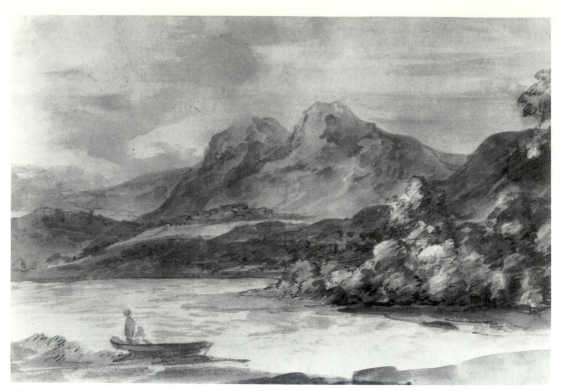

Plate 25: cat. no. 37

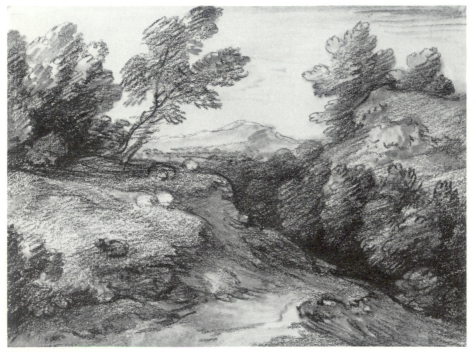

Plate 26: cat. no. 36

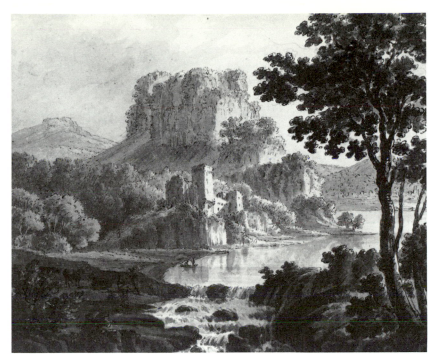

Plate 27: cat. no. 38

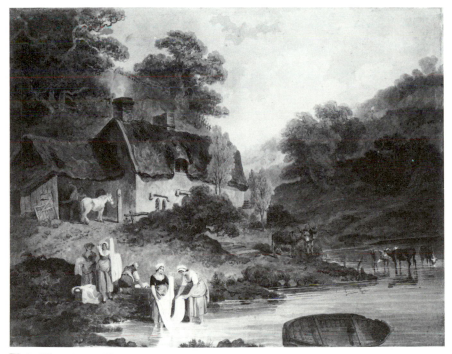

Plate 28: cat. no. 41

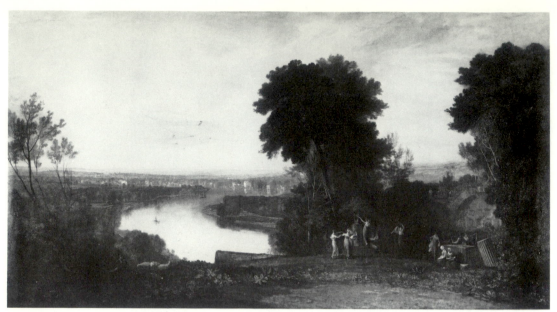

Plate 29: cat. no. 59

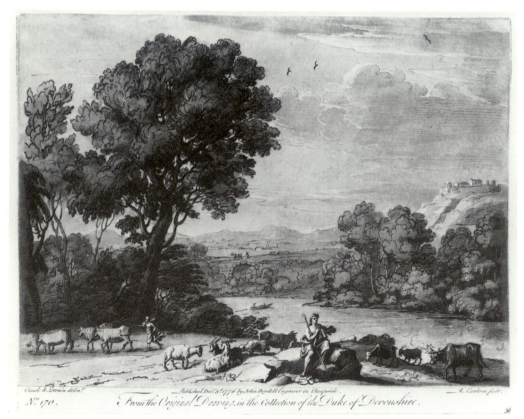

Plate 30: cat. no. 45b

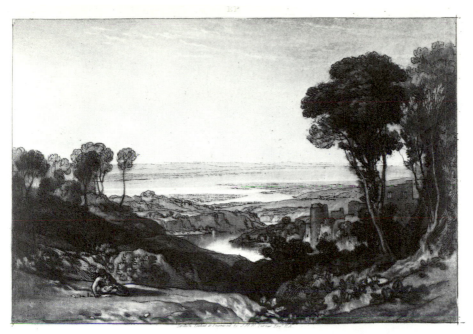

Plate 31: cat. no. 56

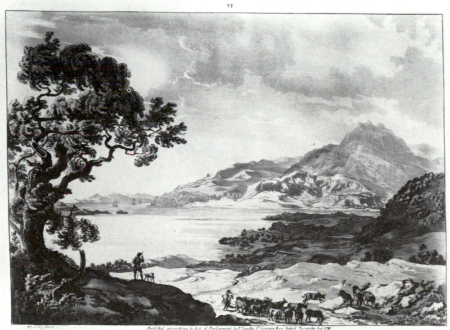

Traeth Mawr in the Road to Caernarvon from Feftiniog

Plate 32: cat. no. 48

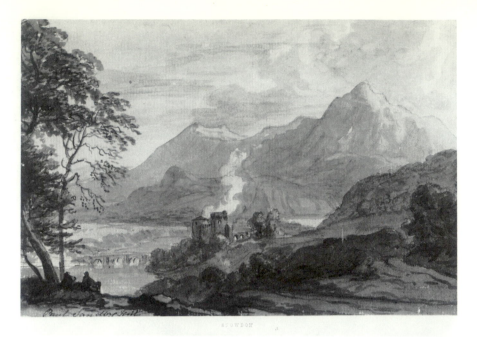

Plate 33: cat. no. 50

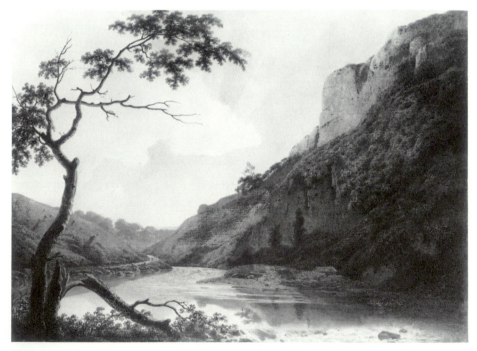

Plate 34: cat. no. 44

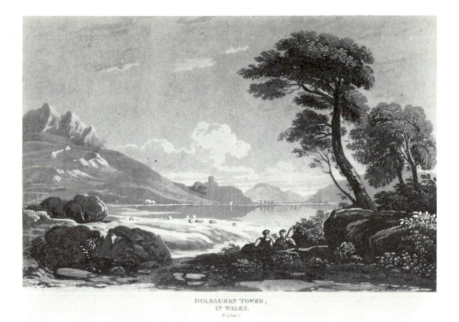

DOLBADERN TOWER,
IN WALES.

Plate 35: cat. no. 60 – *Dolbadern Tower*

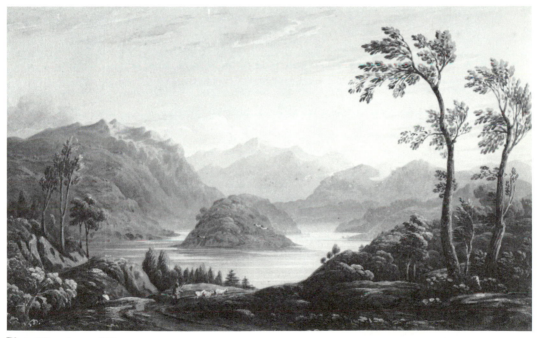

Plate 36: cat. no. 122

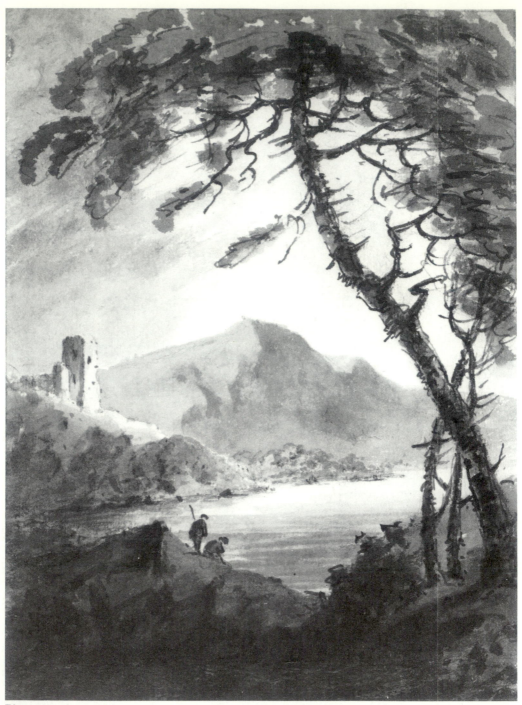

Plate 37 : cat. no. 71

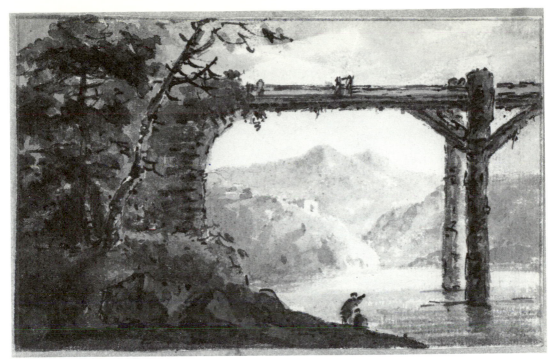

Plate 38: cat. no. 69

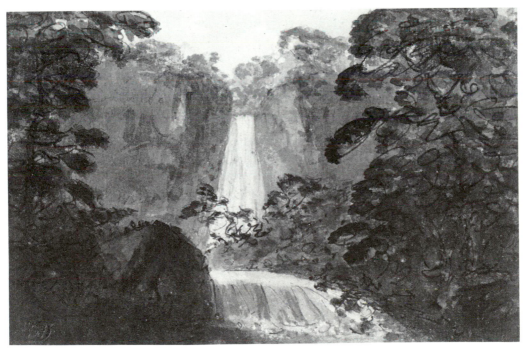

Plate 39: cat. no. 72

Plate 40: cat. no. 73

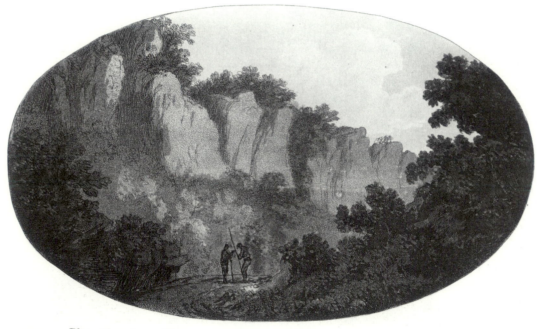

Plate 41: cat. no. 64a

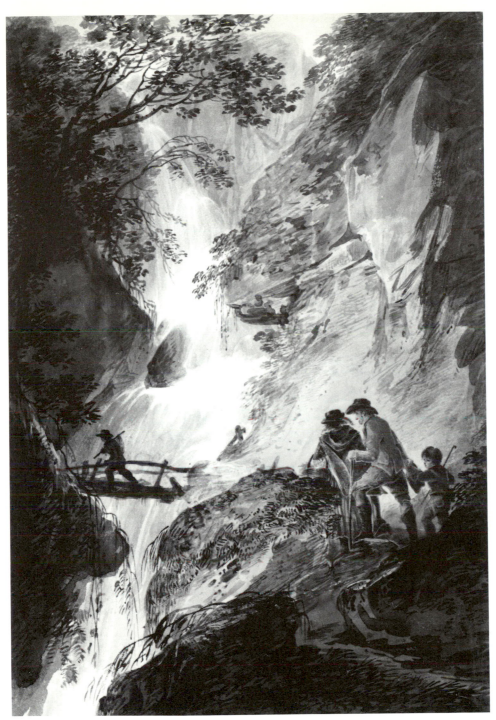

Plate 42: cat. no. 112

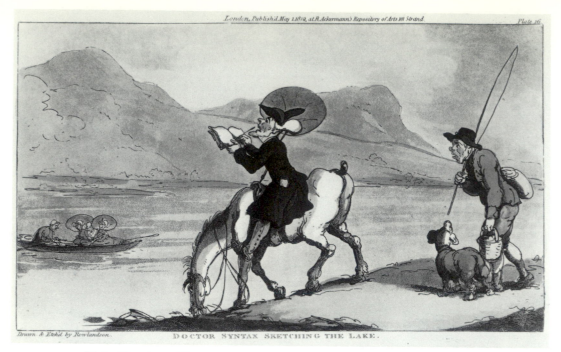

Plate 43: cat. no. 79a

Plate 44: cat. no. 80

Plate 45: cat. no. 81

AN ARTIST Travelling in WALES.

Plate 46: cat. no. 97

Plate 47: cat. no. 115

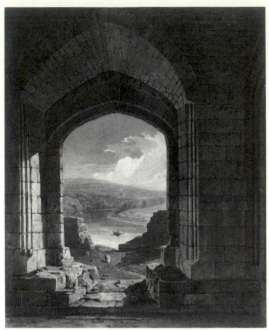

Plate 48: cat. no. 121

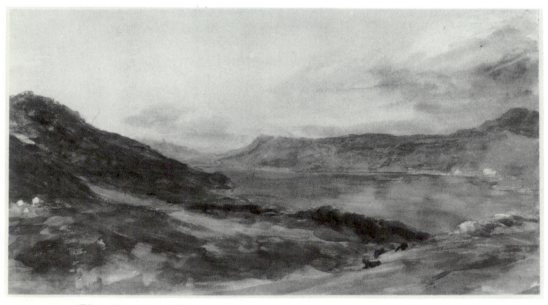

Plate 49: cat. no. 103

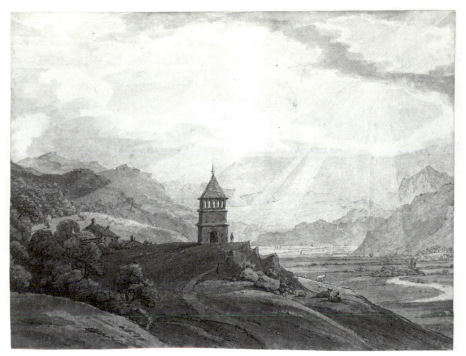

Plate 50: cat. no. 117

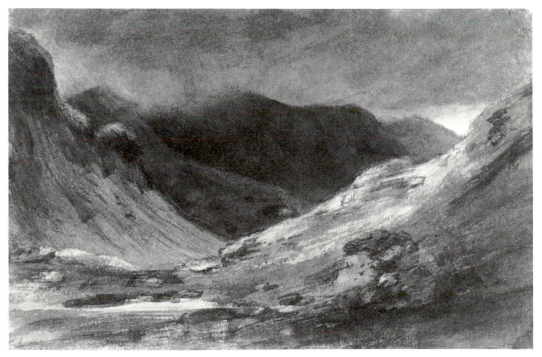

Plate 51: cat. no. 102

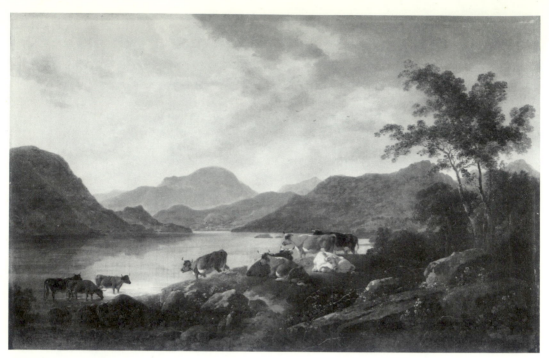

Plate 52: cat. no. 107

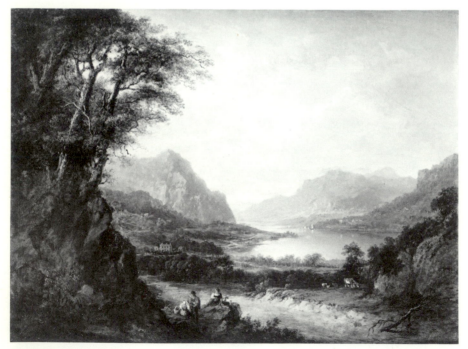

Plate 53: cat. no. 110

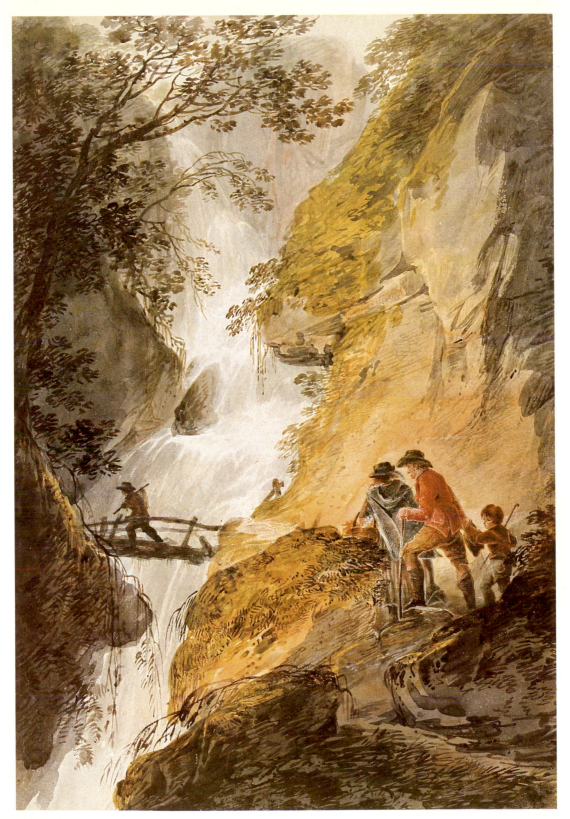

Plate I: cat. no. 112

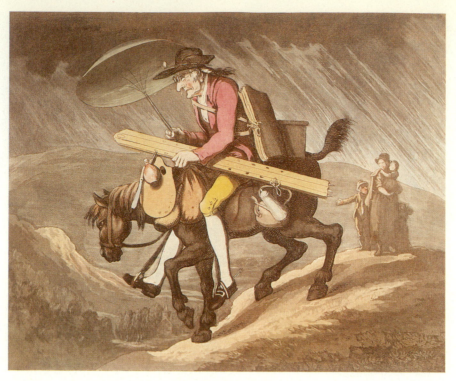

Plate II: cat. no. 97

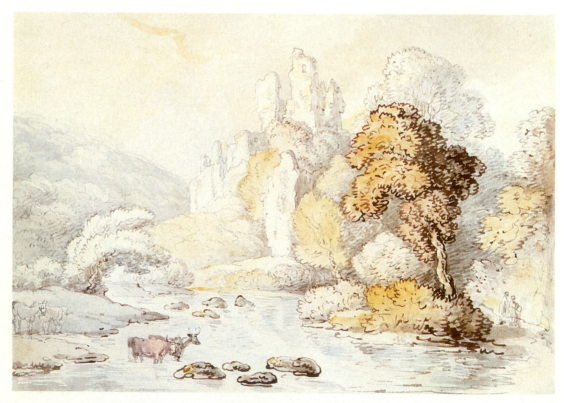

Plate III: cat. no. 115

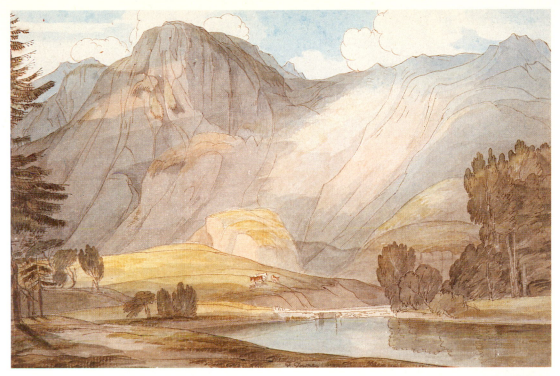

Plate IV: cat. no. 119

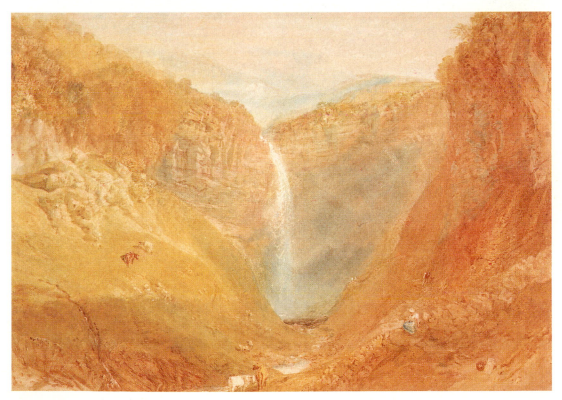

Plate V: cat. no. 120

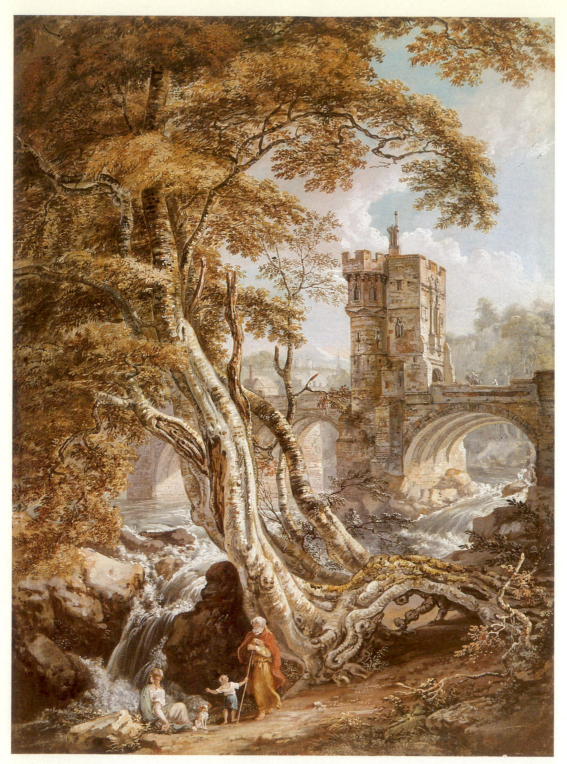

Plate VI: cat. no. 116

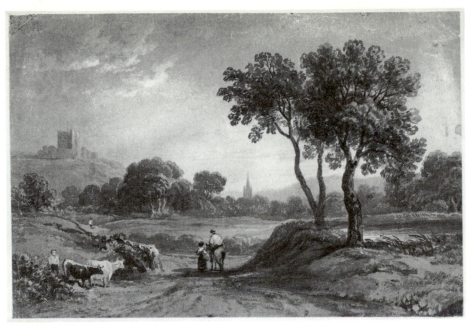

Plate 54: cat. no. 106

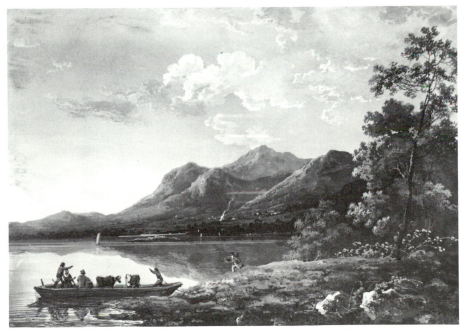

Plate 55: cat. no. 108

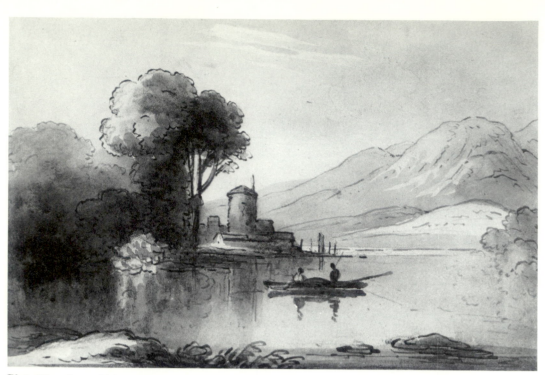

Plate 56: cat. no. 114

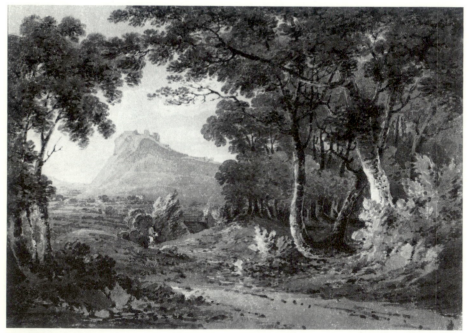

Plate 57: cat. no. 101

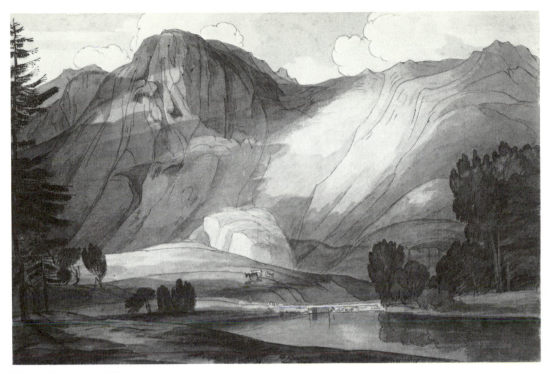

Plate 58: cat. no. 119

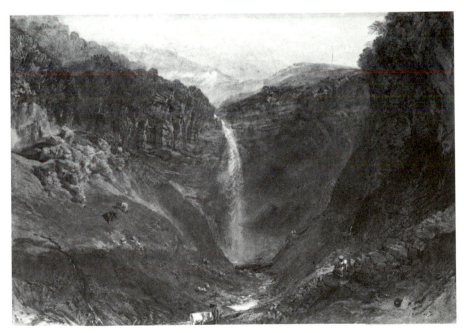

Plate 59: cat. no. 120

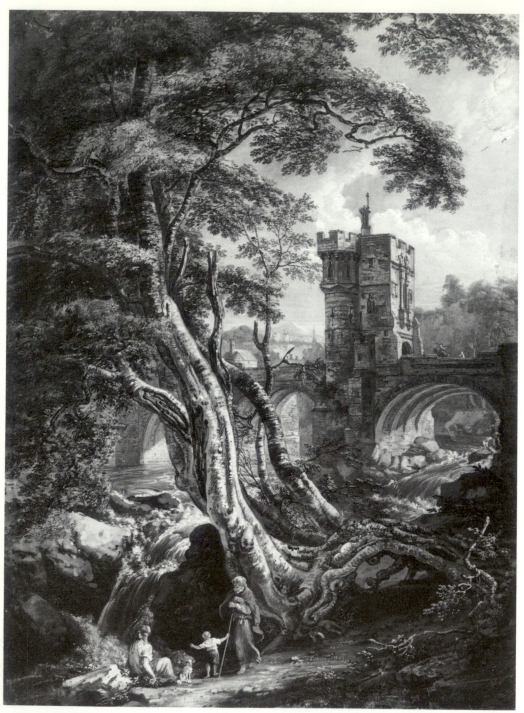

Plate 60: cat. no. 116

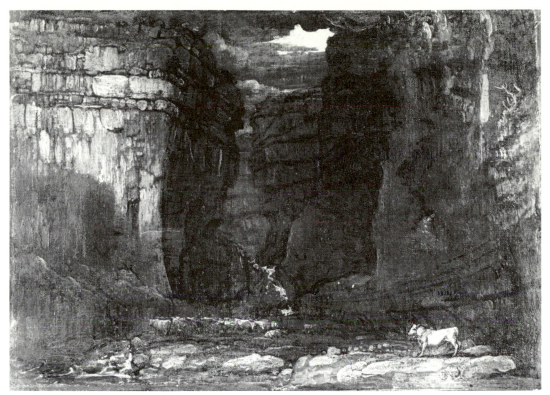

Plate 61 : cat. no. 131

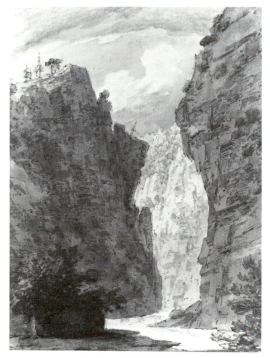

Plate 62 : cat. no. 105

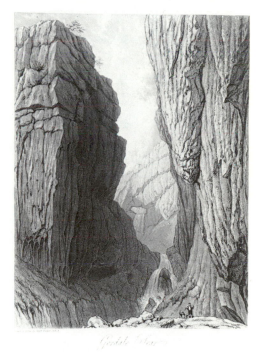

Plate 63 : cat. no. 132

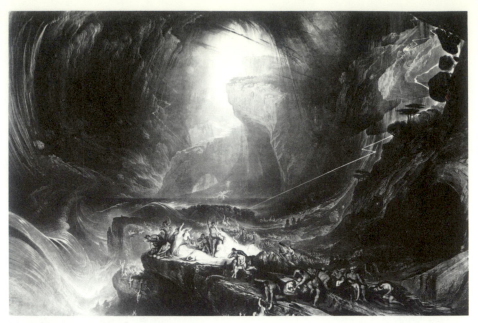

Plate 64: cat. no. 134

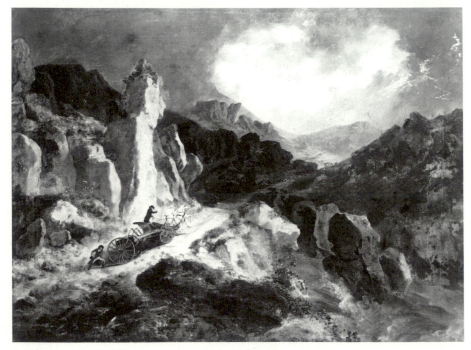

Plate 65: cat. no. 129

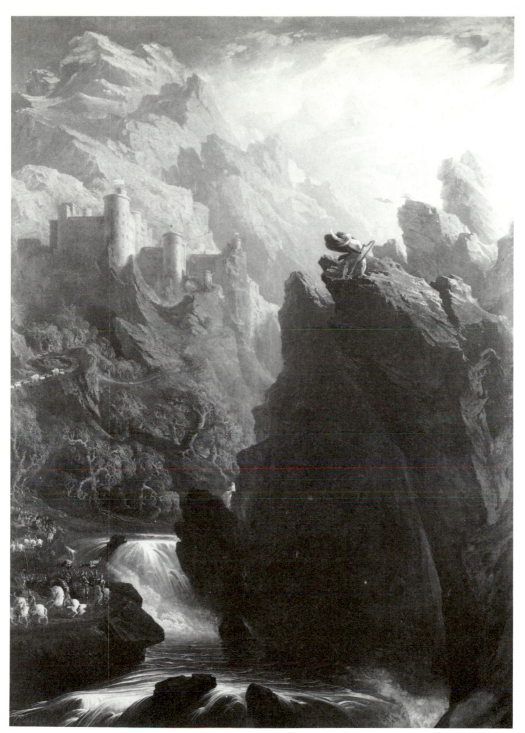

Plate 66: cat. no. 133

Plate 67: cat. no. 13

Plate 68: cat. no. 130

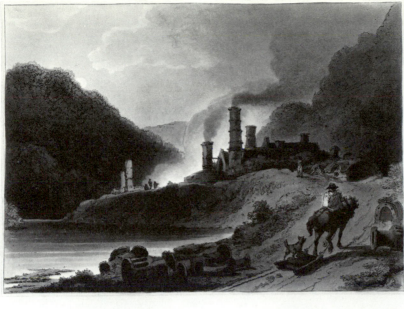

IRON WORKS, COLEBROOK DALE.

Plate 69: cat. no. 127a

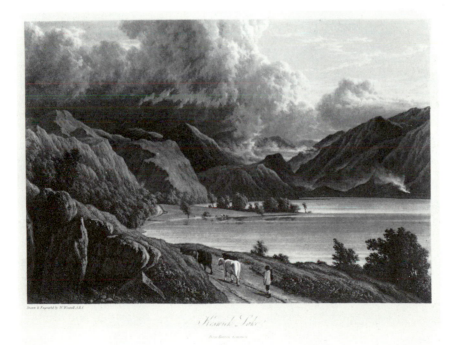

Keswick Lake

Plate 70: cat. no. 151

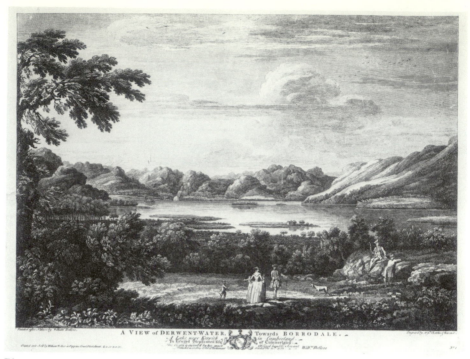

Plate 71: cat. no. 136

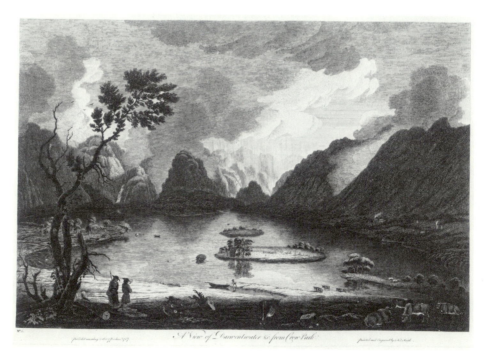

Plate 72: cat. no. 137

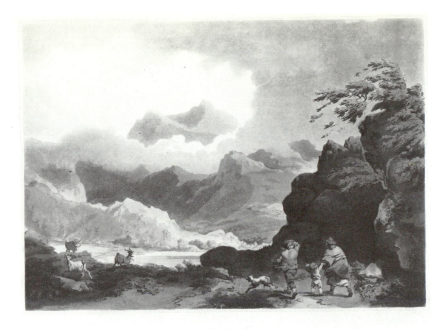

Plate 73: cat. no. 127

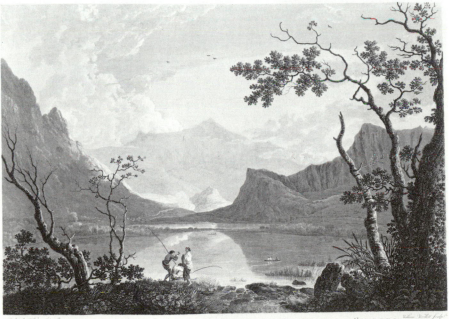

Plate 74: cat. no. 22

Plate 75: cat. no. 123

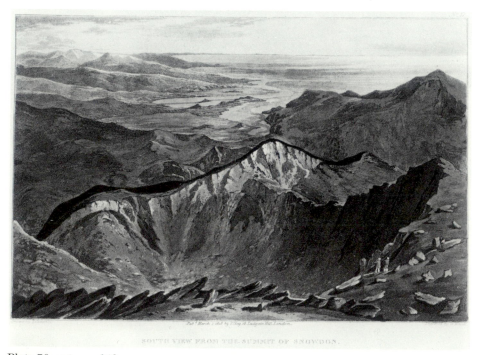

SOUTH VIEW FROM THE SUMMIT OF SNOWDON.

Plate 76: cat. no. 149

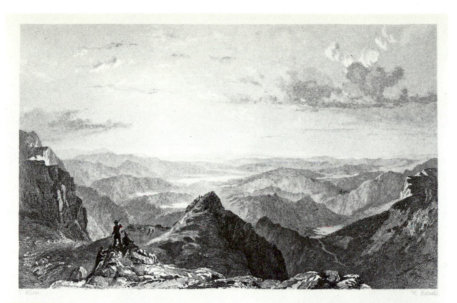

VIEW FROM LANGDALE PIKES, LOOKING SOUTH EAST, WESTMORLAND.

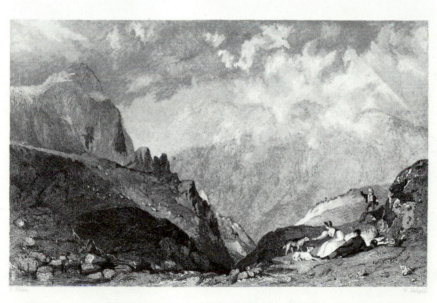

VIEW FROM LANGDALE PIKES, LOOKING TOWARDS HOWFELL, WESTMORLAND.

Plate 77: cat. no. 157d

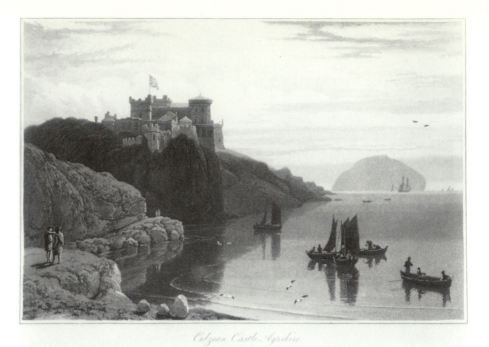

Culzean Castle, Ayrshire

Plate 78: cat. no. 144a

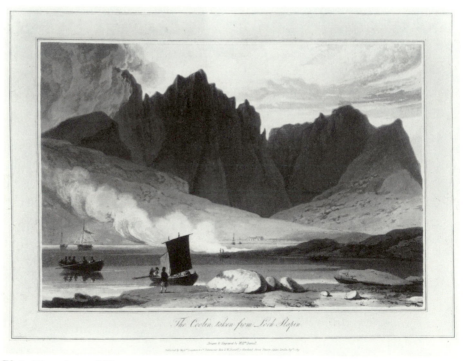

The Coolin taken from Loch Slapin

Plate 79: cat. no. 145

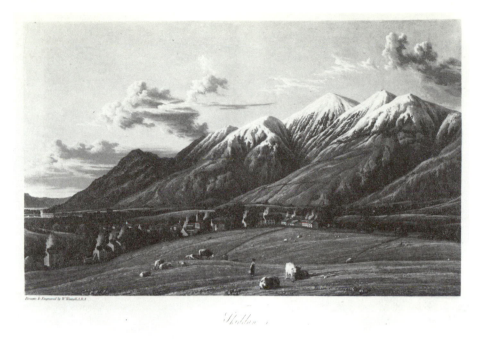

Drawn & Engraved by W. Westall, A.R.A.

Skiddaw

Plate 80: cat. no. 151a

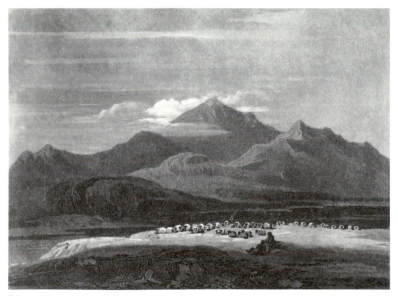

Plate 81: cat. no. 165g

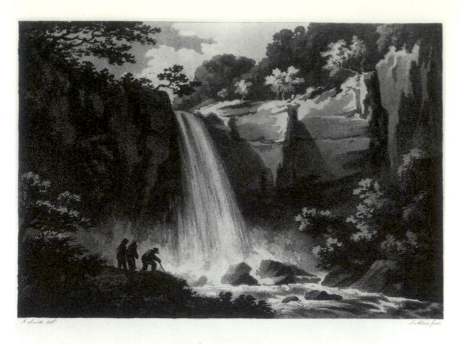

Melincourt Cascade

Plate 82: cat. no. 139

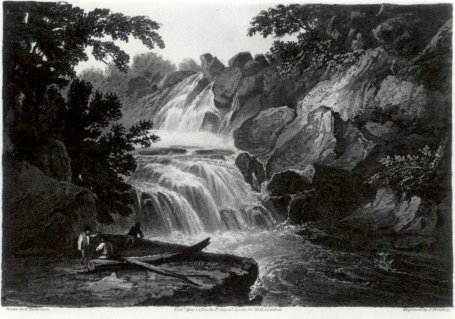

RHAIADYR Y WENNOL.

Plate 83: cat. no. 150

WATER FALLS.

Plate 84: cat. no. 181

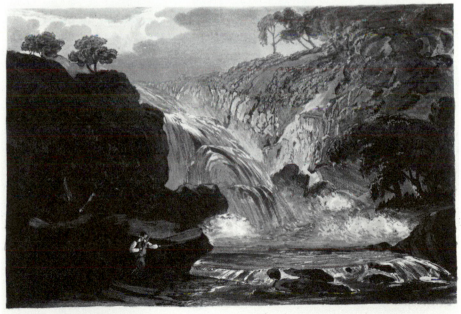

RHAIADR Y · MAWDDACH.

Plate 85: cat. no. 156

Plate 86: cat. no. 169

Plate 87: cat. no. 167

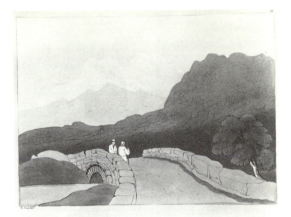

1st progress.

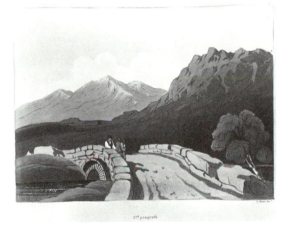

2nd progress

Plate 88: cat. no. 163 – 4 states

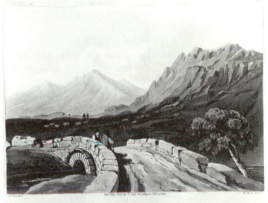

VIEW NEAR HARLECH, N.W.

3rd progress ...the finish.

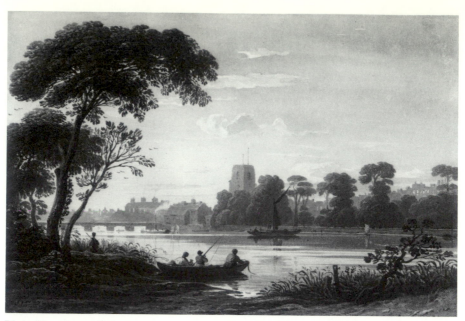

Plate 89: cat. no. 124

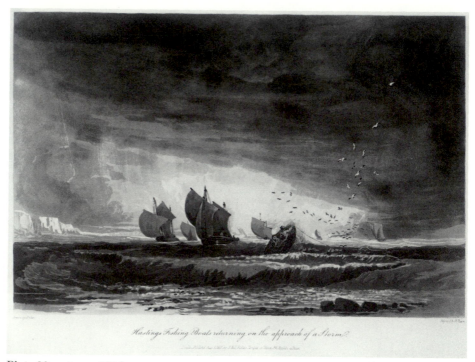

Hastings Fishing Boats returning on the approach of a Storm.

Plate 90: cat. no. 165d

Plate 91: cat. no. 166

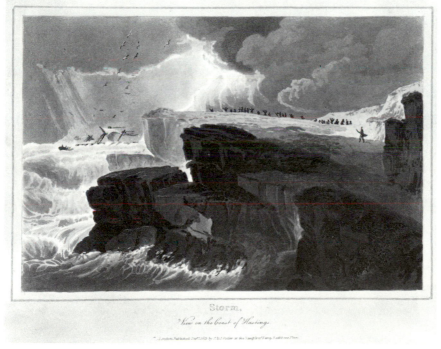

Storm,
View on the Coast of Hastings.

Plate 92: cat. no. 165f

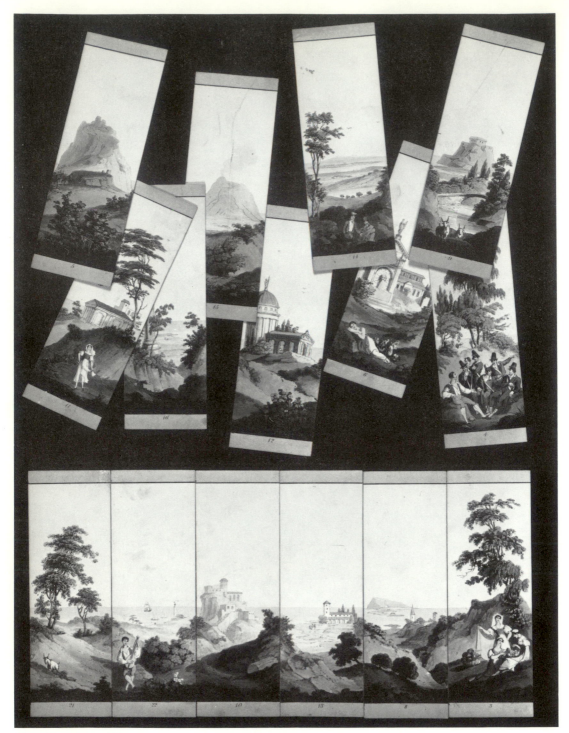

Plate 93: cat. no. 173